Painting Floral
Still Lifes

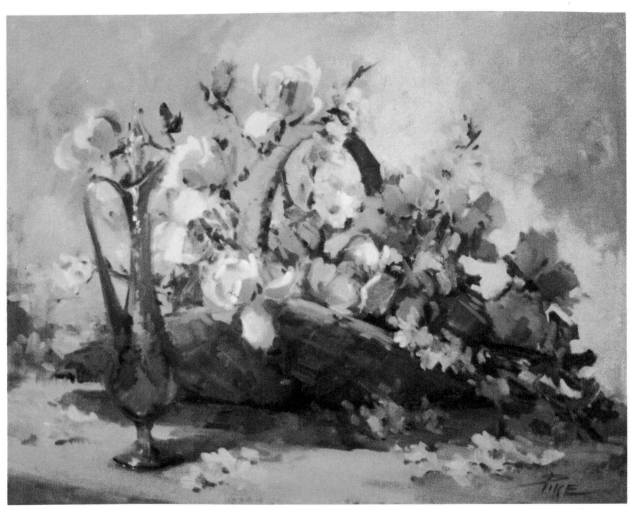

Oriental Magnolias and Venetian Glass *Oil on canvas, 24x30 inches. The shimmering color of the glass decanter perfectly complements the white magnolias that have touches of pink and violet on the underside of their petals.*

JOYCE PIKE

Painting Floral Still Lifes

NORTH LIGHT BOOKS

CINCINNATI, OHIO

Painting Floral Still Lifes. Copyright © by
Joyce Pike. Printed and bound in the United
States of America. All rights reserved. No part
of this book may be reproduced in any form or
by any electronic or mechanical means includ-
ing information storage and retrieval systems
without permission in writing from the pub-
lisher, except by a reviewer, who may quote
brief passages in a review. Published by North
Light Books, an imprint of F&W Publications,
Inc., 1507 Dana Avenue, Cincinnati, Ohio
45207. First Edition. First paperback printing
1989.

93 92 91 90 5 4 3 2

**Library of Congress Cataloging in Publica-
tion Data**

Pike, Joyce.
 Painting floral still lifes.
 Includes index.
 1. Still-life painting—Technique. 2.
Flowers in art. I. Title.
ND1390.P54 1984 751.45'435 84-
8052
ISBN 0-89134-323-7

To my dear friend Helen Wayne and my best
friend—my husband Bob.

Acknowledgments

I would like to express my eternal gratitude to my dear friend and associate Dorothy Judd who has worked alongside me from beginning to end as my manuscript coordinator and typist. Her uncanny ability for detail and organization, along with her continual encouragement, has contributed more than I can ever express.

I would also like to extend my heartfelt thanks and appreciation to Dr. Esther Davis who provided initial help, advice, and guidelines.

I am also grateful to Garry Colby for help with much of the photography, to Marsha Melnick and Jennifer Place for organizing and editing, and to North Light senior editor, Fritz Henning, for his supervision and guidance during the completion of the book.

Contents

Burst of Spring *Oil on canvas, 18x24 inches. I love when winter is over and flowers start to bloom, and this painting is my tribute to that time of year. The vignetted roses, painted in a loose, brushy manner, perfectly suit the season.*

Introduction

*W*hen I paint a floral still life, I often place the strongest emphasis on the flowers, underplaying both objects and form, in an attempt to recreate the feelings you would have when strolling through a garden. I want my paintings to have freshness and spontaneity as well as stir the inner emotions of the viewer, and throughout the years I have found ways of applying paint to canvas that support these aims.

The seeds for writing this book were planted when my students kept urging me to record my lessons. It took years to actually complete the project, but the result of being able to share with you the uncomplicated, practical techniques I have developed has been well worth the effort.

As you glance through these pages, you will see that this book is based on a series of progressive lessons. The first part of the book explains the theories behind my painting style—how I arrange a still life, handle color and palettes, apply the principles of value and temperature. Then, in easy-to-follow practice studies, I demonstrate how to paint various flowers, fruit, and still life objects. The last section of the book puts everything together in a series of full painting demonstrations.

Throughout, I encourage you—the reader and artist—not only to understand my methods of painting but also to develop your own personal approach. I believe firmly that anyone with desire and diligence can learn to paint with some skill, but to learn to observe and execute with an artist's eye and hand is more difficult. Hopefully, this book will help you to meet both those challenges.

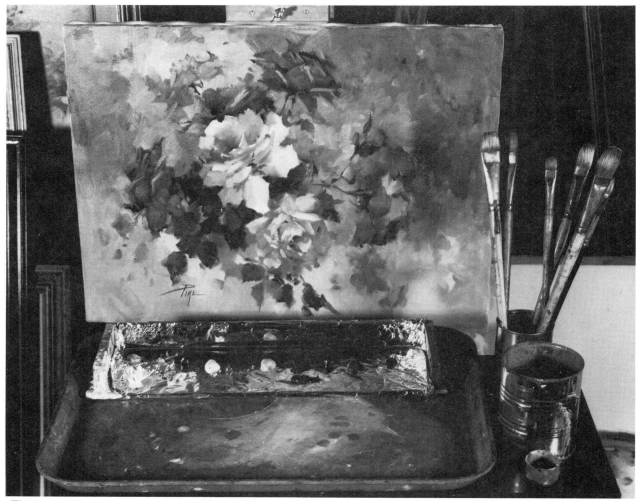

The set-up *Here is how my palette usually looks while I am working on an oil painting. Notice that I have set out my colors on a tin foil covered surface which makes clean-up easy. All mixing is done on the cafeteria tray.*

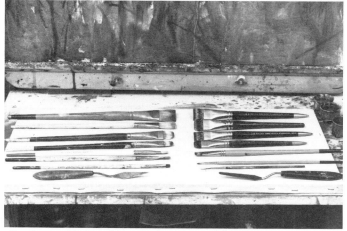

Brushes and knives *My complete range of brushes, from numbers 2 through 12, enable me to tackle any subject. The brushes on the right are brights, on the left are filberts. Also shown are two of my painting knives.*

Materials

*A*s you read through this section you will see that I have favorite materials that suit my particular techniques. I am comfortable working in both oils and acrylics, but for simplicity's sake oil paintings are shown throughout the book and the instructions given will be for oil paints. I often, however, use an acrylic wash to tone or underpaint my canvas, so I will also discuss using this.

My materials are quite traditional, and I use a limited palette, so if you are an experienced painter, don't be afraid to include your favorite brushes or paints just because they might not be mentioned here. If you are a beginner or feel that you need guidelines, this chapter will tell you what to buy to get started.

Painting Surfaces

My favorite surface for painting is a medium-to-rough grade of linen stretched and treated with a white lead and rabbitskin glue ground. If you find linen canvas too expensive, many linen/cotton blends are available. Pure cotton, while much less expensive, is not as flexible and therefore more difficult to stretch.

When properly prepared, pure linen will probably outlast all other painting surfaces, although cotton is now found to last much longer than previously imagined. I also like working on Masonite, both the smooth and the rough sides, which I coat with several layers of acrylic gesso, then protect with a thin coat of shellac. No one really knows how long Masonite will last.

I prefer not to use canvas board as it will warp and is not considered a quality painting surface.

Canvas Stretchers

It is certainly possible to make your own wooden canvas stretchers, but art supply stores carry light- and heavy-duty stretcher bars in most sizes, so it is seldom necessary to make your own.

The size of your canvas is a personal choice. I prefer painting most flowers and objects close to life-size, so my canvases are often large. Other painters prefer using small canvases.

To stretch a canvas you need a steel ruler, scissors, a staple gun, and a pair of canvas-stretching pliers. Fit the corners of the stretchers together, tapping lightly with the end of the pliers. Measure opposite corners to make sure the corner angles are square. Cut a piece of canvas that will wrap around the stretcher

with at least an inch of overlap on all sides. Staple one side of the canvas to the center of one side of the assembled stretchers. Then, pulling tightly, staple the canvas to the opposite side, then to the other two sides. Working from the middle outward, staple the canvas in a few places on one side of the stretcher; then do the same on the opposite side, pulling the canvas taut with the pliers; then do the same until you reach the edges. Fold the corners and staple these down as well.

Painting Grounds

Canvas needs a layer of protection before it can be painted, or the fibers would soon rot from the oil in the paint. A painting ground, or priming, can be either oil-based or acrylic. By far the easiest thing to do is to buy one of the already prepared acrylic gesso grounds. They are suitable for either oil or acrylic paints.

You can buy oil-primed linen canvas by the yard or the roll, though it is expensive. If I have the time, however, I enjoy making a ground for oil painting by applying a rabbitskin glue sizing followed by white lead oil primer. White lead must be ordered specially from an art supply store, and is illegal to use as a house paint due to the poisonous lead content. Remember, however, that this oil-primed surface is only suitable for painting with oils. Acrylic paintings require an acrylic-primed ground.

Whichever ground you choose, apply several coats to the surface, using a large brush, letting each coat dry thoroughly and sanding lightly before applying the next.

Using Old Paintings

Occasionally I will work over another oil painting if the original has no texture or marks that are impossible to eliminate. It is sometimes possible to take advantage of the colors of the old painting by incorporating them into the new piece. It also keeps old paintings from accumulating under the bed! Be careful, however, not to work over a painting that has been varnished, or to paint with acrylics over an old oil painting. It could cause your new work to chip, crack, or peel off. I apply a turpentine wash to the surface of an old oil painting before I reuse the canvas, as added protection against chipping or cracking.

Brushes and Knives

My favortie brushes for painting in oil are bristle brights, which have short bristles. When I am working in acrylics, I prefer filberts or longs (flats). Rely on the brushes most comfortable for you, and always buy the best quality you can afford. A good brush, if properly cared for, will last a long time. Try to keep one set of brushes for work in acrylic, and one set for painting in oils.

Buy two of each size brush so you can keep your colors clean by using a different brush on different colors. I use brushes numbering from two (small) through twelve (large). The larger sizes are useful for bold paint coverage, and the smaller ones, naturally, for more detailed work. The selection shown in the photograph will accommodate any subject matter.

Your brushes are your best tools. Whether you paint frequently or occasionally, clean them thoroughly after each use. Stand the brushes on their handles for storage or when painting, never on their bristles.

Brushes used with oils need cleaning in turpentine. Never soak brushes bristles-down in your cleaner, or they will bend out of shape. After washing with turpentine, dip the brush in motor oil (any weight will do). This will keep your brushes soft and pliable. Do not worry if the bristles become discolored, but be careful to clean out all the paint residue. To keep your brushes well shaped, place them flat between the pages of an old telephone book to keep the bristles straight and ready for the next painting session.

Make sure, too, that you keep your brushes clean while you paint. Dipping a brush in dirty turpentine and reusing it can cause muddy colors. Ideally, use a separate brush for each family of colors, but if that is not possible, be sure to clean the brushes before you change colors.

Brushes used with acrylics must be kept wet while being used or they will get stiff. To clean acrylic paint brushes simply wash thoroughly with soap and water.

I use two different kinds of knives: a palette knife and a painting knife. A palette knife is used for mixing your paint and cleaning off the palette; a painting knife is used primarily for painting directly on the canvas.

Palettes

Many types of palettes are available in art supply stores—wood, plastic, disposable paper—but here are several ideas for palettes I find easy to use.

For oil paints, a light fiberglass cafeteria serving tray, like the one shown in the photograph on page 10, makes a great palette. It is large in size, has a rim, is lightweight, and can be easily cleaned with turpentine. To remove paint build-up, I clean the tray with oven cleaner about every six months.

For acrylics, I use wet paper towels, the brown industrial type, for my palette. I simply lay several down on my work surface. They are sturdy, and the light brown tone enables you to see your colors well when mixing. By wetting the towel first, you will prevent your acrylics from drying too rapidly. I also use a spray bottle to keep the paints on my palette moist. When you are ready to change colors, throw that towel away and you always have a fresh palette.

Paint

I am often asked whether I prefer working with oils or acrylics. I prefer acrylics, but when teaching, I demonstrate primarily in oils, using an acrylic underpainting.

When I am not working on commission, I usually work in acrylics; few people can tell the difference in my finished paintings. I use the acrylic paint wet-into-wet so quickly that the completed work has the appearance of an oil painting.

To follow the demonstrations in this book, you can use either oils or acrylics. My palette of colors is discussed on page 24, and if you don't already own paints you can refer to that section to make your list.

Most acrylic colors are sold under the same names as oils. There are a few differences, and these can be checked with dealer color charts. Most art supply stores will be happy to give you advice on choosing colors and the equivalent colors for oils and acrylics. If you are not already familiar with paints, as you work you will discover your own favorite.

Whatever type of paint you choose to work with, it is a good idea to place enough of each color on the palette to complete the area of your painting. Running out of a color you have mixed will force you to substitute a color which may not match.

Experiment with all the options open to you. Use an acrylic underpainting or wash, and finish the painting in oil; do a complete painting using a turpentine and oil wash or underpainting, with an oil overlay; or use an acrylic underpainting or wash and finish with an acrylic overlay.

Painting Mediums

To achieve the paint consistency I like to work with, I use a painting medium. For oil painting my usual medium is the following mixture: one pint of turpentine, four ounces of linseed oil, and two ounces of damar varnish. There are also many commercial mediums on the market, and each serves a slightly different purpose, so it is wise to check labels and to consider your method of working when choosing a medium.

For acrylics I simply use water to thin my paint to a nice working consistency. There are mediums available to make acrylics shinier, duller, thicker, or slower drying. It is all a matter of personal preference and desired results as to whether you will use them. Your local art supply store should also be able to give advice; don't be afraid to ask questions.

Varnishes

If you have completed an oil painting you may want to add a final protective coat of varnish. You must wait three to six months before varnishing or the oils may not be dry. Damar varnish, available in gloss or matte finish, is a good choice for a final varnish. I also use aerosol retouch varnish to restore the luster of some colors that can dull during the drying process. Spraying retouch varnish lightly over the dry-looking areas will not only restore the original luster, it will also let you judge the overall color effect your painting will have after final varnishing. A heavy application is not needed. A light coat is enough to allow adhesion of the next layer.

If your completed painting has dried with shiny and dull spots, spray the entire painting with the retouch varnish (following manufacturer's directions) and the painting will become uniform in finish. This will also give your painting temporary protection until the three- to six-month drying period has elapsed.

To apply the final protection coat of varnish use a wide soft brush (three inches is a good width) and work evenly from side to side.

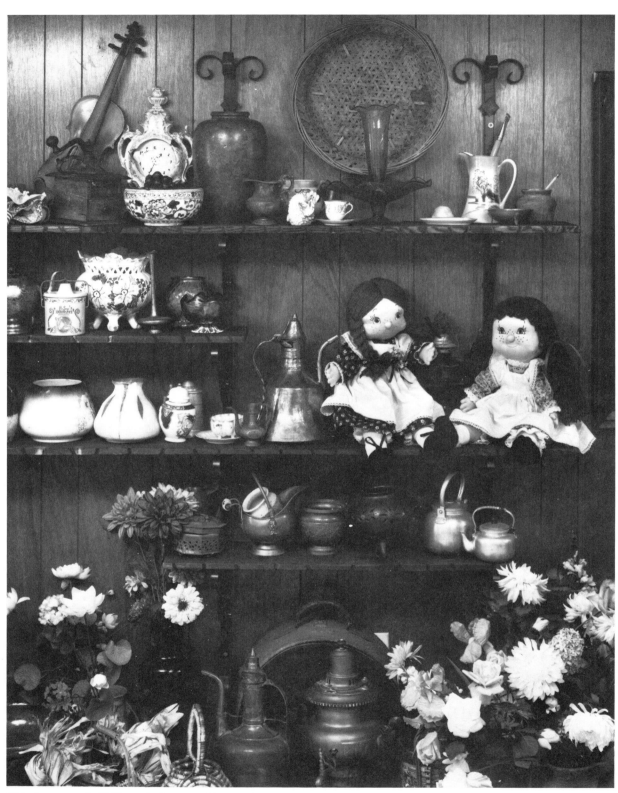

Objects on my shelf *Through the years I have col-
lected many objects for my still-life paintings. The
items shown on these shelves are just some of my
favorites, and range from valued antiques to
treasured flea-market finds. I try to choose items
that have diffent shapes and textures, both as
flower containers and as props to use in a still life.*

Getting Started

*B*efore actually beginning
to paint floral still lifes, there are a few basic
techniques and concepts you should become
familiar with. It will be helpful to read
through this part of the book before even
picking up a paint brush. Then, when you
actually begin painting one of the floral
studies or following the demonstrations shown
later, you will know what I mean by certain
terms or instructions. You won't have to
waste time leafing back through the book
while you are working.

The first consideration is how to go about
selecting flowers and objects to make up a
still life, and, how to arrange them into a
strong and unified set-up. I hesitate to use the
word "composition" here, because I prefer to
define composition as the lights and darks
placed on the canvas in a well-designed
pattern. Achieving this pattern, however, does
depend on first arranging your still life
elements in a pleasing way.

Next, I will introduce you to the
components involved in my personal
approach: finding the focal point in the
set-up, establishing the light source, toning
and underpainting, blocking-in the still life,
and building form with values. This part of
the book will also deal with color: the
characteristics of colors, how to use the color
wheel for mixing colors, and how and when
to gray the colors you have selected. Finally,
I will talk about perspective, and give you
some hints that will make drawing still life
elements easier.

Each floral study or demonstration that you
will follow later in the book will include all
of the components discussed in this first part.
It simply adds up to my working process. As
you try the studies yourself, you will no
doubt develop your own personal way of
painting, but I still must stress the importance
of a good foundation—painting vocabulary
and mastering your tools—before your own
style can really evolve.

Selecting Flowers and Objects

Finding flowers to paint depends largely on where you live, the time of year, and whether you have access to a garden. It is ideal to go out your back door and gather fresh blooms from your garden. There are circumstances, however, where it is impossible to do anything but visit your local florist. It is easy to be inspired when the open fields, roadways, and parks are full of wildflowers and flowering trees. But when you are facing a refrigerated florist's display, it can be much more difficult to imagine these confined bunches of flowers as part of a romantic still life. Many flowers can be purchased from the florist, but I do not recommend buying the rose, because it is usually trimmed with the outside petals removed. It does not have the same soft look of a garden rose. Wild or garden-grown flowers have much more variety in shape and size than commercial flowers. And florist's arrangements tend to be stiff and unsuitable for painting until rearranged more loosely in your own container or vase.

Since it is such a marvelous experience to paint outdoors, I urge you to set up your easel, and paint whatever happens to be growing—from shaggy sunflowers to black-eyed susans.

Choosing Objects

I have been collecting objects to use in my compositions for years. Some of my favorite pieces have monetary value, others are simply interesting junk. But, as you will see, they all show up time and time again in my paintings. Prowl antique stores and flea markets and search for appealing objects—remember that broken items need not be painted as broken.

Your choice of articles should be personal. Rather than copy another artist's approach, bring your own personality to whatever you choose to paint.

A dear friend and student of mine has a special love for old shoes. Her collection numbers in the hundreds, and she has painted the shoes from every possbile angle. The subject matter has never become tiresome for her, and this is evident in each and every one of her paintings. If you are bored with your subject matter, the viewer will know.

When looking for subject matter, look for props that excite your imagination. Hats have always been my special obsession. I love to wear hats and as you can see, they show up from time to time in my still lifes. Everyone has favorite objects they love to paint. But no matter if it is a rose or a nose—it is how it is painted that counts!

Backdrops

Almost any table will do for setting up a still life, but you will probably want to cover it with a cloth, as well as hang another drape in the background. The color of the background cloth will affect your composition so select carefully. It is useful to have some lengths of both light and dark colored fabrics on hand to choose from.

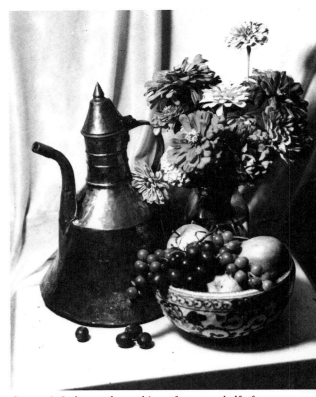

Set-up A *I choose three objects from my shelf of "treasures" to create a simple but effective composition. I've arranged the objects so no two are sitting on the same visual plane. Also, the tallest (of the flowers) is at the rear; the bowl and fruit in the front, which enables your eye to travel back into the picture toward the flowers. Notice that I've let a few grapes fall onto the table. This enhances the naturalistic qualities of the still life.*

Step 1 *To start the painting I lay in an acrylic wash all over the canvas, and with a darker color in oil, begin to suggest the forms and patterns of the composition. Now I begin to work with the various values that define the abstract shapes evident in the flowers and fruit. The pitcher, a solid mass with highlights and very dark areas, is easy to block in.*

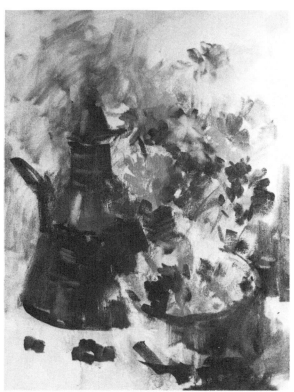

Step 2 *Here I add definition to the flowers and fruit, and indicate the pattern on the outside of the bowl.*

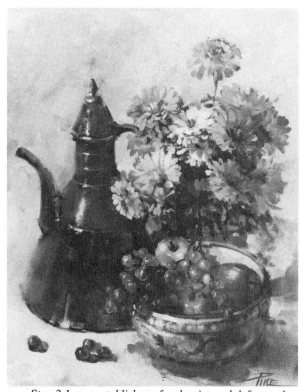

Step 3 *I now establish my focal point and define and add detail to all the parts of the composition. I emphasize both the lights and darks, and aim for just enough realism in my treatment of the flowers and fruit to make the painting believable. The last step is to add the background and shadows on the table.*

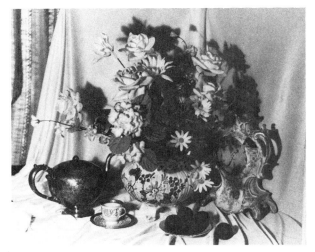

Set-up B *When you choose this many items for a still life it is helpful if they are related in some way or it can be hard to visually pull the painting together. In this case the painting becomes a reflection of an afternoon pause for tea. The roses echo the formality of the clock and cup and saucer. The silver teapot and the plums add texture and color. The daisies keep the overall effect from being too stuffy. The objects are arranged in a narrow sort of triangle that has the teapot at its apex.*

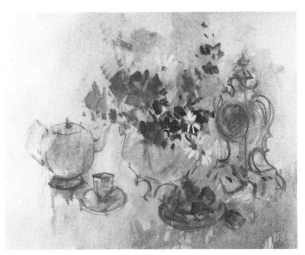

Step 1 *I begin by freely covering the canvas with an acrylic wash, only slightly indicating the dark masses of some of the forms. Because of the complexity of using five different objects, I find it helpful to draw in the shapes with charcoal. I am careful to make sure the perspective is correct so the items sit solidly on the table.*

Arranging the Still Life

The photograph on page 14 shows a collection of my favorite objects for use in my still life paintings. I'll use these items over and over, but of course in different ways. A tureen, for example, might show up in one painting as a flower container, in another as quite a different prop.

On the next several pages you will see how I have used some of these objects to construct pleasing still lifes. In the first demonstration I chose three objects; in the second I arranged five different items into a more complex arrangement.

When selecting the components to be used in your set-up, first be aware of height. No two objects should be the same height, but if for one reason or another, you want to use two objects that are the same height, paint one of the articles taller than the other. After all, you are the creator of the still life and you are in control. Next, you should try to

vary the shapes of your objects as well as vary the colors and textures. Remember that the objects are used for balance—not necessarily for subject matter. Although subject matter is important, it should not stand as the most important consideration in a painting.

It is always a good idea to try to create the illusion of movement in your composition. Entice the viewer's eye to move from one spot on the canvas to another. Try placing your objects in such a way that the eye travels into and around the whole composition.

Adding Flowers

The most important thing to remember when you begin to arrange the flowers in your still life is that you want them to look fresh and natural, even though they are being restrained by a container. Try to achieve an effect that is

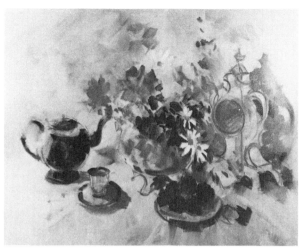

Step 2 *I now start to block in my lights and darks. I reinforce the focal point (where the daisies meet the darkest leaves), and start to indicate some of the background shadows.*

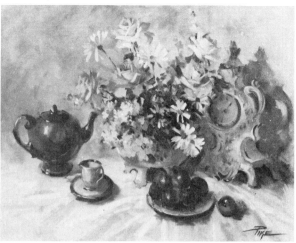

Step 3 *I secure my middle tones, then add just a bit of detail to the objects. Notice that only a few of the flowers are painted to completion. The background and tablecloth are freely brushed in to echo the loose feeling of the flowers.*

not too crowded, but do not let the blossoms fall too far apart either. Also try to consider the characteristics of the particular type of flower that you are painting. Study the flowers carefully and find something that sets them apart from other flowers. The geranium, for example, is distinguished by the manner in which the blossoms grow at the end of many short stems. It is shaped quite like an umbrella with a few short buds hanging down.

Next, make sure you arrange the flowers so they face in different directions. It is especially important to include profile views of the flowers as this clearly adds variety. Use just enough greenery to support, but not to take away from, the dominance of the blooms.

Finally, flowers should not be arranged in a straight line, square, or circle. A regular or predictable pattern is boring. Instead, flowers should be on different levels, with a few touching.

Simplification is the magic word. Start with a simple, well thought out arrangement, then you will be free to paint with boldness.

While you are painting, you will be concentrating on placing the darks and lights on your canvas in a well-designed pattern. This is what I call composition, so it is important to plan this aspect of your painting carefully. Color has little to do with composition unless it reads as part of that dark and light pattern. Your painting may get by if your color is a bit weak, but a painting cannot be successful without a solid composition.

I could elaborate on the subject of composition, but I earnestly feel that the demonstrations throughout this book will show you more than I could say. The principles I will point out for you to follow are sound and practical. The amount of time you are willing to practice, using these principles, will determine your individual progress.

The Focal Point

When you arrange flowers and objects into a pleasing composition, you must decide where in the painting you would like the viewer's eye to go first. This will be the *focal point,* and there should only be one in any painting.

One of the important aspects in establishing a center of interest is by using your darkest dark and your lightest light in this area. This might be the edge of a flower and the dark of the leaves, or the highlight on the edge of a container and the dark of the background.

It is advisable not to have the focal point in the center of the canvas. This tends to create a static kind of design. The idea is to arrange the composition so the viewer's eye travels through the objects and flowers from one spot to another. This is what gives a painting vitality.

The Light Source

Establishing a fixed light source is critical to creating a successful realistic composition. The direction of the light source should be consistent while you are working, otherwise the composition will seem confused. It would be disheartening to find, when your outdoor painting is completed, that you had used light coming from two different directions. This, of course, can happen when using artificial illumunation, but never under natural lighting conditions.

Once you determine your source of light, you should maintain it; this same rule applies whether you are working indoors or outdoors. Don't change your original composition because the light source has changed (you will encounter this when painting outdoors). When painting indoors under controlled lighting it is easy to decide on the direction of the light and keep it consistent.

The best and simplest approach to lighting a subject indoors is to use a spotlight. When I use artificial light, I use a spotlight with a warm 100-watt bulb. When I can use natural light indoors, I prefer north light. It is important to know whether your light source is warm (reddish or orange) or cool (bluish). If the light is warm, then the shadows in the still life will be cool; if the light is cool the shadows will be warm.

Next, look carefully at your set-up to see how the shadows created by your light source fall. Keep in mind that you are attempting to create the illusion of three dimensions on a two-dimensional surface. How light moves through the picture can help the feeling of depth and keep the forms from looking pasted on the canvas. It also helps to emphasize the pattern of darks against the pattern of lights. A good exercise is to place a white cup on a white table with a white background. If your light source comes from one side, you will see the light side of the cup against a seemingly darker background. The light also goes behind the cup and strikes the background, so here you will see the dark side of the cup against a lighter background. This aids in the illusion of three dimensions.

Try not to paint an object as if you were wearing blinders. Compare value to value, color to color, and be aware of the spatial arrangement between objects. This will improve your drawing ability as well as your painting.

Set-up A *The focal point and the light direction.*

Set-up B *The focal point and the light direction.*

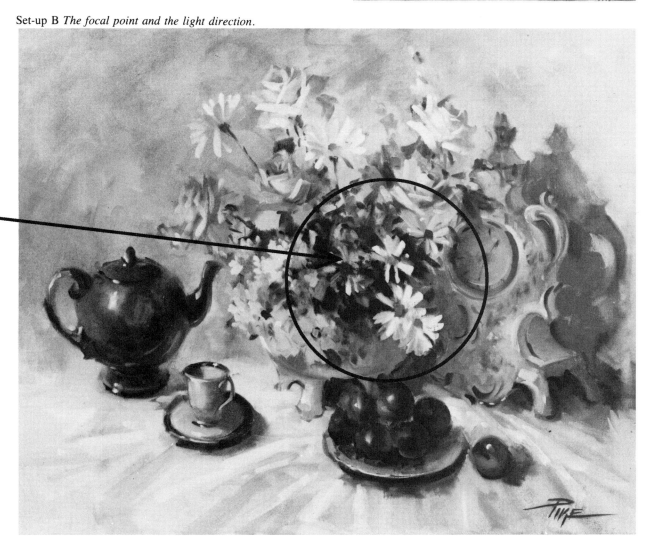

Color

Over the years I have developed a palette that I have found perfect for my own style of painting. I have a system for using the colors on my palette that enables me to mix all the colors I need with relative ease.

My palette is limited, basically without earth colors. For mixing colors, I use the triadic color system (explained on page 24). I apply my colors based on analogous color harmony, an easy system that revolves around choosing one dominant hue for each painting. The additional colors and grays used in the painting depend on which primary hue is chosen as the dominant hue (see page 24).

My Palette

Except for raw umber, I eliminate earth colors from my palette, because I find it difficult, sometimes impossible, when working with them to achieve the sparkling, brilliant effects that are possible when working with pure, non-earth pigments.

Color is a most important consideration in one's art education. I introduce my students to color with a truly simplified approach. I ask them to mix the secondary and intermediary hues from the three primary colors (see the color wheel on page 25). In the process of mixing, they find that all colors needed can be achieved from the three primaries. This has proven to be an excellent learning experience and I urge you to follow it.

On my own palette, however, I use other pigments straight from the tube for my secondary and intermediary colors. For example, I use Grumbacher red for my primary because it is a true red color. For orange, instead of mixing red and yellow, I use cadmium orange. For a red-orange, I use cadmium red light, and so on around the color wheel. A strong violet, for example, cannot be mixed from Grumbacher red and ultramarine blue. Alizarin crimson mixed with ultramarine, used as my red-violet, does the job nicely.

Note about color mixing terminology

Determining what is a pleasing and appropriate color to use in a painting is always a matter of personal judgment of the artist. In addition, the process of mixing colors is not a precise procedure, and learning how to mix the colors you want is best achieved through practice and experience. However, in order to help the inexperienced painter better understand my painting demonstrations, I will indicate the approximate volume proportions of the tube colors I use for my mixtures. This diagram illustrates the simple terminology.

I have placed ivory black in the center of the color wheel as a neutral. Black can be an important pigment, especially when intense darks are needed. Many times black will be the perfect additive to a color for just the right gray. It is my feeling that white can cause more problems than black when overused. It is necessary to use white, as we all know, but be careful if your color is to remain intense. Adding too much white can result in chalky colors.

I also have six other colors on my palette which I put to specific uses in my work. Sap green is my favorite and most-used green; I go through it like toothpaste! This color, I feel, has no equal for glazing and mixing grays. The color mixing chart beside the color wheel shows the beautiful results achieved when sap green is mixed with other colors.

By mixing sap green and alizarin crimson, you can get a vibrant dark mahogany color. The transparent quality of this mixture allows me to achieve, in one application, either a metallic look or a dark rich tone. If you ever run out and need a close substitute for sap green, mix Indian yellow and a small amount of phthalocyanine green.

When I wish to use a dark underpainting, I tone my canvas with raw umber (the one earth color on my palette), then work color into it. I use this method primarily when painting a landscape on location. I seldom

mix raw umber with any of my palette colors.

Shiva red crimson and Matisson pink I find valuable as underpainting colors—they add just a bit more diversity to my basic range of reds and pinks, but they are considered fugitive or unstable. Though intense, these colors can fade over time.

The palette you use is your own personal choice. Know it well! But remember, as long as you have your three primary colors, you will be able to mix almost any color you need. Most artists choose their premixed pigments based on their personal needs, so begin with the colors I have suggested here and then experiment until you have found the right colors to complement your subject matter.

Color Characteristics

The following list will give you a good idea of the colors available to you, their characteristic properties, and how to use them. All the colors discussed are oil paints, but similar colors are also available in acrylics.

Cadmium red light Opaque. Mixes well with all colors. Strong and permanent.

Alizarin crimson Transparent. Can be used for glazing, yet should not be used alone as it has a tendency to darken and fade. Mixes well with greens to produce a beautiful gray. Fugitive.

Cadmium orange Traditional orange. Opaque. Mixes well with all blues for good grays. I use it sparingly with white to get my whitest, most vibrant whites.

Cadmium yellow light Opaque. This is a true yellow that mixes well with other colors to make earth tones.

Indian yellow Vibrant, transparent yellow. Very good for glazing, yet mixes well with opaques. Great for underpainting flowers.

Sap green I find this transparent color exceptionally versatile. When mixed with alizarin crimson it makes a beautiful dark mahogany color; great for glazing.

Thalo yellow green (phthalocyanine*) Semi-transparent. A good yellow hue used to obtain a sunlight effect that mixes well with reds. I

use it in portrait painting to achieve vibrant darks when mixed with cobalt violet.

Viridian green A transparent green often used to gray flesh tones. Very helpful for painting skies, water, and deep leaf greens.

Thalo green (phthalocyanine*) A very strong green. A good color to keep on hand to suggest transparent glass.

Ultramarine blue A reddish-blue. This is the most used blue on my palette because of its exceptional brilliance and ease of handling. Can be used for glazing.

Cerulean blue A ceramic-like pigment with some degree of luminosity. Useful for light blues and sky colors.

Thalo blue (phthalocyanine*) A very vibrant color to keep on hand when a strong accent is needed.

Cobalt violet (Bellini) A beautiful violet-purple which, when used with other hues, makes good flesh tones. Is great to add to grays.

Cobalt violet (Grumbacher) A dark, slightly grayed rich blue-purple. Permanent.

Raw umber Semi-transparent earth of yellowish hue used mainly for underpainting or sketching.

Ivory black The most widely used black. Good mixing qualities.

Matisson pink A premixed light pink. Intense in hue. Not considered truly permanent.

Shiva red crimson A strong dye quality. More vibrant than alizarin crimson. Fugitive.

Titanium white I prefer to use titanium white rather than flake white, zinc white or a zinc-titanium mixture, because it is the whitest of all white paints.

**Thalo* is a registered trade name of Grumbacher. The same color, or one very close to it, is usually identified by its correct chemical name *phthalocyanine*. Manufacturers often identify their products with special names. Winsor & Newton, for instance, calls their equivalent of phthalocyanine blue *Winsor blue.*

The Triadic Color System

Primary colors cannot be produced from any combination of other colors, and they can be used to produce all additional colors on the color wheel. I have noted below the tube colors I use in the color wheel and on my palette. The three *primary* colors are:

Red (Grumbacher red)

Blue (Ultramarine blue)

Yellow (Cadmium yellow, light)

Secondary colors are a combination of two primary colors in equal proportions. The three secondary colors are:

Orange (Cadmium orange)

Green (Viridian green)

Violet (Cobalt violet—Bellini)

Intermediate colors are mixtures of one primary color and one secondary color—colors located next to each other on the color wheel. Each intermediate color combines the characteristics of a primary color and a secondary color. The six intermediary colors are:

Yellow-green (Thalo [phthalocyanine] yellow-green)

Blue-green (Cerulean blue)

Blue-violet (Cobalt violet)

Red-violet (Alizarin crimson)

Red-orange (Cadmium red light)

Yellow-orange (Indian yellow)

Dominant Hue

Approaching color using the color wheel on page 25 and according to the following system of analogous color harmony takes all the guesswork out of color mixing and leaves little to chance. Basically the colors used in a painting should consist of a dominant hue, its complement (located directly across the color wheel), adjacent hues, and possibly small touches of discords (the other two colors in the triangle formed by the dominant hue).

The dominant hue works together with its adjacent hues to produce a satisfying analogous color arrangement. When the dominant hue is mixed with its complement, harmonious grays occur.

For example, if I choose red as a dominant hue, then red-orange and red-violet are the adjacent hues and green is the complement. Let's say that I am painting some fresh wild roses. I would first paint my roses in a full range of pure reds. Then, being careful not to disturb the needed areas of pure color, model the roses by adding whites for the highlights and grays mixed from red and green for the shadows. I would indicate leaves in a range of greens grayed by red. I might also use some neutral gray in this area, created by mixing together equal amounts of the dominant color and its complement. For my background, I would use the dominant hue grayed by its complement and lightened with plenty of white. I might also work small amounts of adjacent hues into the background to vary the tones. I will add tiny amounts of the two discord colors, in this case yellow and blue, to give vibrancy to the painting.

The question may be asked: What would the dominant hue of a white rose be? The answer is: all white flowers will lean toward some hue, even though they may be called white. Look closely, and if need be, exaggerate the hue slightly. Use artistic license and don't be afraid to have fun.

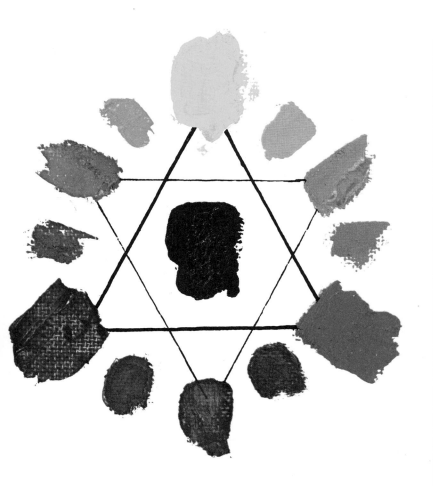

GRAY SCALE	1	2	3	4	5	6	7	8	9	10
Cadmium Orange / Ultramarine Blue										
Cadmium Red, Lt. / Sap Green										
(Bellini) Cobalt Violet / Sap Green										
Grumbacher Red / Thalo Yellow Green										
Cadmium Red, Lt. / Thalo Yellow Green										
Alizarin Crimson / Sap Green										
Alizarin Crimson / (syn) Indian Yellow										
Cerulean Blue / (Bellini) Cobalt Violet										
Cadmium Orange / Sap Green										
Alizarin Crimson / Viridian Green										
Cadmium Red, Lt. / Ultramarine Blue / Sap Green										
Alizarin Crimson / Ultramarine Blue / Sap Green										

The simple grouping of color on a wheel helps you understand the basics you need to know. The large swatches of yellow, red, and blue are the primaries—colors that cannot be mixed by others. The next larger swatches are the secondaries—orange, violet, and green. These and the other colors can be mixed from the primaries. Colors directly opposite each other on the wheel are complements. For example: violet is the complement of yellow, orange the complement of blue, and green the complement of red, etc.

The color wheel is useful when deciding the painting's dominant hue and for graying hues with their complements.

This is my color mixing chart showing some of the possible results of mixing colors from the opposite sides of the color wheel. The mixture proportions necessary to produce the colors shown is best learned through thoughtful experimentation. The gray scale at the top is useful for comparing values while you are mixing your colors.

Mixing Grays

As you are beginning to see, my method of mixing grays in painting has little to do with mixing black and white. For me, there is nothing more satisfying in painting than being able to control the use of pure colors by combining them with subtle grays mixed from my dominant hue and its complement. These grays enhance the pure colors. The resulting paintings have a freshness and sparkle that would be otherwise unobtainable.

The most practical way to begin mixing grays is to mix a pure color with its complement and vary the degree of value needed by adding white. Mixing equal amounts of a color and its complement results in a neutral or complete gray. Remember, all three primaries are actually used to create a gray. If your dominant hue is red, the remaining two primaries—blue and yellow—when combined, make green. So you see, when green is your graying agent all three primaries come into play. The combinations are endless.

It might be helpful to make a chart of grays using all the colors on the color wheel grayed by their complements. Then mix several values of each color made by adding white. The format could be similar to the color mixing chart on page 25.

When you know what can be accomplished by creating grays from each of the colors on the color wheel then, and only then, can you start to experiment by using other closely related hues rather than the direct complement.

Knowing the subtle variations of your tube colors is a great help when mixing grays. For example, sap green is a yellow-green and is my favorite because of its versatility. It can be used to gray reds, violets, and oranges. When you begin to explore all the possible gray mixtures, you will discover, as I have, your favorite combinations. Soon you will reach automatically for a particular gray to solve a problem. I have many preferred grays, but I especially like what I call "elephant" gray, which is mixed from ultramarine blue, cadmium orange, and white. It is such a versatile combination because the temperature is so easy to control. To achieve a slight lavender tint I merely add a touch of cadmium red light. By adding a bit of sap green I get a glorious gray-green that is perfect for the distant leaves in foliage.

Work with your color wheel nearby at first. Eventually, color mixing and graying colors will become second nature and you will find great satisfaction in exploring the infinite possibilities of color each time you begin a new painting.

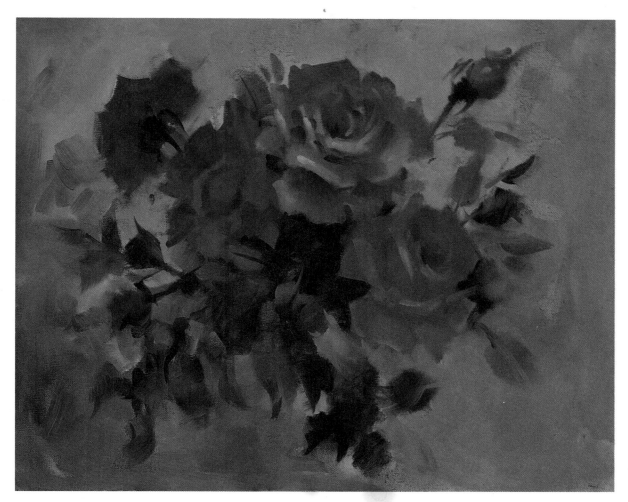

Graying roses *This floral study uses grayed tones in the roses, the leaves, and in the background. But, as you can see, the use of gray does not detract at all from the freshness or color of the flowers. Instead, using grays simply enhances the areas of pure color.*

I have purposely used an even number of flowers in this study to show that a commonly taught design rule, about using an odd number of objects, can be broken. I have added compositional interest, however, both by turning the roses in different directions, altering their size, and by painting a bold mass of leaves. The rosebuds serve as resting spots for your eyes as you visually walk through the canvas.

Toning and Underpainting

Once you have prepared a canvas, set up your still life, and selected your palette, you are ready to begin! The first application of paint is the underpainting, or toning. I find it difficult to stare at a white canvas and envision my composition. Therefore, I like to cover my canvas with a thin wash of paint. The use of toning or underpainting, or both, is an important facet in my work and must be carefully considered.

Toning is a broad, transparent wash of color applied in a loose manner over the entire canvas. In places the wash is allowed to show through subsequent layers of paint, which helps to give the work color variation and excitement. Underpainting takes toning a step further by actually indicating the pattern of the composition.

Acrylic or Oil

The choice of which medium to use for toning or underpainting depends on my aim for each particular painting. Both acrylics and oils are suitable. The values are controlled by using water to thin acrylics and turpentine to thin oils rather than making the colors lighter with white. This keeps your color fresh and helps prevent subsequent muddy layers.

One of the many advantages of using an acrylic toning or underpainting is its rapid drying time. You can quickly lay in a pattern of dark and light, then scumble over the dry surface. This results in iridescent effects which do not disturb the undertone. There are times when I want swirling brush strokes, controlled drips, or even sponge effects as part of my toning. Drips are made by loading the brush with pigment thinned with water and allowing the color to flow down at random into interesting, casual looking patterns. The sponge effect is accomplished by laying on fluid color, then using a crumpled paper towel to blot various areas and create some pleasing effects.

I use oil paints thinned with turpentine for toning or underpainting when I want to paint *alla prima,* that is, painting the whole picture "all at once" without allowing any areas time to dry. This is particularly good for creating soft misty illusions and lost-and-found edges that are difficult to achieve when the paint becomes dry.

Another advantage of oil toning or underpainting is that you can easily wipe out the light areas in a painting with a rag dipped in turpentine—a process often necessary for my technique. Sometimes I like to draw over a slightly wet surface. I feel the slippery surface gives me better control of my brush. Also, I can remove or correct lines in my initial drawing more easily when the paint is still wet, by simply wiping out with a turpentine moistened rag. In acrylics, you would have to paint over the mistake with another layer because the paint dries so fast.

In choosing oil versus acrylic toning you must consider the type of painting surface you are using. I prefer using oil on a canvas prepared with a white lead ground as it adheres beautifully. If I am using a canvas prepared with acrylic gesso, then I usually tone with acrylic paints. If you do choose to use acrylics, work in thin layers of paint when toning, especially if you are using oils for the remainder of the painting. Remember, you can paint oils over acrylics, but not acrylics over oils (due to the very slow drying time of oil paints versus the quick drying time of acrylics).

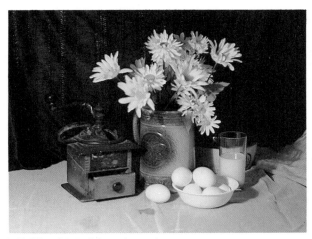

Still life with Daisies *I begin by setting up a simple but strong arrangement of shapes and contrasting textures.*

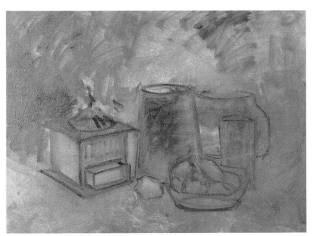

Step 1 *Here you can see how I make use of both toning and underpainting. This will be a low-key painting with a grayed green as dominant hue, so I tone with a mixture of raw umber and ultramarine blue. I indicate my shapes and darker tones using more raw umber, always aware of working out a pleasing abstract pattern of darks and lights.*

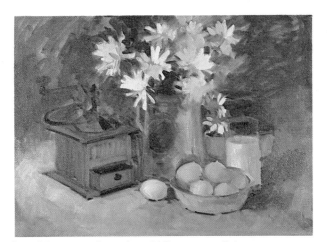

Step 2 *I now work on the middle tones, refining the basic shapes before adding details. I concentrate on adding grays to build up the shadow areas, and I begin to lay in the darker background tones.*

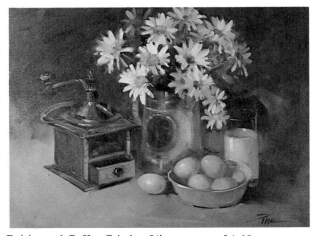

Daisies and Coffee Grinder *Oil on canvas, 24x18 inches. The actual painting hopefully reflects the solid foundation of the toning and underpainting. The process allows you to concentrate on adding details, losing and finding edges, and adding lights and darks in subsequent steps.*

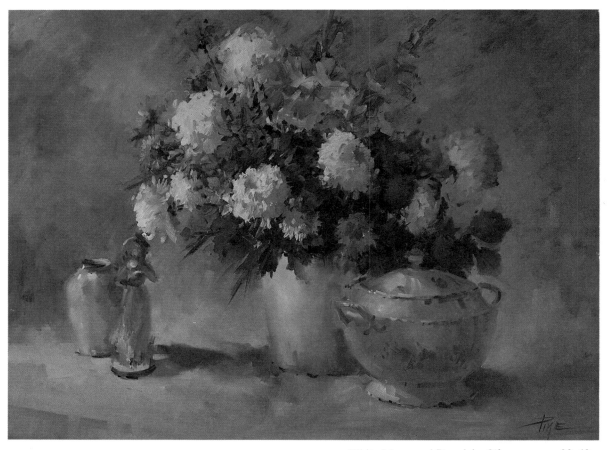

High Key, Low Key

This concept may seem a bit confusing at first, but understanding high and low key and negative-positive in a painting is really very simple and logical.

My high-key paintings are generally composed of approximately two-thirds light tones and one-third dark tones. In terms of still life, this will usually mean that the light tones are in the background, or negative space; and the darks are found primarily in the foreground, or positive, objects.

My low-key paintings are made up of about two-thirds dark tones and one-third light tones. Again, the dark is negative background, and the light is positive foreground.

If you examine the paintings shown here you will see how the two types of painting differ. (Seeing both black-and-white and color points out the value differences). It is a good idea to choose one approach or the other before you begin a painting, as it will make your color choices easier. Your paintings will have a better chance for drama and excitement if you decide at the outset what key you want them to be.

White Mums and Porcelain *Oil on canvas, 30x40 inches. In color it is easy to see the romantic soft effects possible with a low-key approach. The darks that appear in the leaves serve to add visual snap and contrast.*

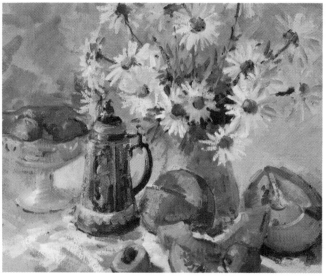

Daisies and Beer Stein *Oil on canvas, 24x30 inches. This painting is high key, having predominantly light tones in the background and flowers, with darks in the leaves, objects, and fruit.*

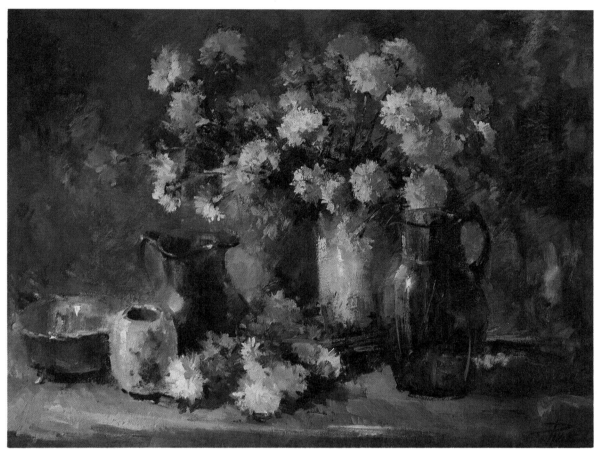

June's Wedding Carnations *Oil on canvas, 30x40 inches. Just because a painting is low-key, it does not have to be dark, murky, or depressing. This painting has an iridescent sparkle and a sense of romance from the liberal use of pure color.*

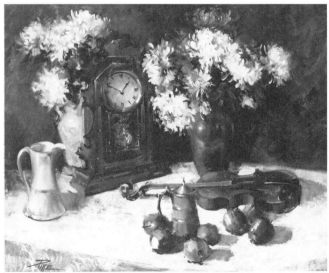

Mums, Apples, and Violin *Oil on canvas, 30x40 inches. My low-key paintings tend to have strong darks, which in this case play up to the positive lights on the table and in the mums.*

Color

The next choice you must make is what color to use for the toning. I generally tone a canvas using a thin wash of either my dominant hue or its complement, depending on the mood I want in the painting. For example, if I am using blue as a dominant hue, which is cool, I often use a warm, cadmium orange underpainting. When this is overpainted with various tones of blue (preferably without using white) the effect is iridescent. Another of my favorite toning combinations is Indian yellow mixed with a small amount of raw umber. I then add a bit more raw umber to begin blocking in the darks and lights.

Keep in mind whether the painting will have a high-key (light) background or a low-key (dark) one. A light painting is usually best toned in soft shades of your dominant hue. A dark painting is effective if underpainted in brilliant hues that are allowed to show through in small areas.

Warm paintings, Matilija Poppies *Oil on canvas, 30x24 inches. A warm color scheme enhances the realism of the Indian corn and basket in this painting. I chose yellow-orange as a dominant hue, and created the grays by adding blue-violet. Bright touches of adjacent hues, yellow and orange, add sparkle to the textures of the basket and corn. Notice the use of the discord colors, red-violet and blue-green, in small amounts throughout the painting, especially in the corn. The warmth of the overall painting also makes a vibrant contrast to the cooler cast of the poppies.*

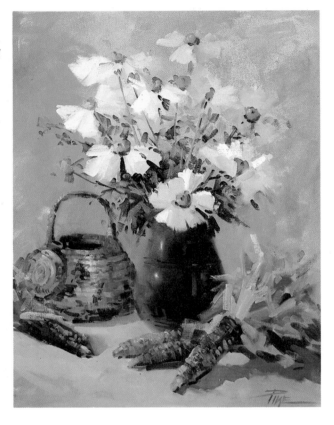

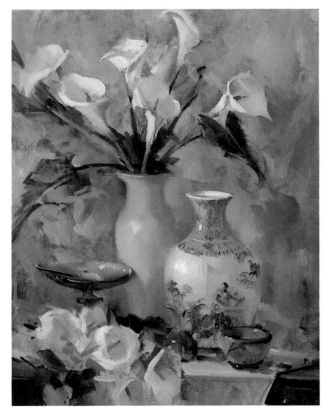

Cool painting, Calla Lilies and Oriental Vases *Oil on canvas, 30x24 inches. It is obvious that I have pushed the dominant hue to an extreme in this painting to create a mood. To add variety and vibrancy, however, I used more than one blue pigment. Orange, the complement, is evident both in the grays and as bits of color in the vase and the stamens of the flowers. The adjacent hues, blue-green and blue-violet, break what would otherwise be a monochromatic painting by adding variation in the leaves and background tones. I have avoided the discords, yellow and red, to keep the flavor of the painting cool and consistent.*

Warm and Cool

When considering temperature in a painting, two factors must be kept in mind: light and color.

The light under which you are painting will be either warm or cool, and this difference in temperature will be reflected in your work. Artificial indoor light is basically warm, as is direct outdoor sunlight. There are cool (blue) light bulbs available for working indoors if you prefer such light. Natural north light is considered cool. A foggy or cloudy day will also make your light seem cooler because of natural diffusion.

If your light is warm, the shadows in a painting will appear cool. If your light is cool, the shadows will seem warm. Everything, of course, is relative: something is always warmer than, or cooler than, something else. But remember that you should not have warm lights and warm shadows, or cool lights and cool shadows in the same painting. If you are painting a warm flower, its reflected light will be cool, and vice-versa.

It is easy for the artist to choose a warm or cool approach in terms of color. Warm tones are reddish, cool tones are bluish. You can change a primarily warm painting to a cool one by glazing with phthalocyanine blue mixed with painting medium. A glaze of Indian yellow and alizarin crimson mixed with medium can make a cool painting warm. Generally, the more translucent a color is, the cooler it is. Alizarin crimson, for example, is cooler than cadmium red light, although they are both warm colors.

Also note that you cannot gray a warm color with another warm color; it will not gray. Its complement, however, being opposite on the color wheel, is also opposite in temperature and therefore makes a perfect gray. In painting it is the relationship, warm against cool, that creates the illusion of objects having dimension or existing in space.

Darks, Lights, and Midtones

Essentially, the visual effectiveness of your painting will depend on the use of value—or darks, lights, and all the midtones, halftones, or grays in between. Value gives an object dimension and indicates how light falls on it.

I use my darks, lights, and midtones to establish the composition in an abstract pattern of values that indicate shape, mass, and strong linear elements as well as color. I always do this first, before adding any detail. For me, the structure of a painting comes from a free interpretation of its values and masses rather than from contour drawing.

As I drive to work each morning, I use my time to study patterns, color, and values. I see, for example, a man with his umbrella sitting on a bench waiting for the bus. In terms of value, I note only the dark mass of the bench against the man's light raincoat. His head is turned down in a resting position; all details of his features are lost. I see only a dark and light pattern. My thoughts transfer hastily to the subtle, predominantly green color around him. The bench is dark green, the sidewalk a grayed green. The foliage of distant trees, still wet from the recent shower, has areas of lights, darks, and midtones but is still green-gray throughout. This all took less than a few moments to perceive—the time spent waiting for the signal light to change. I don't mean to suggest you should do your composing while driving, but you can and should take advantage of every opportunity to make mental sketches of value and color to train your eyes.

Another method I use for practice is to turn the sound off on the television and do quick value studies of the images. Train yourself to retain a single image in your mind's eye and then to transfer it quickly to paper. Don't look up until you have finished sketching.

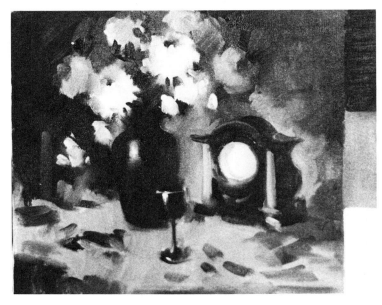

Three-value study *Here I have blocked-in the composition with black, white, and grays—I use my darkest dark against the lightest light in the area of the focal center. Then I begin to add some middle values. I keep these values intact throughout the entire painting, no matter how many colors I add during subsequent layers.*

Leva's Clock and Mums *Oil on canvas, 30x40 inches. The finished painting shows how the strongly defined values initially blocked in are carried through to the final, more complex rendering.*

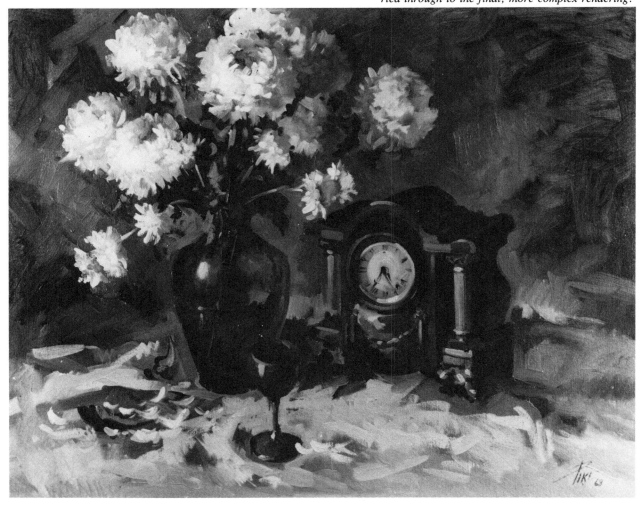

Black and White and Gray

If you paint an egg against a white background, outlining the contour only, you see nothing but an oval object. Painting the same egg in varying degrees of dark, light, and midtones will create a solid, tangible object existing in space.

Modeling forms with dark and light patterns applies to everything we paint. The best method for learning about value is to paint using only black and white; color may be confusing. Use the value scale on page 25 as a guide to identifying values. When you feel completely comfortable with black and white, then advance to a monochromatic (single color) color scheme, and then, finally, to full color.

White is very deceptive. Many of the flowers and objects you will paint will be white, and you will be astounded when you begin to discover how many different colors these white flowers contain.

I explain this to my students by relating an incident that I experienced several years ago. My husband and I had purchased a new white automobile, or what appeared to be white. Our first outing was a trip to a snow-covered park. As we were playing in the snow, I happened to turn around, and much to my chagrin, saw a very dirty gray car. In relation to the snow, the car was at least three values darker.

When you paint white flowers or objects, keep your background values dark enough to allow the shapes to be read clearly. Also remember that you can intensify your white by adding blue to the shadow areas.

Dimension

The illusion of three dimensions is produced by showing five areas of light and shadow:

Body light The area of the object in light.

Body shadow The darkest area of the object (core).

Highlight The highest concentration of light hitting an object.

Reflected lights Reflections of color from neighboring objects rather than direct light. These are never as light as highlights.

Cast shadows The darkest of the five areas of light and shadow; but again, relative to the other values.

Whenever you set up a still life to paint, be sure you consider all five of these value areas. First paint your darks and lights, then add the middle values. Make sure your highlights are clean and sharp, using a rag to wipe out the area on the canvas first if necessary.

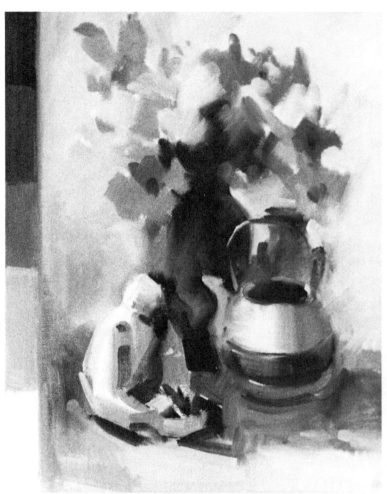

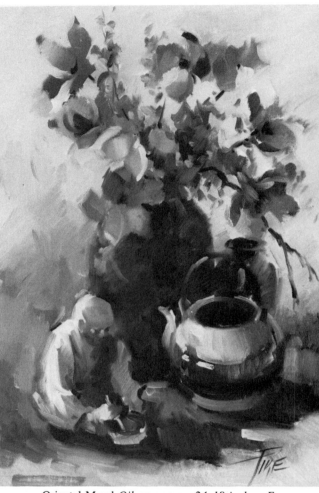

Five-value study *This composition uses several midtones for the initial blocking in of the shapes. The pattern of lights and darks here is subtle, like a soft musical arrangement.*

Oriental Mood *Oil on canvas, 24x18 inches. Free and easy brushstrokes keep the shapes large and simple. Little detail is needed to indicate shapes if your value pattern is well established.*

Painting Folds

When you begin to paint the background or table drapes, there are certain techniques that make modeling the folds easier. Put on your lightest lights first with a good application of paint, then paint in your darkest darks. After paint has been applied to these areas, take a smaller brush and blend the darks into the light areas slightly to show the actual creasing of the folds. You must consider the same five areas of light and shadow when painting folds as when creating any form.

Another important point is that each plane of an object has different value. Even if you think you see two separate planes of the same

hue or value, do not paint them that way. You must create the illusion of three dimensions on a two-dimensional surface, so, if necessary, use a stronger value or color change to help create the modeling of the form. The lightest plane of an object will be the plane that is parallel to the light source.

Also remember that in order for an object or area to show, you must have a light next to a dark and a dark next to a light. For example, the dark of a flower should be against the light of the background, and the light of a flower should be against the dark of the background.

Backgrounds

The background should be considered right from the beginning, even though you may not paint it in until most of your objects or flowers are complete.

You should know what color your background will be before you start. And you should decide what color backdrop to use. I had a student tell me, as I was critiquing his work, that he had used a green backdrop but painted it red. When I asked him why, he replied, "Because I didn't want to take time to change the backdrop and I knew I could paint it any color I wanted." Although this is basically true, the student was not aware that the backdrop color influences everything in the painting. Reflected lights, especially, will change. It takes a well-trained artist to be able to transpose the color of one backdrop to another. So, keep the color of the backdrop close to the intended color and value of the background.

The first thing to decide, then, is whether your painting will be high key or low key. This decision will bear on whether your background will be dark or light. The color of your background should lean toward the dominant hue you plan for your composition. I keep my background dark against the light side of my set-up and light against the dark side to create the illusion of form.

When you begin to paint in your background color, keep your brushstrokes fluid and free. Use plenty of paint, and carve in the background to emphasize the outside contours of the flowers. Try to create a subtle and interesting pattern or texture with your strokes but don't overdo it, or it may detract from the main area of your picture. Correct the edges and shapes of your flowers as you work, occasionally both losing and finding edges to create atmosphere, especially in masses of leaves or more distant floral areas.

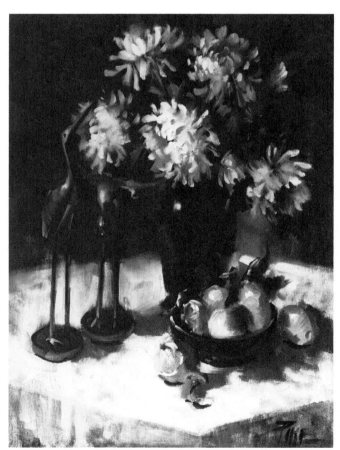

Roses and Hat *Oil on canvas, 30x24 inches. With a light background you can create subtle patterns that emphasize the mood of a painting.*

Mums, Cranes, and Fruits *Oil on canvas, 24x18 inches. A dark background creates drama, and is used most effectively against light-colored flowers.*

Drawing

In drawing it is important to work freely and use your whole arm, not just your hand and wrist. This is true whether you are drawing with a pencil, charcoal, or a brush. If you follow the natural movement of your arm you will have more control, and also a freer quality in your drawing.

In my case, the plumb line and outside vertical contours of the object are best handled from the top down. It seems more natural and I have better balance then. Being right-handed, I start an elliptical curve from left to right. You will naturally find the approach easiest and most comfortable for you.

Basically, I approach drawing much as I approached the penmanship lessons I had as a child. I was taught to work freely, creating rhythm and balance by making curved, overlapping strokes. Those early lessons in penmanship have helped me learn to draw with the brush.

Using the Brush

Successful painting depends on mastering your materials, so this next section will help you control using your brush in both drawing and painting.

I hold my brush lightly, about midway down on the handle. I hold it so lightly that it sometimes feels as if it could drop out of my hand. This way I can make light, dancing strokes. If I need more control, when sketching object shapes, for example, I can tighten my grip. When drawing, and the painting surface is not wet, I let my little finger rest against the canvas if I need balance and more control.

Painting

Learning how to achieve various effects with the brush takes practice. I use different hand positions for different types of strokes. It is also important to use the right size and type of brush. A soft, long-haired brush gives an entirely different stroke from that of a wide, short bristle brush.

The amount of paint needed on the brush is also important to the brushstroke. If I only use a small amount of paint, I may not be able to achieve a desired effect.

The following demonstration will help you see how I hold the brush and manipulate the paint throughout all the steps of a painting. I have chosen to paint a clay pot in black and white. By eliminating color, I can concentrate on the pattern of darks and lights and it is much easier to show the variety of brushstrokes and techniques.

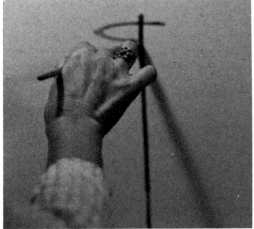

Step 1 *I start by dropping a vertical plumb line that is the desired height of the object. It is a good idea to measure, using the outside edge of the canvas as a guide, to be sure the plumb line is straight. I am able to see into the opening of the pot, so I know eye level is above the top ellipse of the pot; in this case eye level is above the canvas edge. Now, I draw my first ellipse in relation to eye level. (See section on perspective beginning on page 40 for more information on drawing objects.)*

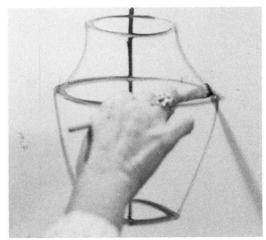

Step 2 *The second ellipse is slightly wider and deeper than the first, since the shape of the pot is wider at that point. The depth of the ellipse is slightly deeper. This is almost indiscernible, but it should be indicated in order to realistically explain the perspective change in relation to eye level. Now I draw the bottom ellipse, making sure the pot appears to sit solidly on the table. The plumb line and correctly placed ellipses make it relatively easy to draw the outside contour shape.*

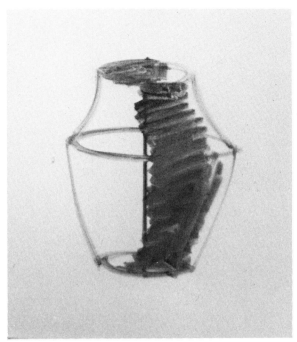

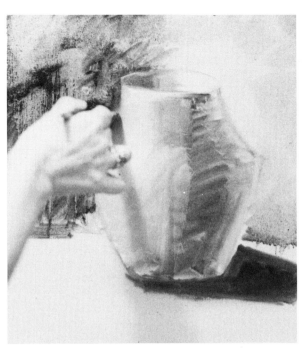

Step 3 *Holding my brush freely, and using plenty of paint, I begin to indicate the values of the pot. I use a loose, scrubbing horizontal stroke to paint the dark side of the object. A midtone fills in the dark of the inside visible at the top. Now I add the lighter value to the light side with the same free, horizontal strokes.*

Step 4 *I next paint the entire dark and light pattern of my background using scrubbing strokes in various directions. I hold the brush lightly. I can now go back and correct the outside contour of the object. I gauge my values according to the background tones, working light against dark and dark against light.*

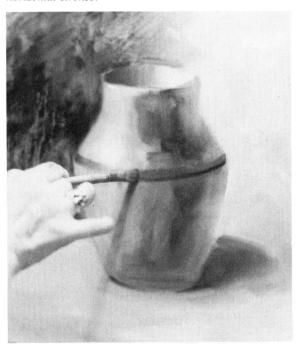

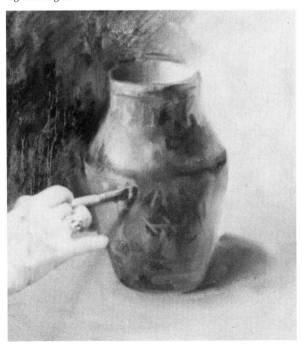

Step 5 *Now that the entire pattern of light and dark has been established, I concentrate on losing and finding edges. I find extending my little finger helps my balance. Generally, I use my brush straight-on rather than at an angle. I choose my areas carefully for blending values. I never lose the entire edge of an object. I lose the edges by painting from the background in toward the object. Sometimes it is necessary to restate an edge.*

Step 6 *Learning to control the pressure of holding your brush is important when painting a pattern on your object. The pressure should be neither too heavy nor too light. At this point, you do not want to disturb what you have already accomplished. A soft sable brush enables me to apply paint over paint without removing the paint beneath. Here again, balance is necessary, so I use a pencil grip with my little finger extended.*

Perspective

There are certain aspects of drawing, such as perspective, that many beginners would rather avoid, either from lack of knowledge or laziness. To try to fake perspective, however, generally leads to the need for correction, or even having to redo areas of a picture. Learning the relatively simple principles of linear perspective will help you avoid problems in your paintings. It may take a few extra minutes to check your drawing, but the outcome is well worth it. There is absolutely nothing wrong with *eyeball* perspective (drawing without the aid of a ruler). The ability to *accurately* eyeball an object with some accuracy, however, usually comes only after years of practice.

Linear perspective provides a way of creating the illusion of depth in a painting through the use of receding lines. Its principles are that: 1) objects diminish in size as they recede in space; 2) apparently parallel lines come together at the horizon line, at a point called the vanishing point.

The horizon line is a horizontal line occurring at eye level. When drawing, its position in relation to a still life may well be out of the picture area. Its position will depend on whether you are looking up, down, or straight ahead at the object you are drawing.

If you take a cube as an example, one-point perspective will occur when you only see one face of the cube and there is just a single vanishing point directly behind the cube. Turn the cube so you see two sides and you will have two-point perspective. This creates a right- and a left-hand vanishing point. Tilt the cube again so you also see the bottom and you have three-point perspective, which now adds a vertical vanishing point.

For your purposes, the most commonly used perspective will be two-point when you want to draw a square or rectangular object, and the ellipse, which is a foreshortened circle, for round or cylindrical shapes.

Eye Level

The need of establishing eye level in a still life is as important as when painting a landscape. To find the eye level, hold a brush with your arm outstretched in front of you in a horizontal position, at the height of your eyes. The imaginary straight line projected from both ends of the brush is the horizon line or eye level of your position. If you sit down, your eye level drops with you; if you stand up, it will rise with you. This may sound elementary, but I have had many students, with years of painting experience, who know little about simple perspective and eye level.

Once you know where your eye level occurs in relation to your still life, you will be able to determine how to draw each object in perspective. For example, if you are painting an object, such as a cup, your eye level will dictate how much of the inside of the cup you see and what the shape of the ellipse of the cup opening will be. If there is another object lower than the cup, such as a saucer, you will see more of the inside of the saucer than of the cup because it is lower.

If your eye level, or horizon line in the case of a landscape, is not determined and maintained while you are painting, your objects may appear to be on different visual planes.

Using Perspective

A working knowledge of perspective is essential if you want the objects you draw to seem solid and lifelike. This knowledge even helps with establishing the underlying elliptical shapes of flowers.

When drawing a round object, whether it be a pot, vase, or anything symmetrical, use either a literal or an imagined plumb line that is vertically parallel to the edge of your canvas and that runs through the middle of the object. Add the necessary ellipses to establish shape, then draw the outside contours using the plumb line to make sure the sides of the objects are equal. Don't worry about placing a spout or handle on an object until you have established the main body. This way the object will not appear to be leaning over and will more likely appear to be the right size and shape.

For a square or rectangular object, you must first locate your eye level and project the imaginary lines dictated by the top edges of the object to meet it at the vanishing points on the horizon line. All other lines of the cube or rectangle will also meet at these points.

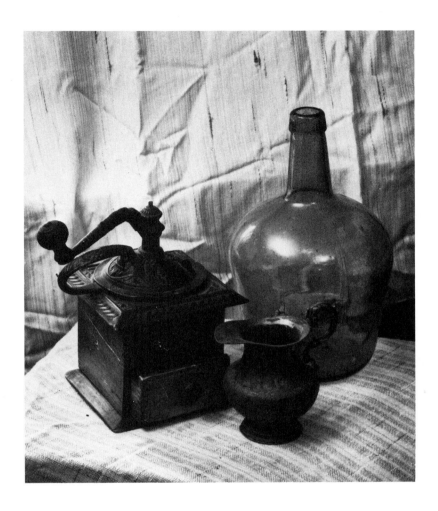

Objects in perspective *Here are three typical objects in two basic shapes—a cube and two cylinders—to serve as practice subjects for perspective. To establish a cube first determine if it is to be drawn in one-point or two-point perspective. In this case two sides of the cube, or coffee grinder, are visible, as well as the top, so we will establish two vanishing points on the horizon line (eye level). Being able to see the top of the cube tells us that eye level is above the object. By taking a ruler and extending the sides of the cube toward the horizon line we can establish both the line and where the vanishing points occur at the spots where the lines meet. The diagram shows how both a cube and a cylinder have structures that conform to the rules of perspective.*

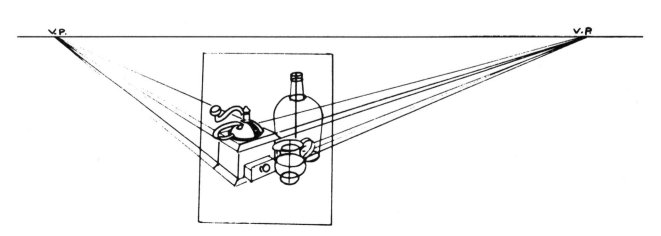

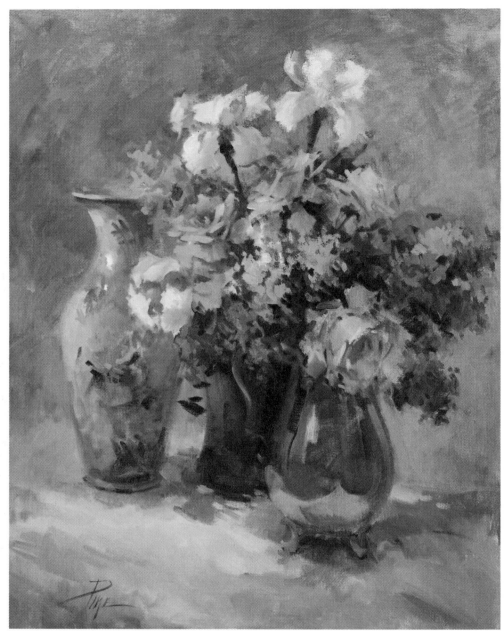

Symphony in Lavender *Oil on canvas, 30x24 inch-es. This painting glows with soft pink and lavender tones that reflect in the silver pitcher. The large open roses and delicate irises provide areas of more concentrated color.*

Floral Studies

Floral Studies 1: Red and Pink Roses

Dominant hue:	red
Adjacent hues:	red-orange/red-violet
Complement:	green
Oil palette:	titanium white
	alizarin crimson
	ultramarine blue
	cadmium red light
	cadmium orange
	Grumbacher red
	sap green
	cerulean blue
	cobalt violet (Bellini)
	Matisson pink

The rose is a complex flower with many personalities. This first floral study, therefore, will demonstrate painting several varieties of roses in an arrangement that shows the flowers in many positions. I plan the study as a high-key painting with red the dominant hue.

I arrange my flowers against a light-colored drapery and make sure that my focal point, where the light rose meets the dark leaves, is off center. This helps to ensure an interesting composition. I use a warm, 100-watt spotlight to illuminate the arrangement from the left-hand side.

As you follow the floral study you will see that my goal is to paint the complicated rose in a simple way and yet create the illusion of a large flower with many petals.

Beginning

I tone my canvas with a turpentine wash of sap green and cadmium red light. Later I will wipe-down areas for the light and middle tones.

Before beginning to block-in flowers, take a close look at their shapes and positions. Roses, for example, when viewed in profile show the undersides of their petals with turned-back tips. The petals of the fully matured flowers facing you display only the tips. Some roses have only a few petals that opened widely; others have many petals and a tighter configuration.

Block-in

The outside contour of a flower is important for depicting the character of the different species. I begin to block-in by sketching the contours of each rose with alizarin crimson, varying the value as necessary to establish the different rose colors. Once the placement of each flower is secure, I begin to lightly indicate the inner petals.

Next I wipe-down the light areas in the larger petals with a tissue. The lightest petals and tips on the pink roses are wiped-down almost to bare canvas. I adjust the pressure on the tissue to vary the values of the remaining light and middle values on each rose.

Adding the lights

I start painting the red roses where the light is the strongest. I use Grumbacher red in some areas and cadmium red light (which is one of the adjacent hues) in others. Sometimes I even use a combination but always without adding white. Touches of cadmium orange add warmth and light to some petals. I also use Matisson pink on the red roses but not too much, or it will bring the roses over to a dark pink rather than a red. A darker-dark is needed on the red roses so I mix alizarin crimson with a tiny touch of ultramarine blue. This red-violet is the other adjacent hue, and I use it to darken the values in the deep centers of the petals.

For the light petals of the pink roses, I use equal parts of cadmium red light and Grumbacher red, controlling the value by adding white. If you want a very light pink rose more white will be needed. For the shadow tones, I add white to alizarin crimson with a speck of cerulean blue. The alizarin crimson block-in becomes the darkest-dark on the roses.

Set-up *The photograph shows the casual arrangement of red and pink roses.*

Block-in *I clearly indicate the basic shape of each rose.*

Leaves and stems

Rose leaves vary in size, but all are almond shaped and occur in three or five-leaf clusters. Some will twist and cup slightly. The color of the leaves and stems will change with the color of the flowers and with the season. The leaves of red roses will show a tint of cadmium red light mingled with a rich dark green made from a mixture of sap green and a touch of ultramarine blue. The leaves of the pink roses are usually a lighter green-gray and may have a reddish tint. A mixture of cerulean blue and cadmium yellow light in equal parts with a touch of cadmium red light added to gray the mixture works well. The stems on roses are quite straight, and it is best to simply suggest them rather than paint them in detail. However, always show the connecting stem when a rose is separated from the mass.

Background

I find red or pink roses against a gray background to be most effective, and I use almost equal amounts of a color and its complement—in this case sap green and cadmium red light. I add white to adjust the values—depending on the areas being covered. I paint in the background loosely and freely, letting areas of the original wash tone show through. To secure my shapes, I carve the background values around the contours of the flowers and leaves.

Centers

A partially closed rose has a tight cluster of unopened petals around the center. The center of this tight cluster should be painted with a dark tone before the petals are added. The center on a fully opened rose is not as dark.

Final details

You will see reflected lights on the far side of a rose if the open center on the flower is at all visible. Since the spotlight is warm the reflected light will be cool. I usually use cobalt violet (Bellini) with touches of cerulean blue and white. Remember, reflected lights cannot occur in direct light. There are times when I want to decrease the intensity of hue or value in the shadow areas. Here, I softened some of the leaves into the background.

Petals *By adding darks, lights, and midtones, I create the petals.*

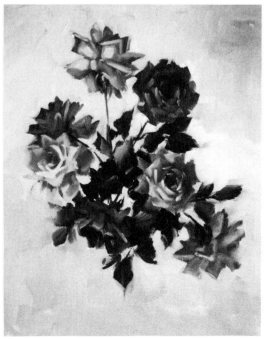

Final details *Leaves and stems complete the picture, and I add the final highlights and the background.*

Floral Study 2: White Roses

Dominant hue:	blue-green
Adjacent hues:	blue/green
Complement:	red-orange
Acrylic palette:	phthalocyanine blue
	cadmium red light
	cadmium yellow light
Oil Palette:	titanium white
	ultramarine blue
	cerulean blue
	cadmium orange
	Indian yellow
	sap green
	alizarin crimson

I find white or yellow roses to be the most difficult roses to paint, so I have developed a simplified yet effective procedure for painting them, which is slightly different from my methods for painting red or pink roses.

The key here is to eliminate painting unnecessary details. I also keep the values seen in the white petals separate and vibrant rather than overblended.

All white flowers will contain a tint of one of the primary hues; most will have a light yellow or yellow-green in the center. The roses used for this study appeared ever so slightly yellow.

Arrange your roses with care. Notice that I have positioned each flower to show a different view. And, of course, when arranging the flowers I try to avoid placing the focal point in the center of the composition. I next place my spotlight in front and to the left of the roses to give the best degree of light and shadow against the dark background. This will be a low-key, cool painting with a blue-green dominant and blue and green adjacent hues.

Beginning

I tone the entire canvas with a medium dark (blue-green) acrylic wash made with phthalocyanine blue, cadmium red light, and cadmium yellow light, thinned with water. I use a large brush so my strokes can be bold and free, which will give a slightly textured effect. I now allow the canvas to dry thoroughly. Next I sketch-in the outside contours of each rose using a very thin mixture of white and turpentine.

Block-in

I scrub a thin layer of Indian yellow oil paint over the middle area where the petals cluster together on the full-view, center rose. Then I wipe-down the tone with a tissue to create a slight yellow glow.

I begin to suggest the shadow darks on all three roses with what I call my elephant gray. This is a mixture of equal parts of white, ultramarine blue, and cadmium orange. I make sure I keep these shadow tones off the areas where light strikes the petals. I am also careful just to block-in the shadow areas at this stage—not to begin indicating details.

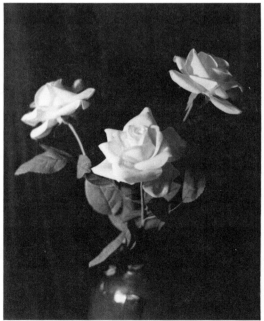

Set up *Notice that each flower in this arrangement shows a different view of the rose.*

Initial sketch *After toning the canvas, I sketch the outside contour of each flower with straight, direct brushstrokes.*

Adding lights

For the petals in the light areas, the mixture is white with just enough cadmium orange to eliminate a dead look. Notice that I make direct, straight strokes on the light areas of the petal. I save indicating details in petals or petal tips for the final stage. I keep in mind that I am building toward the lightest-light, so I control my values carefully. I want to make sure I can still add detail (highlights) toward the end of the painting, so I don't want to use my lightest white now. Also, at this stage, I never do any blending—every value must remain intact.

Stems and leaves

This study is cool; therefore, the leaves will be painted cooler than the leaves of the warm red and pink roses. A good mixture for these leaves is sap green and a small amount of ultramarine blue grayed with a tiny touch of cadmium orange.

Background

The background is a mixture of equal amounts of ultramarine blue and sap green with a touch of alizarin crimson; the values are controlled by adding white. The darkest value of the background sits next to the lightest flower areas to help create form. As I reach the edges of the flowers I use this tone to secure the outside contours of the petals and leaves. I paint freely, always remembering light against dark, and dark against light.

Centers

The center of the full-view open rose contains a tight cluster of petals. The acrylic wash with the wiped-down Indian yellow oil paint glaze suffices for the dark value. I then suggest the light petals of the center with a mixture of white, a tiny touch of cadmium yellow light, and a bit of cadmium red light.

Final details

Now I will add the strongest highlights on the light petals, and I will also reinforce the focal area (where the darkest foliage tone meets the lightest area of the largest rose).

I add a mixture of equal parts of cerulean blue and cadmium yellow light, with a touch of white to a select number of the leaves in light. I also add a few leaf clusters to the background. Some leaves are lighter and some are darker than the background tone. I lose a few leaves into the background by blending. On the rose petals, however, I keep the edges clear, as I feel it is important for each value of the petals to be strongly stated and maintained.

Block-in *I fill in the sketched contours with medium shadow tones.*

Adding lights *I indicate the curves and directions of the petal with straight strokes of light paint.*

White Roses

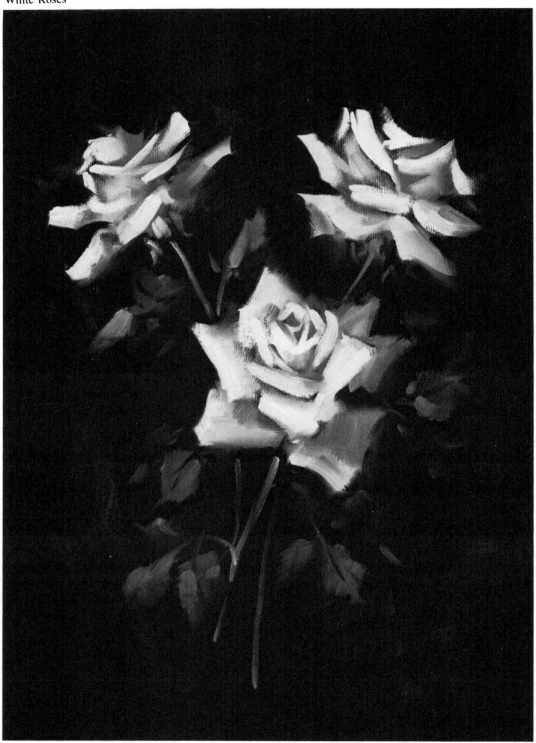

Final details *The petals come to life when I add the highlights. The clusters of leaves enhance but remain subordinate to the blooms.*

Floral Study 3: Magnolias

Dominant hue: green
Adjacent hues: blue-green/yellow-green
Complement: red
Acrylic palette: phthalocyanine blue
 cadmium yellow light
 cadmium red light
Oil Palette: titanium white
 black
 sap green
 ultramarine blue
 cerulean blue
 cadmium red light
 cadmium yellow light
 cadmium orange
 alizarin crimson
 cobalt violet (Bellini)

One of the joys of floral painting is the never-ending source of subject matter. There are hundreds of species of flowers to choose from—each unique blossom presenting a different challenge. This study will spotlight the handsome *Magnolia virginiana*. It has waxy, deliciously fragrant, creamy-white blossoms and long, oval leaves. In the far South the tree can reach a height of sixty feet, but in the California climate where I live, they grow as upright shrubs and small trees.

In some ways, painting the magnolia is like painting the figure. The graceful curve of each petal is a lesson in itself, and it takes a great deal of practice for a painter to successfully portray that gracefulness. For this study the dominant hue is green. I plan a low-key, cool painting with a spotlight placed high on the left side.

Beginning

Because the heat generated from the spotlight will cause the blossoms to open faster than usual, I have to work with speed. After arranging the magnolias, I turn the light on only long enough to make sure I have a good pattern of lights and darks with pleasing cast shadows. I also check that the focal area is not in the exact center of the arrangement. Then I turn the spotlight off and prepare my canvas. In a broad loose manner, I create a gray-green tone with a mixture of phthalocyanine blue, a touch of cadmium yellow light, and a touch of cadmium red light. I then allow the canvas to dry thoroughly.

I carefully sketch each magnolia petal (taking into account its personality) using thinned white oil paint. Next I freely block-in the mass of each petal with titanium white thinned with turpentine.

Block-in

For the lightest-lights on the petals, I use a mixture of white with specks of cadmium yellow light and cadmium red light. This color is *almost* pure white. The shadow areas are white mixed with one part ultramarine blue and a quarter part of cadmium orange. I control the temperature of this gray mixture (either to the warm or the cool side) by adding more or less orange. In order to see my values clearly, I compare one area of a flower to the next, rather than focus on one spot.

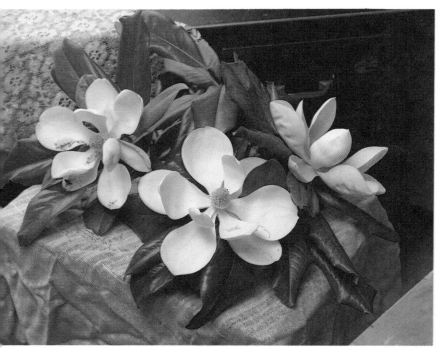

Set up *The photograph shows how graceful and individual each magnolia petal and blossom is.*

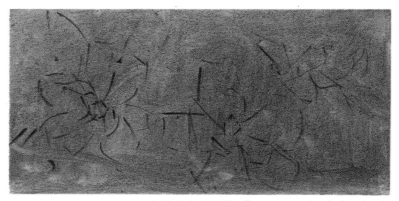

Initial sketch *The flowers are sketched in freely over the initial toning to establish location and shape.*

When I have placed every value and hue correctly, I use a clean, dry, soft brush to delicately merge some values to a satin smoothness. I am careful not to overblend and lose the clarity of the values.

Stems and leaves

The stems of magnolias are actually small branches and are almost always a soft gray. The leaves are elongated ovals, and because their structure is so graceful, I want to make them an important part of this study. Since the flowers are white, the foliage will incorporate the adjacent hues. The leaves are dark green with tints of rust-red, which I mix from equal amounts of green and ultramarine blue with a touch of cadmium orange. For the rusty tone seen on the underside of some leaves, I add cadmium red light to the dark leaf tone described above. The new leaves, which are of course smaller, will be a brighter green. For this tone, I mix cerulean blue with cadmium yellow light (the other adjacent hue), grayed with a tiny touch of cadmium red light.

Background

I use one of my favorite mixtures for the background tone—sap green and cobalt violet. I control and vary the values by adding white to suggest warm grays. Because of the composition, little background tone is needed, and I work carefully around the leaf mass. I don't mind if a bit of the leaf green gets worked into the background, but I try to keep that to a minimum.

Centers

The centers of magnolia blossoms consist of many clusters growing from a common base. The base is gray-green and I paint it with a mixture of sap green and a touch of alizarin crimson. I then suggest the clusters with cadmium yellow light.

Final details

As I paint, I am always aware of keeping my colors clean, and this is especially important when painting white flowers.

I reestablish the focal area with darks and lights, and I soften edges where necessary. To do this, I hold the brush so the tip of the bristles lie flat against the canvas, then I move it gently with my fingers to blend the desired areas. Generally, objects outside the focal area should be understated, while objects within the focal area should be painted with more detail.

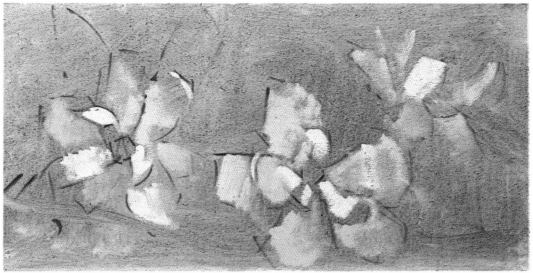

Block-in *I begin the flowers with the lights, and then start adding shadow tones.*

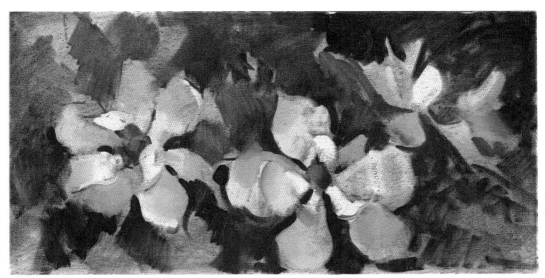

Adding leaves and centers *The long, light oval leaves are made to dominate the composition.*

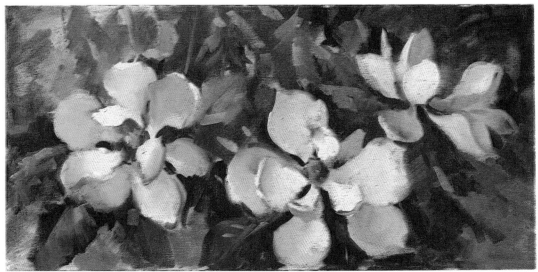

Final details *I now give rounded form to the center clusters before adding the final highlights.*

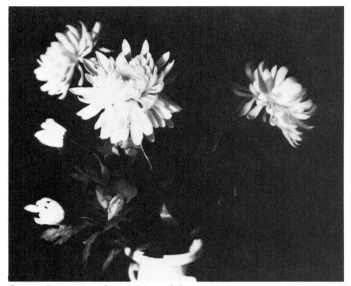

Set-up *By moving the position of the spotlight you can create various light and shadow patterns.*

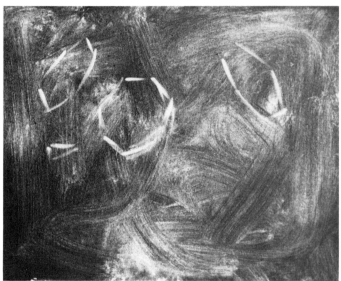

Initial sketch *I tone the canvas with large brush-strokes, and then simply indicate the floral shapes.*

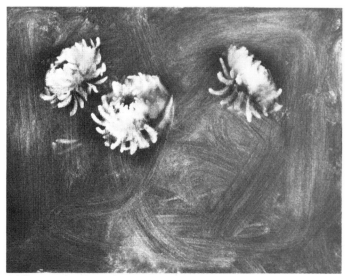

Adding petals *The indentation of each flower establishes their position and direction making it easier to begin adding the masses of petals.*

Floral Study 4: Chrysanthemums

Dominant hue:	blue
Adjacent hues:	blue-green/blue-violet
Complement:	orange
Acrylic palette:	phthalocyanine blue
	raw umber
Oil Palette:	ultramarine blue
	cadmium orange
	cadmium red light
	black
	cerulean blue
	cadmium yellow light
	cobalt violet (Bellini)
	titanium white

There are many varieties and shapes of chrysanthemums. My favorites are often called football mums because they are sometimes worn by the spectators at football games. The flower's shape resembles a ball with a slight indentation at the top. A few petals at the base of each flower tend to sag downward, which gives the flower its round shape. The stems are usually long and rigid.

I have again picked three flowers for the study, but this time I've also included some small, closed blossoms. This will be a low-key, cool painting using blue as the dominant hue, with the light coming from the left side.

Beginning

I tone the canvas with a dark acrylic wash of phthalocyanine blue and raw umber, aiming for a free, irregular pattern. I then allow the canvas to dry thoroughly. Now I use white thinned with turpentine to sketch the approximate shape of the blossoms using straight, direct strokes. The two flowers shown in profile are more elliptical than the full-faced flower, which is spherical in shape.

Block-in

I begin blocking-in the flowers with the middle value, using a slight scrubbing stroke. I keep in mind that I am creating an irregularly shaped ball with a slight hole at the top. This indentation establishes the direction the flower is facing. I fill in the shapes of all three flowers and buds in a middle-value gray, which is a mixture of ultramarine blue and orange. I add more ultramarine blue and a bit less orange to the mixture so I can establish the dark shadow areas. I mix white with a small amount of orange (almost pure white) to begin indicating the areas in light. These light, middle, and dark values create the illusion of

the objects turning. It is necessary to secure this sense of direction before painting the petals. The indentations are darkened with a mixture of ultramarine blue and orange and are softly blended into the middle value on the far side of the indentation.

Petals

Starting with the largest, center mum, I establish the focal area by making sure the lightest petals occur against the dark indentation. To suggest these light petals, I use white, a tiny touch of cadmium red light, and a bit of cadmium yellow light. I continue adding petals around the flower, varying the values by combining the light and shadow tones with more or less white. I try to define the least number of petals possible so as not to break up the feeling of the blossom. I use the same colors to indicate the petals on the other mums and buds, but I play down the values on those flowers to bring the larger mum forward.

Stems and leaves

I paint the leaves in this study carefully, paying attention to the distinctive shape of the chrysanthemum leaf. Cerulean blue and cadmium yellow light in equal parts with a tiny touch of cobalt violet (the blue-green adjacent hue) is an effective mixture for the leaves that are struck with light. I only want a small contrast of value between the leaves and background. A touch of ultramarine blue and cadmium red light added to the above mixture

makes a good dark or gray tone. I use the basic leaf color for the veins, but I either lighten or darken the tone depending on the tone of the leaf. (I use a light mixture on a dark leaf and a dark mixture on a light leaf.) Lastly, I add a few stems, mainly where they connect to the flowers, using the same color as the leaf tone.

Final details

The important thing to remember is to understate the petals—adding too many petals can give the finished flower a "bag-of-worms" look. To finish the flowers, I add a few light petals to the dark side of the flowers and a few dark petals to the light side. I also add reflected light to a few well-chosen petals on the shadow side of the flower. For this finishing touch, I create the blue-violet adjacent hue by mixing cobalt violet, cerulean blue, and white. Remember, in order to have the illusion of depth, an object or area should have a light next to a dark and a dark next to a light.

Background

I want to keep the background dark so the white mums will stand out. Using a mixture of ultramarine blue, a touch of cadmium red light, and black, I start to carve in around the already applied petals. This isn't difficult if you keep your background color clean: one stroke will usually create the desired effect.

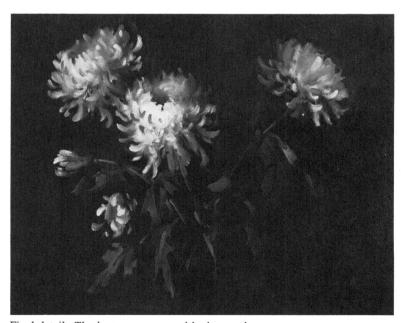

Final details *The leaves, stems, and buds complete the illusion of realism to the arrangement.*

Floral Study 5: Iris

Dominant hue: violet
Adjacent hues: blue-violet/red-violet
Complement: yellow
Acrylic palette: cadmium yellow light
 violet
Oil Palette: titanium white
 alizarin crimson
 cobalt violet (Bellini)
 cerulean blue
 Grumbacher red
 cadmium yellow light
 phthalocyanine yellow-
 green
 sap green
 Matisson pink

In the basic anatomy of the iris there are three petals that grow upward (standards) and three that grow downward (falls). Very often, in the hybrid iris, the standards and falls differ in color and may also differ in size. Otherwise, the structure of the many varieties of irises remains the same. As you are arranging the flowers for this study, turn an iris slowly to see what happens to the petals. Notice that you never see all three standards in their entirety but instead see two, with only a bit of the third standard showing.

Beginning

For the background tone, I wash in a very light acrylic mixture of cadmium yellow light and a touch of violet. When dry I sketch in the flowers with thinned alizarin crimson.

Block-in

I first plan all of the dark shadow sides of the petals carefully before putting any paint on my canvas. I use a mixture of alizarin crimson and cobalt violet to obtain a pink-violet for the upper and lower petals of all the flowers. Then I add cerulean blue to that mixture

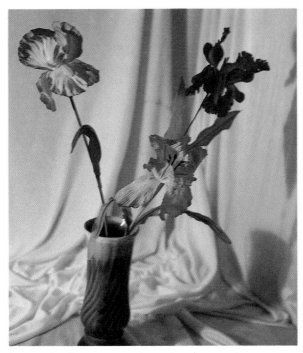

Set-up *The flowers seem almost lost against the background.*

Adding tones *I add darks and lights to further define the petals, and then suggest the stems.*

(the blue-violet adjacent hue) for the upper petals. I control the values by adding white. To highlight the down-turned petals struck by light and also the bud, I use a bit of Grumbacher red added to white. This mixture, applied over pink-violet, becomes the red-violet adjacent hue. I use a fan-shaped brushstroke to give a slight scalloped appearance to the tips of the petals.

Background

As violet is my dominant hue I use a grayed mixture of cobalt violet, cadmium yellow light, and white for the background tone. To vary the tones slightly I add phthalocyanine yellow-green to the above mixture.

Stems

The stems are painted with a mixture of sap green and cobalt violet. The stems are straight and even, and I indicate them with direct, simple brushstrokes using several tones of the above grayed green.

Final details

Study each flower carefully to determine the details. On most flowers you will glimpse the beautiful yellow stamens. Use cadimum yellow light darkened with green for the shadows of the stamens. Light areas can be indicated by yellow mixed with white.

The reflected light is cool. I use cerulean blue with white to suggest a subtle touch of that light in the petals in shadow. I blend Matisson pink and white into the tips of the scalloped, down-turned petals in direct light, and the study is now completed.

Final details *A lighter, brushy background tone complements the violet colors in the irises. The yellow stamens also add snap and contrast.*

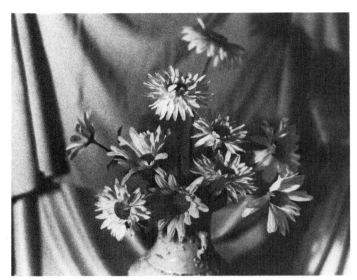

Set-up *I arrange daisies so they are seen from many different angles.*

Initial sketch *I indicate the general position and perspective of each flower in this initial drawing.*

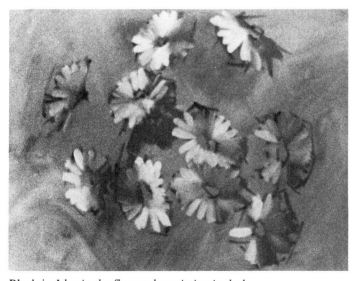

Block-in *I begin the flowers by painting in dark and light values, later adding petal-shaped strokes.*

Floral Study 6: Shasta Daisies

Dominant hue:	yellow
Adjacent hues:	yellow-green/yellow-orange
Complement:	violet
Acrylic palette:	cadmium yellow light
	violet
Oil Palette:	full palette

One of the best known daisies, and my favorite, is the Shasta daisy. The flowers are well formed, of good size, and last particularly well when cut—which is good news for flower painters.

I planned a cool, high-key painting with a yellow dominant hue. My spotlight is warm and placed on the left side of the still life.

Beginning

I tone the canvas with a mixture of acrylic cadmium yellow light and a small amount of violet diluted with varying amounts of water. I apply the wash in a loose manner without using a definable pattern. My aim is to achieve a slight texture and to cover the area quickly.

I have arranged this still life with extra care. Some of the daisies are in full view, some in three-quarter, and others in half view. A few daisies show only their back sides and profiles, and a few are separated from the main mass. Some flowers touch and overlap, which gives a pleasing and natural look. You may find, as I do, that using a few faded blossoms in an arrangement gives a more life-like feeling.

If every blossom is perfect it just doesn't look convincing.

When the canvas is completely dry, I start to sketch the flowers in perspective, using ultramarine blue oil paint thinned to a tint. Notice that all of my ellipses are sketched with a series of straight lines. I find round things just get rounder somehow, and this system helps prevent shapes from getting too circular.

Block-in

I paint the lightest petals without detail, using a slight scrubbing stroke; I use a one part mixture of white, a tiny touch of cadmium yellow light, and a tiny touch of cadmium red light. This makes a slight tint of color. I add the petals to the shadow sides with a mixture

of one part ultramarine blue and half part of cadmium orange (producing a soft blue-gray). White is added as necessary to control the value. At this stage I am not overly concerned with painting individual petals.

Stems and leaves

I secure my focal point by placing the darkest area of foilage against the lightest petal area. The mixture for this dark is one-half part ultramarine blue, one part sap green, and a tiny touch of cadmium red light to gray. Then I continue to suggest the other stems and leaves that radiate from the focal point. Although they are still part of the overall dark pattern, I change the mixture to a lighter tone of sap green with a tiny touch of cadmium red light.

Background

For the background I mix white with a small amount of cadmium yellow light, a touch of cobalt violet, and a dash of sap green. I place the darker tones of the background on the side nearest the light source and the lighter tones away from the light. This allows the light of the flowers to show against the dark of the background and vice versa. When painting backgrounds, I strive for an animated effect by using broad, lively strokes and allowing some of the initial wash to show through.

Centers

I use cadmium orange and sap green for the center area in shadow, and I use a mixture of cadmium orange and cadmium yellow light for the center area struck by light. To secure the direction in which each flower is facing, I place a short, sure brushstroke at the base of each center with a mixture of cadmium red light and sap green.

Final details

As I bring the study to a finish, I emphasize a few petals in both the light and shadow areas. I paint these by starting the brushstroke from the outside and, as I approach the center, diminishing the pressure of the stroke. Only a few indications of petals are necessary to give the illusion of a finished flower.

I also reestablish the stems and leaves where necessary with a sap green and cadmium red light mixture. Next I add a few touches of light on the leaves with a mixture of cerulean blue, cadmium yellow light, and a small amount of white. A mixture of cerulean blue with hints of cobalt violet and white provides small areas of reflected light on several of the petals in shadow.

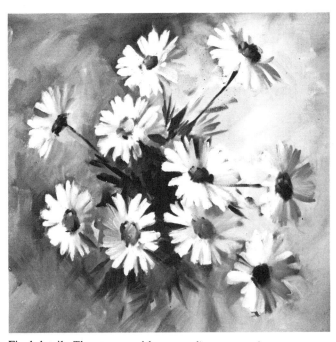

Final details *The stems and leaves radiate outward from a centered focal point, creating a lively and explosive type of composition.*

Floral Study 7: Zinnias

Dominant hue: red-orange
Adjacent hues: red/orange
Complement: blue-green
Acrylic palette: phthalocyanine blue
cadmium yellow light
cadmium red light
Oil Palette: titanium white
alizarin crimson
cadmium red light
Grumbacher red
ultramarine blue
cerulean blue
Indian yellow
sap green
black

Zinnias are characterized by their brilliant color and their stiff, crêpe-paper look. Their basic shape is flat, circular, and thick, rather like a hockey puck. Being able to draw the ellipse of each zinnia is important, because it is the rigid attitude of each flower that will give your floral study life. When you turn a zinnia in different directions, notice how the ellipse changes; you will see either the complete circle or various elliptical shapes.

As I arrange the zinnias for this high-key study, I show several from the side and one from the back, rather than having all the flowers face front. I complete the composition by arranging a pleasant leaf pattern.

Beginning

I prepare my canvas by toning with a pale grayed-green acrylic mixed from phthalocyanine blue, cadmium yellow light, and cadmium red light. As you follow these studies, remember that you will be working on all the flowers simultaneously. Do not bring each flower to a finished point before beginning the next; save the details for the last.

Block-in

I begin in oil by using alizarin crimson to indicate the entire red zinnia. Then I apply a small amount of ultramarine blue over that flower's shadow area, and wipe out around the front edge where the petals are in light.

Now I block in the orange flowers with a mixture of alizarin crimson and Indian yellow in equal parts. I add a tiny touch of ultramarine blue to this mixture to create the darks, making sure to place the darks only on the shadow side of the flower. I again wipe out the areas of light at the edges.

The yellow zinnia is seen mainly from the underside with the petals facing downward around the stem. This emphasizes the shadow area. I block-in the entire flower with Indian yellow then go over the shadow with a touch of black. This results in a dull green color. Next I wipe-down the areas in light.

Block-in *I have used three different colored zinnias, and established these quickly in the initial block-in.*

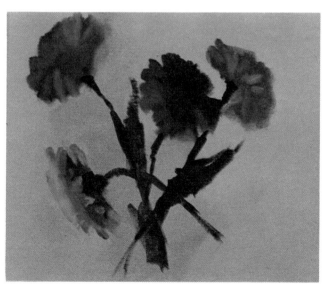

Adding leaves *The simple composition is given structure by the strong linear elements in the leaves and stems.*

Stems and leaves

Study the leaf character of each flower you paint. You will notice that with zinnias, the leaves are slightly elongated. It is not necessary to make all the leaves exactly the same or to paint every leaf you see. If you indicate enough detail to make a pleasing shape on a few leaves, you can let the rest of the leaves remain in abstract form. I use sap green grayed with a touch of cadmium red light to block in the stems and leaves. For contrast, I also add a touch of cerulean blue to some leaves.

Background

I paint the background next, before the final details. The tone here should be light, to emphasize the vibrant colors of the flowers. I mix sap green with a little red and a great deal of white to make a pale green-gray. I paint loosely and correct the shapes as I work, by carving in from the outside shape of the flower.

Centers

I suggest the center of the flowers with a mixture of alizarin crimson and sap green. The direction that each flower faces should be positively stated.

Final details

Now I am ready to define the petals on the light-struck edges of the flowers.

For the red zinnia, I use white mixed with a tiny touch of Grumbacher red. Using a loaded brush, I form the petals from the outside in, finishing each stroke where the petals connect to the center. I also suggest a few petals on the shadow side as well, to show reflected light. For that I use a small amount of cerulean blue with a touch of white.

The light petals on the orange zinnias are a mixture of Grumbacher red, cadmium yellow light, and a touch of white. Notice the foreshortened petals and how they are placed selectively.

The yellow flower petals are cadmium yellow light mixed with white. The strongest light is on the downward petals.

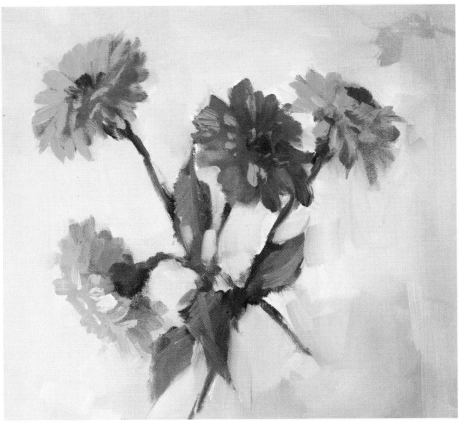

Final details *Here I add the final dark and light petals.*

Initial sketch *Complicated floral shapes are reduced to their basic shapes by using straight, angled brushstrokes.*

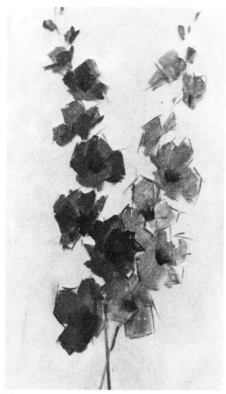

Block-in *I begin with the medium values for each of the different colored gladiola florets.*

Floral Study 8: Gladioli

Dominant hue:	red
Adjacent hues:	red-violet/red-orange
Complement:	green
Oil Palette:	titanium white
	Grumbacher red
	cadmium red light
	Matisson pink
	alizarin crimson
	phthalocyanine yellow-green
	cobalt violet (Bellini)
	cadmium yellow light
	cerulean blue

The gladiola is considered a spike flower and produces beautifully formed florets that open in sequence from the lower portion of the stalk to the top. Often the lower blossoms will be past their prime before the upper petals even open. As you sketch the florets, notice that each has a slight degree of turn—some face you, some turn right, and others left. You can decide how many florets to actually include on the stalk to avoid sameness in your painting. You're the artist.

Because each floret is slightly cone shaped, the center appears to fall deep into the blossom and is therefore usually in dark shadow. I am using a red and a salmon-pink gladiola for this study, which presents the challenge of painting both a light and a dark flower within the same composition. I plan a high-key, warm painting with a red dominant hue. The focal area is where the three salmon florets overlap the deep red blossom, toward the bottom of the stalks.

Beginning

My turpentine wash is a grayed red-violet mixture of ultramarine blue and a touch of cadmium red light, with no white added. Next I sketch the flowers with ultramarine blue thinned to a tint. I keep my lines angular rather than round when sketching the petal shapes. For compositional balance I make sure the flowers are not pointing into the corners of the canvas.

Block-in

To block-in the red gladiola, I use Grumbacher red for all the medium-dark areas. Then I mix ultramarine blue and alizarin crimson for the darker centers and shadows. For all the light areas, I find that mixtures of cad-

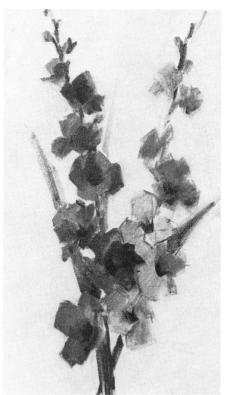

Stalks and leaves *The straight stalks look slightly curved where they meet the blossoms.*

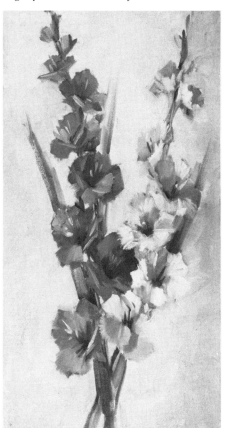

Final details *After working on the background, I add the highlights and deepen the centers.*

mium red light and white, and Grumbacher red and white are satisfactory. Notice that I keep my colors pure and without gray. The highlights are a mixture of Matisson pink and cadmium orange.

I block-in the darks and shadows of the pink gladiola with Indian yellow and a tiny touch of alizarin crimson (the red-orange adjacent hue). The deep tones in the centers are alizarin crimson mixed with a touch of ultramarine blue (the other adjacent hue). I combine Matisson pink and cadmium yellow light for the light side of each floret.

Stems and leaves

The stalk of the gladiola is actually straight; however, because the individual blossoms bend in various directions as they mature, the stalk appears to be slightly curved. The opening of the top buds can also cause slight bends in the upper stalk. The gladiola's few leaves are erect and sword shaped. I play these down as I don't want the leaves to dominate the composition. For the dark values in both the leaves and stalks, I mix sap green with a touch of cadmium red light.

Background

A red-violet mixture (ultramarine blue and cadmium red light) was used for the initial wash, and I use this same color with a small amount of white for the background. I work around the outside contour of each flower carefully. I don't lose too many edges into the background because I want these flowers to remain clean and crisp.

Centers

I paint the stamens with light values on the dark flower and dark tones on the light flower. The light mixture is white with a touch of cadmium yellow light; the dark mixture is alizarin crimson and sap green. The darkest part of the centers of the red galdioli are painted with alizarin crimson and ultramarine blue.

Final details

The highlights on the red gladiola petals are a mixture of cadmium orange, Matisson pink, and a touch of white. Then I vary the tones by using a mixture of Matisson pink, cadmium red light, and white on a few florets. I paint the highlights on salmon gladiola petals with a combination of cadmium yellow light, Matisson pink, and white. Finally, I highlight the leaves with a lighter value made by mixing cerulean blue, cadmium yellow light, and white.

Block-in *I indicate the clusters of flowers in several different values over a toned canvas.*

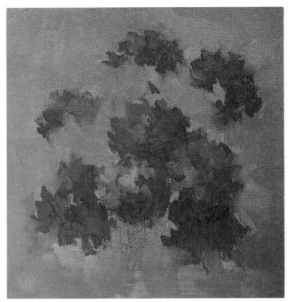

Adding lights *The petals gain definition with darks and highlights.*

Floral Study 9: Geraniums

Dominant hue:	red
Adjacent hues:	red-orange/red-violet
Complement:	green
Oil Palette:	cadmium red
	alizarin crimson
	Grumbacher red
	Matisson pink
	sap green
	cadmium yellow light
	cerulean blue
	ultramarine blue
	cobalt violet (Bellini)
	titanium white

Living in California is a real blessing for the flower painter. Flowers grow all year round—and geraniums are among the most plentiful.

In this study I want to stress that if you hope to show the character of a particular flower, you must study it carefully and find what makes it differ from other flowers. The geranium's distinctive characteristic is that its blossoms grow at the end of many short stems. This trait gives the flower the appearance of an umbrella with a few small buds hanging down, which shows clearly when the flowers are painted in profile. I therefore include profile views in this study, to emphasize the geranium's individuality. I plan a high-key, warm painting.

Beginning

I tone my canvas with oil paint using a warm red-gray wash, of cadmium red light, a touch of sap green, and a good amount of turpentine. I lay-on an even wash, without my usual play of texture and brushstroke. Because the shape of the flower is determined by its many blossoms, I decide to skip the initial sketchy outline and begin by blocking-in the basic color and values.

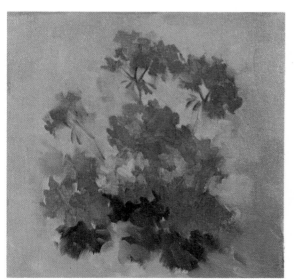

Leaves and stems *The dark complementary leaves help establish the focal point of the composition.*

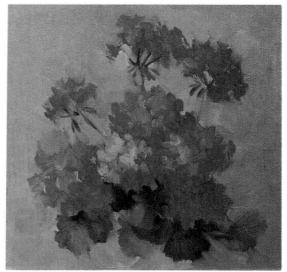

Final details *Adding the unopened buds and highlights completes the study.*

Block-in

I first block-in the various values of the flowers using cadmium red for the light areas, Grumbacher red for the mid-tones, and alizarin crimson for the shadow areas. I start painting these bright flowers with maximum brilliance.

Leaves and stems

The leaf pattern provides a base for the composition, as well as accenting the focal point. I mix two parts sap green, one part ultramarine blue, and a tiny touch of alizarin crimson to paint the leaves in shadow. I add a touch of cadmium yellow light and cerulean blue for the light leaves. The leaves are round, and I paint them using fan-shaped or scalloped brushstrokes. Only the leaves in light will need detail. For the stems and buds, I use sap green with a touch of cobalt violet.

Background

I choose a grayed version of the red dominant hue for the background tone, and I mix it from one-part cadmium red light, a touch of sap green, and three parts white. As I proceed, I add a little more sap green for variation. The finished look is therefore slightly textured.

Final details

It is better to leave most of the flower as a suggestion rather than make an overworked statement. So, I bring only a few blossoms on each cluster into completion. I use Matisson pink and white to add highlights near the focal area. With touches of Grumbacher red, I add life to the buds that are beginning to open.

Floral Study 10: Lilacs

Dominant hue:	violet
Adjacent hues:	blue-violet/red-violet
Complement:	yellow
Oil Palette:	titanium white
	cobalt violet (Bellini)
	cerulean blue
	ultramarine blue
	Grumbacher red
	Matisson pink
	sap green
	cadmium yellow light

Because fresh lilacs are seasonal here in California (they prefer a cool temperature), I use silk flowers for this study. I bend a few of the florets away from the stems to make them appear more natural and find the result pleasing. I plan a high-key, warm painting.

Beginning

I tone the canvas with a mixture of cobalt violet and sap green, thinned with plenty of turpentine. I want a slightly textured wash in a middle-value violet-gray. Next, I sketch the flowers with the same color mixed with less turpentine. I emphasize the irregularities in the outside shapes of the flowers by using short, choppy brushstrokes. I also suggest the stem directions.

Block-in

I begin painting the shadow side of each flower cluster using cobalt violet and cerulean blue. (The blue is one of the adjacent hues.) I need to darken a few areas within the shadow sides, and for this I add ultramarine blue to the above mixture. I take care not to darken all of the first shadow tone.

Using an animated brushstroke, much like a criss-cross or cross-hatch, will help you keep the mass of flowers looking lively. The preliminary turpentine wash helps you create blossoms in shadow without getting sharp edges; softness comes from painting over a wet surface. Often the shadow side of the flower can be considered finished after blocking-in.

Never paint the details in shadow (dark or reflected light) areas until your light sides have been established. And when you go back into your darks to secure cast shadows—for example, where one flower overlaps another—keep the values strong and separate, or you will lose form.

I now begin to freely indicate the lights with a mixture of cobalt violet, Matisson pink (the other adjacent hue), and white. Then, where the values blend, I carefully suggest a few middle-value blossoms in a combination of the shadow tone and the light tone.

Set-up *These are silk flowers, since I could not get fresh ones. I made them more lifelike by bending a few blossoms away from the main stem.*

Initial sketch *My short, choppy brushstrokes emphasize the irregular contours of the flowers over the toned background.*

Stems and leaves

I like to plan the leaves as part of a dark and light pattern. I carefully observe the characteristic shape of each leaf and paint it accordingly, even though I know I will lose some clarity when I blend the background edges later.

The leaf of a lilac is delicate, small, and soft gray in color. The leaves have a tendency to curl at the sides, and I want to incorporate this characteristic into the study to give the flowers a realistic appearance. For the leaves I mix sap green with a small amount of cobalt violet. Where I need darks, I add a touch of ultramarine blue. I paint the lights with a mixture of cerulean blue, cadmium yellow light, and a hint of white—leaning a bit to the blue side. Remember, if you need gray to soften pure color, use a bit of complement.

Background

This time I have chosen not to use an oil overlay on the background. I want to show that it is not always necessary to paint over already-applied color, even if the first wash is thin. However, I do add a light tone of pink (white with a touch of cadmium red light) to the background next to the shadow side of the lower center lilacs. I blend this light tone into the wash on the canvas.

Final details

To relax the stiff look of the flowers, I indicate a few single blossoms that are slightly apart from the rest of the mass. Then I soften some edges. Within each flower I bring a few more single blossoms into the light, by using a criss-cross stroke to give the illusion of petals. To complete the study, I add a few dark accents as well as strengthen the highlights.

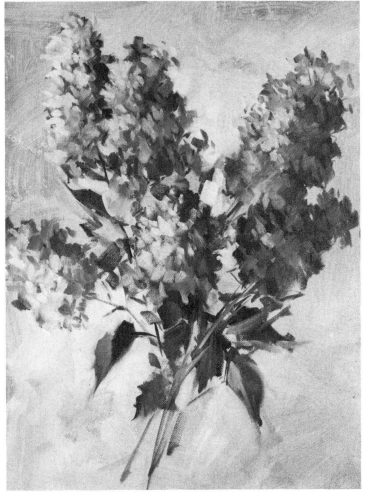

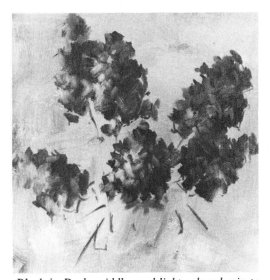

Block-in *Dark, middle, and light values begin to define the shapes of the complex flowers.*

Final details *The treatment of the stems and leaves helps to make this floral study life-like.*

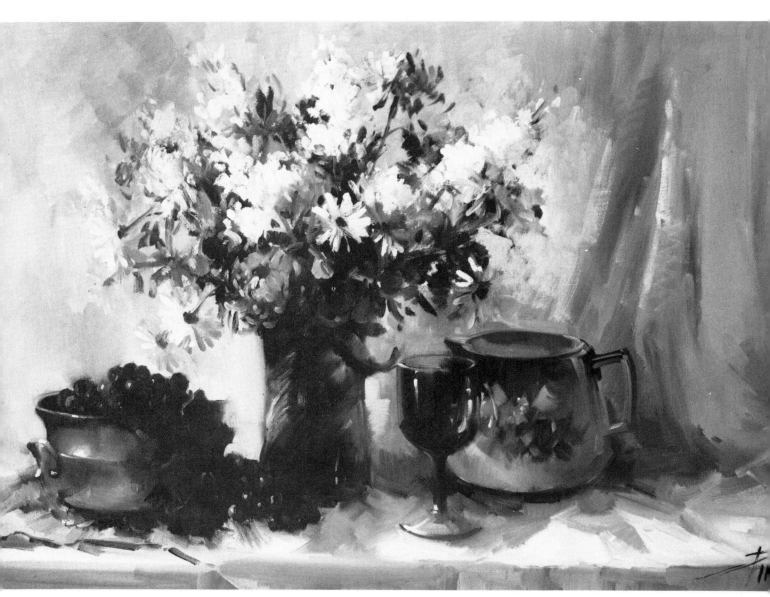

Marguerites and Stocks *Oil on canvas, 24x36
inches. Notice how the grapes spilling over the bowl
make this arrangement more interesting by uniting
the dark shapes, creating a logical and pleasing
overlap. Without the spill-over the bowl and the vase
would appear separate and rather isolated.*

Fruit Studies

I like to include fruit in my floral still lifes for two reasons: fruit adds important spots of color, and fruit is useful in balancing a composition.

In terms of color, fruit can either complement or contrast with a floral arrangement. Sometimes a painting filled with pale flowers and objects gets just the right amount of snap with the addition of a few dark plums or a bunch of purple grapes. Dark paintings get needed relief with a dish of peaches or some lemon wedges.

Fruit helps in building a composition because it easily fills any desired space. You can put fruit in various sized bowls or directly on the table. Be aware, however, that if you put fruit in a bowl, you need to carefully place your eye level high enough to permit you to see the fruit. Also, be aware of leaving enough space around the fruit, as well as maintaining correct perspective.

When I paint fruit, I tend to overstate several qualities. Although most fruits look round, they are really quite angular in shape. An apple, for example, has a shape akin to a wet cardboard box. I generally paint round fruits as even more angular than they actually are. I also intensify the colors of fruit. I find that the finished painting better suggests reality that way.

A final hint is to include a piece or two of cut fruit in a composition. It helps make the painting look less rigid and formal.

Apples

Set-up *I choose different-colored apples for this study.*

Block-in *After I tone the canvas I sketch the basic outlines of the fruit.*

Fruit Study 1: Apples

Dominant hue:	red
Adjacent hues:	red-violet/red-orange
Complement:	green
Oil palette:	titanium white
	alizarin crimson
	viridian green
	ultramarine blue
	Grumbacher red
	cadmium red light
	cobalt violet (Bellini)
	cadmium orange
	cadmium yellow light
	cerulean blue

Apples come in many different colors—the two most common being red and yellow-green. For this study I chose three different varieties: Golden Delicious, Red Delicious, and the rounder Jonathan apple. Apples are one of the most popular fruits to include in a still life, so it is wise to practice painting them.

The Red Delicious apple is slightly elongated in shape—much like a wet cardboard box—not really round and not really square. The Golden Delicious has a similar shape but is golden yellow to yellow-green in color. The Jonathan apple is almost round with a definite indentation at the stem end. Its colors vary; some may even be a mixture of both red and green, or green and yellow. My advice is to not try to paint apples without a real model—the best way is to paint what you see.

I place the three apples in different directions and positions. I arrange each apple so either a stem end or bud end is showing, and I never turn all the apples the same way.

Beginning

I use a red and green-gray to tone the canvas mixed from alizarin crimson, viridian green, and turpentine. I apply very little paint—just a tint. I then sketch the fruit with ultramarine blue using a series of straight strokes.

Adding darks and lights *This is the next step, then I wipe-down areas where highlights will be placed.*

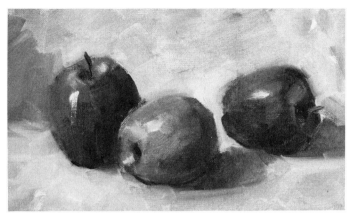

Final details *After more painting and softening some of the edges I add final highlights.*

Block-in

I begin with the dark of the red apples using a mixture of alizarin crimson and ultramarine blue (the red-violet adjacent hue), and an almost undetectable amount of viridian green. Grumbacher red is perfect for the light area. I wipe-down the areas where the highlights will be placed later, then apply cadmium red light (the other adjacent hue) for pure color on the light side of the fruit. The reflected light is subtly applied with a cool mixture of viridian green, a touch of cobalt violet, and white. The proportion is two parts color to one part white.

I block-in the green apple using viridian green and cadmium orange on the shadow side and cerulean blue and cadmium yellow light for the light side. The side of the indentation that is nearest the source of light is in shadow. The area across from the shadow is struck by light. The cast shadows are two parts viridian green and one part alizarin crimson mixed with a touch of white.

Background

The background is two parts viridian green, one part cadmium red light, with various amounts of white. I darken the background slightly behind the light-struck apple on the left and lighten the area in back of the right-hand apple. This helps create the illusion that the fruits are three-dimensional. In relation to the dark apples the background is still very light. I want my brushstrokes to add just enough interest to enhance but not dominate the composition.

Final details

Now it is time to add highlights and details. I previously wiped-down the pigment from the highlight areas. Now I place a touch of white, slightly tinted with cadmium yellow light, on my finger and dab it on the wiped-down spots. I then carefully blend the white toward the outer edges with my finger until the desired amount of highlight remains. The last details are the stems, which I add with alizarin crimson and viridian green.

Fruit Study 2: Lemons

Dominant hue:	yellow
Adjacent hues:	yellow-orange/yellow-green
Complement:	violet
Acrylic palette:	violet
Oil palette:	sap green
	ultramarine blue
	cadmium orange
	cadmium yellow light
	cobalt violet (Bellini)
	cerulean blue
	titanium white

Lemons are egg-shaped, with a textured skin and usually a pure yellow hue. Occasionally you may find a ripe lemon with a tint of green at the stem end. When arranging the lemons for this study, I want to show what happens to the angles as I change the direction of each piece of fruit. The tiny projection at the end of the lemon is one of its unique characteristics, so I turn one lemon into profile. For variety I often like to cut open at least one piece of fruit. Notice that I position one piece of cut lemon at right angles to the light and the other in shadow.

I plan a high-key, warm painting with my spotlight placed on the left. When painting oval objects, pay attention to how easy it is to see shadow, light, highlights, cast shadow, and reflected light. Once you define these five values, it will be easy to paint lemons so they look real and natural.

Beginning

I tone the canvas with a thin tint of violet acrylic paint. When the canvas is completely dry, I scumble a bit of sap green oil paint—thinned to just a wash with turpentine—over the entire surface. I use ultramarine blue, thinned with turpentine, to secure the outside shape of each lemon in a series of short, straight strokes.

Block-in

The shadow sides of all the lemons are equal parts of cadmium orange and sap green (the yellow-green adjacent hue). Next I fill in the rest of each lemon with cadmium yellow light. After this initial block-in, I darken the lemons in the background by adding a bit of the above shadow tone to the cadmium yellow light. I add reflected lights with a touch of cobalt violet and white to the outer edge of the lemon on the shadow side. Cadmium orange works for the lights reflected from the tablecloth onto the fruit.

The cut fruit

I block-in the centers on the cut fruit with equal amounts of cadmium orange and cerulean blue for the portion in shadow. For the piece facing the light, I use equal parts of cadmium yellow light and sap green. The membrane is warm where light strikes it and cool in shadow, so I mix white and a tiny touch of cadmium yellow light for the light area, then add a touch of cerulean blue to that mixture for the shadow tone. I paint the cast shadows with equal amounts of cadmium orange, ultramarine blue, and a touch of white.

Set-up *All the lemons are carefully placed so they face in different directions.*

Initial sketch *Just a few strokes indicate the shapes on the toned canvas.*

Background

Using two parts cadmium orange, one part sap green, and various amounts of white, I produce a good warm hue for the background. I add small amounts of cadmium red light or cobalt violet to slightly tint the background tone for interest. Because I used a white backdrop when arranging this still life, the background must remain light even with touches of gray or color added. Lastly I soften the cast-shadow edges a bit by blending them into the background tone.

Final details

Now I wipe-down the areas on each lemon where the light is the strongest. With the tip of my finger I dab these wiped-down spots with a bit of pure white. I lightly soften the edges of each highlight, leaving the center intact. Stem ends are cadmium orange and sap green.

Block-in *The next step is to build form with lights and darks.*

Final details *I add cast shadows and lose some edges, then add highlights and the white membrane of the cut fruit.*

Set-up *I want to show that peaches are more than just round shapes, and this is helped by the leaf pattern.*

Initial sketch *I tone the canvas, then suggest the basic outlines.*

Fruit Study 3: Peaches

Dominant hue:	orange
Adjacent hues:	yellow-orange/red-orange
Complement:	blue
Acrylic palette:	cadmium red light
	ultramarine blue
Oil palette:	alizarin crimson
	ultramarine blue
	Grumbacher red
	phthalocyanine yellow-green
	cobalt violet (Bellini)
	sap green
	Matisson pink
	cadmium yellow light
	cerulean blue
	cadmium orange
	titanium white

Summer fruits such as peaches, nectarines, and plums appear round in shape, but are actually a bit elongated. They all have irregularities that soften their symmetrical appearance as well as a crease on one side that extends from stem to tip. I decide to paint the peach because of its unique fuzzy outer skin. Peaches are usually a light yellow-pink although the color differs in various species. The peach leaf is shaped like a long oval and usually curls under at the tip. Many leaves grow in a cluster, and this study shows characteristic leaves.

Beginning

First I tone the canvas with a soft acrylic wash of cadmium red light mixed with a touch of ultramarine blue. This is then allowed to dry. Next I add a thin wash of alizarin crimson thinned with turpentine. I prefer to sketch with ultramarine blue thinned with turpentine because it gives definite lines which can disappear when covered with white. It is less likely than earth tones to cause muddy colors, and if you make a mistake, ultramarine blue is not too difficult to remove.

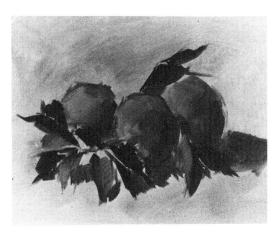

Block-in *The darks and lights are quickly established.*

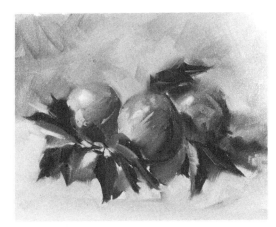

Final details *I add some highlights to the leaves and on the fruit. Then the background is keyed to harmonize and enhance the delicate color of the peaches.*

Block-in

I begin blocking-in each peach with a dark using Grumbacher red with a tiny touch of phthalocyanine yellow-green. This mixture is perfect for the orange-toned peach in shadow. Because the peach has a fuzzy outer skin, I choose to add a touch of gray both in shadow and in the light. I paint the lighter areas of the peach in a range from cadmium orange to cadmium yellow light, gradually adding white as it goes closer to the light with a slight touch of Matisson pink at one end. To give a hazy look, I slightly mute all these colors by adding a tiny touch of cerulean blue to the white. The reflected lights are equal parts cobalt violet, cerulean blue, and somewhat less white. I slightly darken the crease of the front peach using Grumbacher red and a touch of sap green lightened a bit with white. I paint the cast shadow with equal parts of ultramarine blue, cadmium orange, a touch of cobalt violet, and a small amount of white. To create the highlights, I add white and slightly blend it with my fingertips.

Leaves

Peach leaves in shadow are a dull blue-green. For the leaves in shadow I use two parts cerulean blue, one part cobalt violet, and a touch of white. For their light sides I go a little more to yellow by mixing one part cadmium yellow light. For the shadow tone, a bit of cadmium orange is added.

Background

For my background tones I use two parts sap green and one part cobalt violet with a tiny touch of cadmium red light and white, added to control the value. I now apply suggestions of texture over the previously painted thin coat of alizarin crimson. I add dimension to the composition by darkening the background a bit behind the light side of the peaches. I squint at the set-up and merge the areas that diminish. I also concentrate on losing and finding edges in and around the leaves as I don't want the leaves to be dominant.

Fruit Study 4: Grapes

Dominant hue:	red
Adjacent hues:	red-orange/red-violet
Complement:	green
Oil palette:	titanium white
	Matisson pink
	alizarin crimson
	Grumbacher red
	cadmium red light
	cadmium orange
	phthalocyanine yellow-green
	sap green
	ultramarine blue
	cobalt violet (Bellini)

Grapes are a wonderful fruit to add to a still life. The clusters can be arranged easily to fill any appropriate space in a composition. Also, grapes come in both pale and dark colors, so they can provide any desired contrast.

There are two principles to keep in mind when painting fruit—reality and simplicity. Remember these especially when working with fruit that may seem complex.

Beginning

I tone my canvas with a turpentine wash of sap green and cadmium red light.

Block-in

Anything grouped together, like grapes, should be painted as a mass rather than individual units. In this study, I choose Grumbacher red as the dominant hue because it is the truest primary red available. I begin by scrubbing-in the entire shape. Then, with a tissue, I wipe-down the light areas of the most visible grapes. This establishes both the dark and light values. I now intensify the strongest darks by applying alizarin crimson in the shadows. At this point I am careful to use pure color, without graying, to retain a look of brightness and freshness. The skin of this particular type of grape has violet tones as well as green. I add touches of both cobalt violet and phthalocyanine yellow-green in appropriate spots.

Adding Grays

When painting grapes, grays should be added with extreme caution, and the gray values should not appear separate from the grapes' skin color. Even when applying subtle grays in the shadow and light areas, I allow the pure, original color to peek through. I use a touch of sap green to gray the alizarin crim-

Set-up *Grapes can be "draped" to fill areas where you might need darks in a painting.*

Block-in *The grapes get painted as a mass rather than individual shapes.*

74

son shadow tones, but I'm careful not to change the value there. Remember, shadows must remain dark or the forms can get lost. A touch of phthalocyanine yellow-green added to Grumbacher red works nicely for the gray in light. I am still using pure color without white.

Refining the Grapes

After the basic light and dark values are established, I can start bringing some individual grapes into focus. All values of light and shadow must be suggested on a few closer grapes. Only a couple are brought into the light, yet the ones lost in shadow still indicate the subtle grape form.

Reflected light is cool, and here I use equal parts cobalt violet and cerulean blue, with a touch of white. I apply this mixture with a slightly curved stroke directly on the outside contour of the grapes in shadow. Keep in mind that the middle of an object is generally the darkest area, so even the darkest edges will be a midtone in relation to that spot.

I am now ready to paint the highlights using a touch of cadmium yellow light added to white. Not all grapes have the same intensity of light. I want to make sure the highlights occur where the light source strikes the strongest.

You will find cast shadows on fruits that grow in clusters. A projecting grape can cast a shadow over other grapes. There will also be cast shadows on the table, and for this I use a mixture of two parts ultramarine blue, one part cadmium red light, a touch of sap green, and a touch of white.

Background

I mix white, equal parts cadmium red light, sap green, and cobalt violet to make a neutral gray. I mix the color so it remains light and slightly red. I carefully work around the grapes. Then I clean my brush and blend-in a few edges so the grapes will not look pasted on.

Final details

I want to add just a few stem pieces for realism, and I paint these using alizarin crimson and sap green in equal parts. Finally I suggest sparkles on the light side of a few grapes with pure cadmium orange and Matisson pink.

Darks and lights *These are used to build shapes after the initial block-in*

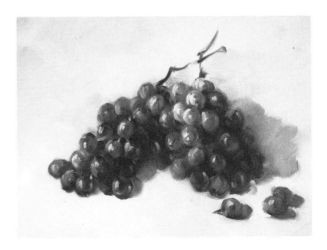

Final details *I wipe out the areas of highlight, then add lights to each spot and blend softly.*

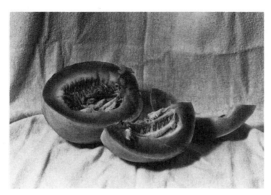

Set-up *A cut melon is more visually interesting than the whole fruit.*

Initial sketch *After toning, I draw the melon outlines.*

Fruit Study 5: Cut Melon

Dominant hue:	green
Adjacent hues:	blue-green/yellow-green
Complement:	red
Oil palette:	cobalt violet (Bellini)
	sap green
	ultramarine blue
	phthalocyanine yellow-green
	cadmium orange
	cadmium yellow light
	alizarin crimson
	cerulean blue
	cadmium red light
	titanium white

The inside of a honeydew melon is delicate light green to a soft yellow. It becomes lighter toward the center and has a rim of soft yellow-green at the outer edge. The outside rind is a creamy white, slightly grayed. The center appears to be light, but actually has deep undertones of subtle pink with a light, almost white, membrane. The seeds are a deep yellow to yellow-orange.

When arranging this set-up, I place the melon slices in various positions until I find a balance that is pleasing to my eye. I try not to have any two slices going in the same direction, and I also try not to have lines that create too much tension, such as an edge of a melon slice coming to a corner of another slice. The idea is to arrange a grouping that is varied and interesting.

Beginning

I tone the canvas with an oil wash of equal parts cobalt violet and sap green. I work in a loose manner, so areas of the white canvas show through the toning and add textural interest. Next, I sketch-in the basic shapes of the melon slices with ultramarine blue thinned with turpentine.

Block-in *The darks, lights, and midtones are freely interpreted.*

Final details *Short brushstrokes indicate the membrane and seeds. The background is adjusted for interest and emphasis.*

Block-in

Before I begin adding tones, I study my lighting to see which melon slice or part of a slice is in shadow. I then start blocking-in these shadow areas in a cool, slightly dark gray mixed from three parts phthalocyanine yellow-green and one part cerulean blue (the blue-green adjacent hue). For the light areas I mix equal parts cadmium yellow light and phthalocyanine yellow-green (the other adjacent hue) with a touch of white. Where the meat of the melon becomes lighter nearer the center, I sparingly add a small amount of white to the shadow sides.

I paint the hollow in the center of the melon with alizarin crimson grayed with a touch of sap green. I suggest the light membrane with a soft, grayed white leaning ever so slightly toward blue (made by adding just a touch of cerulean blue to white). The seeds are equal parts cadmium orange and cadmium red light, and I add a touch of sap green to slightly gray the pure colors. For the rind, I mix equal parts cadmium yellow light, cadmium orange, a touch of cerulean blue, and white. I don't use too much white when I begin painting the rind in shadow but keep adding more as I paint the melon slices closer to the light. The cast shadows are two parts ultramarine blue, one part cadmium orange, and white.

Background

This melon is a beautiful green, and I don't want to take attention away from its color by using too strong a background. I decide on a soft gray, which I mix from two parts sap green, one part cobalt violet and white to vary the tones. To indicate the table that the melon is sitting on, I change the gray slightly by adding a touch of cadmium yellow light to the tablecloth.

Final details

With my medium tones of phthalocyanine and cerulian blue in equal parts slightly grayed with a touch of cobalt violet and white, I refine the meat of the melon. Notice that my brushstrokes go from the outer edge of the rind toward the middle of the fruit. Finally, I add glistening bits of white highlights to indicate the droplets of juice that appear on the exposed surface.

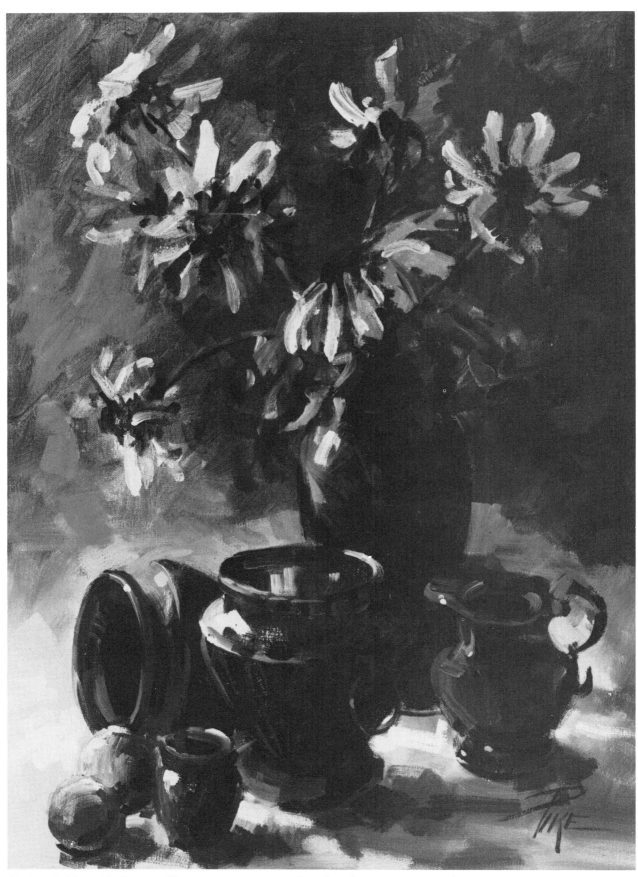

Gloriosa Daisies with Copper *Oil on canvas,
24x18 inches. The dark tones of this painting are
relieved both by the daisies and by the highlights*
reflected on the warm copper surface.
Final details *Highlights and reflected lights com-
plete the picture.*

Object Studies

*I*t is a goal of most artists to master the painting of different textures and surfaces. And, in fact, the painting demonstrations later in this book make use of a full range of surfaces, from silver and porcelain to wood and baskets.

In the following practice studies I demonstrate not only how to achieve the illusion of various surfaces, but I also pay particular attention to achieving the look of a three-dimensional object on the two-dimensional canvas. This involves controlling value changes from light to dark in order to make an object appear to turn.

When you introduce still life objects into your paintings, you can create a mood that flowers alone cannot do. In some paintings I like to portray the character of a person through the objects he or she treasures. In other paintings I make it appear as though someone had just left the scene for an instant by showing an open book or a half-peeled piece of fruit. Paintings can be made to have a masculine or feminine feeling by the addition of objects.

Gather your own examples of wood, glass, porcelain, and metal, and paint right along with me as I demonstrate.

Object Study 1: Wood

Dominant hue:	red-violet
Adjacent hues:	red and violet
Complement:	yellow-green
Oil palette:	alizarin crimson
	cadmium red light
	sap green
	ultramarine blue
	colbalt violet (Bellini)
	phthalocyanine
	yellow-green
	white

I love painting clocks. Wood not only has an interesting texture to paint but also is much easier to paint than it looks. The main thing to be careful of with a solid object like this is value change—everywhere there is a plane change there is also a value change. Some of those changes will be subtle, so take extra care to study the object and sketch its basic shapes before you begin to paint.

Beginning

I tone the canvas with cadmium red light and sap green (leaving the color a little to the red side) with lots of turpentine. I add a bit of ultramarine blue to the left-hand corner and also in the area where the cast shadow will occur. I then allow the turpentine wash to dry.

The clock is basically a rectangle with a finial at the top and decorative trim at the bottom. I use a mixture of ultramarine blue and cadmium red light, with turpentine, for the drawing. To put this drawing in perspective, I first establish the eye level and then use two-point perspective to determine my guidelines. An imaginary vertical center line will help you position the finial at the top and pendulum at the bottom.

Block-in

Now I want to mix two tones—one for shadow darks and one for the lights. The dark mixture is alizarin crimson and sap green in equal parts. The light mixture is cadmium red

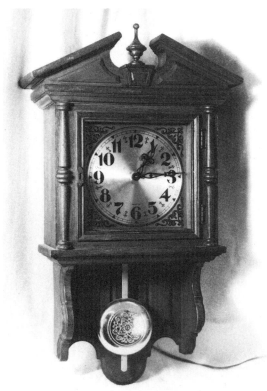

Setup. *No special arrangement is necessary here. My only problem is to select a good view of my favorite subject.*

Initial sketch. *Drawing with my brush on the toned canvas, I carefully establish the proportions and perspective.*

light, phthalocyanine yellow-green in equal parts, a touch of cobalt violet, and just a tiny touch of white.

I vary a few values in the shadow side depending on the density of shadow, adding a tiny touch of ultramarine blue to my dark mixture of sap green and alizarin crimson. For the light I add a little more white to lighten with a tiny touch of cobalt violet as needed. The light is coming from the left-hand side, and you will notice that where it strikes the clock there is a vertical strip of light that occurs to the right of the clock face and extends down into the area near the pendulum. This has the same hue and value as the lighted exterior side on the left.

The face of the clock is blue-gray, which I mix from cadmium red light, ultramarine blue in equal parts, a touch of sap green, and just enough white to produce a soft dark gray. The pendulum is two parts phthalocyanine yellow-green and one part cadmium red light.

Background

The background is a middle value of equal parts ultramarine blue, sap green, cadmium red light, varying with additions of white. I want the color to lean a bit toward violet-gray. I am careful when painting the background around the outer edges of the clock; I want to soften but not lose them. I paint the

cast shadow on the wall using the same basic mixture as the background tone but with less white. Reflected lights occur on just a few of the lines where planes change in shadow, and for these I use a touch of cerulean blue, cobalt violet, and white.

Final details

Highlights are seen mainly on the pendulum and face. I paint the highlight on the pendulum with cadmium yellow light and white—adding a touch of phthalocyanine yellow-green at the top for sparkle. To paint the highlight on the light side of the clock, I add cobalt violet and white to the color used for the block-in. The highlight on the face of the clock is white with a tiny touch of cadmium red light and cadmium yellow light.

I want to play down the numbers and hands, so I softly brush them in using a mixture of sap green, alizarin crimson, and ultramarine blue. Lastly, I add a dot of highlight to the center where the clock hands meet.

Final details. *After adding to the background, I adjust the middle tones and add the highlights.*

Block-in. *The dark and middle values are quickly indicated to show the form.*

81

Object Study 2: Iron

Dominant hue: violet
Adjacent hues: red-violet/blue-violet
Complement: yellow
Oil palette: cerulean blue
 cobalt violet (Bellini)
 cadmium red light
 sap green
 alizarin crimson
 ultramarine blue
 titanium white

For me, this iron pot isn't just any pot. This old pot has known and served many people, and if it could talk, you might hear many tales of days gone by. I want my painting to reflect that sense of nostalgia. You may want to search for a similar object to add to your own collection of potential still life subjects. I plan a high-key, cool painting.

Beginning

I start by toning the canvas with alizarin crimson, ultramarine blue, and sap green—thinned to a wash with turpentine. Then I let the canvas dry for about fifteen minutes. Before I start drawing, I establish the eye level, which in this case is high enough to see the top of the pot a bit. Only then do I sketch-in the plumb line through the center of the pot, using ultramarine blue thinned with turpentine. Now it is easy to establish the outside contour. The width is greater than the height (which I confirm by closing one eye and using the brush handle like a ruler held at arm's length to measure the height in relation to the width). Now I sketch the ellipse at the top of the pot, then the larger one in the middle, and finally the bottom ellipse. Notice that the bottom ellipse is wider than the top one because it is farther from eye level. Lastly I sketch the spout, the handle, and the base.

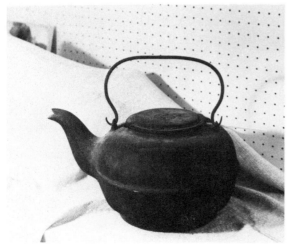

Setup. *The iron pot is carefully placed to show its descriptive silhouette against the drapery.*

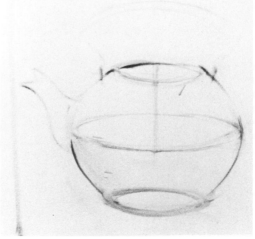

Initial sketch. *After the under toning is dry, I sketch in the elliptical structure.*

Block-in

I begin with the entire shadow area of the object, leaving a small strip on the right for reflected light. I use a mixture of alizarin crimson, sap green, and ultramarine blue in equal parts (creating black). Next I mix equal amounts alizarin crimson and ultramarine blue (the red-violet adjacent hue) to slightly darken the bottom part of the pot.

I block-in a mixture of cadmium red light and sap green in equal parts where the light strikes the strongest, then I merge the light and shadow to produce a slightly grayed tone.

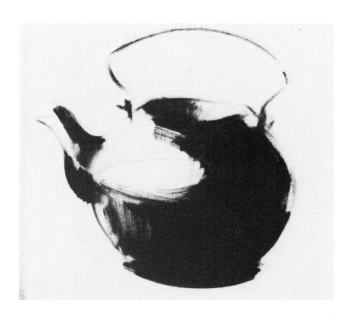

Block-in. *The darks are painted in to establish the form.*

Background

I want to keep the background light. I add white and a touch of cobalt violet over the already toned canvas, and the result is a beautiful gray hue. I add a darker tone for the cast shadow (of equal parts ultramarine blue and cadmium orange with a touch of white) then blend and soften the shadow's edges so the background becomes a pleasing whole.

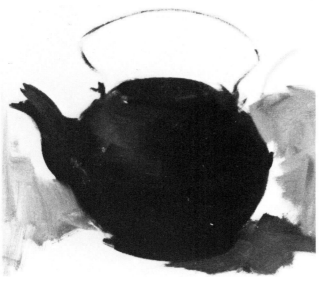

Adding lights. *Now some mid-tones and lights are added.*

Final details

I paint the reflected light with two parts cerulean blue, one part cobalt violet (an adjacent hue), and a little white. This mixture is perfect for the dusty look of dark old objects such as this pot. In losing and finding edges, I discover I must reestablish the handle. Finally I add a few highlights with one part cadmium red light and two parts white, but I keep them subtle so the dusty look of the old pot is not lost.

Final details. *Once the values are correctly stated, it is a simple matter to add the few accents.*

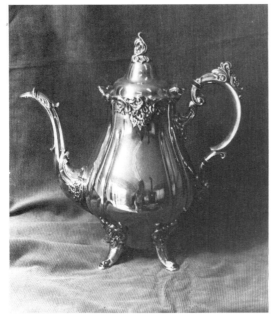

Set-up *This ornate coffeepot will not only show pattern but also reflected light.*

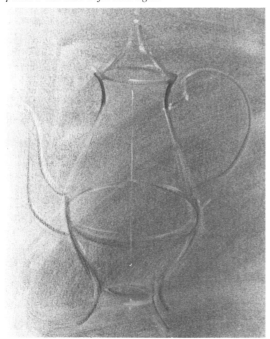

Initial sketch *I use both ultramarine blue and white to sketch the pot on a toned canvas.*

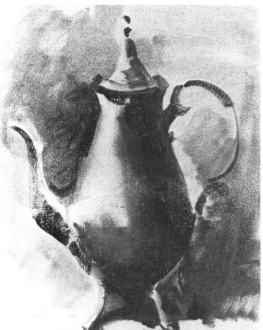

Block-in *I begin with a simple pattern of lights and darks, adding cast shadows on the table as well.*

Object Study 3: Pewter or Silver

Dominant hue:	blue
Adjacent hues:	blue-violet/blue-green
Complement:	orange
Acrylic palette:	ultramarine blue
	cadmium orange
Oil palette:	ultramarine blue
	cadmium orange
	cadmium red light
	sap green
	cobalt violet (Bellini)
	cadmium yellow light
	cerulean blue
	alizarin crimson
	ivory black
	titanium white

Most people think of pewter or silver as being neutral gray in color. In fact, many artists paint one or both of those metals using just black and white. However, I prefer to see them as having a dominant hue of blue grayed by its complement. In painting, the only difference between silver and pewter is their reflective qualities. Their colors are the same. I have chosen a silver coffeepot for this high-key, cool study—it could just as easily have been pewter.

To obtain a look of a high shine on silver, you need to position darks next to lights and not merge them. Lose only a few spots at the edge of the object when painting the background. The satin patina of pewter is achieved by blending the values together after placing the darks and lights. Another difference between the two metals is that silver looks shiny and may reflect other objects or the pattern and color of a tablecloth.

Beginning

I use a dark to medium blue-gray acrylic—ultramarine blue and cadmium orange thinned with water—to give the canvas a quick overall tone. I sketch the pot in two stages, first with a soft gray tone of white, ultramarine blue,

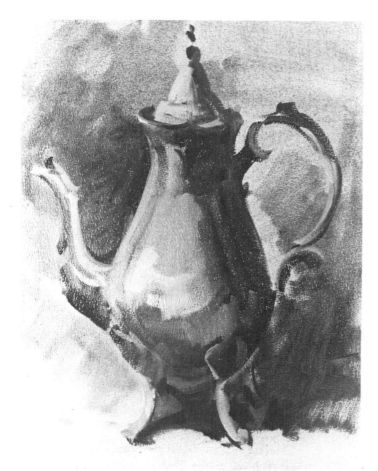

Adding lights *Now I paint some curves, indicating pattern and adding cast shadows.*

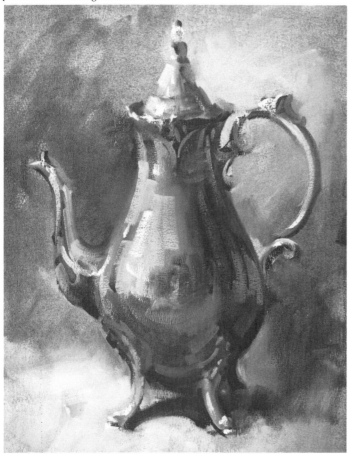

Final details *Highlights and reflected lights give the pot its silver surface.*

and cadmium orange. I drop a plumb line down through the center of the pot, then secure each ellipse carefully, making sure my drawing is symmetrical. Then I emphasize the major outside contours with a stronger dark.

Block-in

I block-in my values first by placing the darks, using two parts ultramarine blue, one part sap green, and one part cadmium red light—mixed a little to the blue. Then I block-in the lights with three parts cerulean blue and one part cadmium orange (the blue-green adjacent hue). I keep the values separated and don't blend.

My reflected lights will go a bit to the violet. Cerulean blue and alizarin crimson in equal parts (the blue-violet adjacent hue) give me a controllable tone to work with.

Cast shadows

The cast shadows should be a bit darker than any other value on the canvas. I mix sap green, alizarin crimson, and ultramarine blue in equal parts. but finding that I need a stronger dark, I add a bit of ivory black.

Background

I want a background that will be a middle-value. I mix equal parts of ultramarine blue, cadmium red light, and a touch of sap green, and by adding a small amount of white, I slightly change the color to a subtle blue-gray. This makes a good medium color. I want the background to be dark enough to contrast strongly with the light-struck side of the pot.

Final details

Every value change on the silver coffeepot should be evident. I wipe-down for the strongest highlights and then apply pure white without blending. Finally, I soften just a few edges into the background.

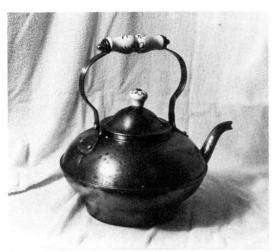

Set-up *The copper teapot is a good choice for a warm still life painting.*

Initial sketch *The plumb line and ellipses need to be correct before I begin.*

Object Study 4: Copper and Brass

Dominant hue: red
Adjacent hues: red-violet/red-orange
Complement: green
Oil palette: cadmium red light
 alizarin crimson
 sap green
 ultramarine blue
 Grumbacher red
 cadmium yellow light
 cobalt violet (Bellini)
 cerulean blue
 cadmium orange
 Matisson pink
 titanium white

Two of the metals most commonly seen in paintings are copper and brass. Although the traditional approach is to use earth colors to paint those metals, I find that the opacity of those paints results in a dulled gray look. A metallic mixture that is transparent, and which I find works well, is alizarin crimson, sap green, and ultramarine blue, going more to the green for brass, and more to the red for copper. These mixtures would be for brass; two parts sap green, one part alizarin crimson and one part ultramarine blue, for copper; two parts alizarin crimson, one part sap green, and one part ultramarine blue.

Highlights, too, need slightly different colors for each metal. For copper, I use a tiny touch of Grumbacher red and white; for brass, a tiny touch of cadmium yellow light with white. In general, the color of the reflected light will contain a suggestion of the complement of the local color of the metal, unless there are reflections from other objects.

Now I will demonstrate an actual painting procedure using a copper tea kettle as the subject for a warm, high-key study.

Beginning

I tone the canvas with a wash mixture of one part ultramarine blue, one part alizarin crimson, and two parts sap green thinned with turpentine. I want the color to lean slightly to-

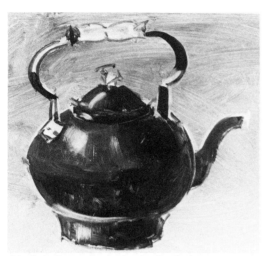

Block-in *I start by laying in the dark pattern.*

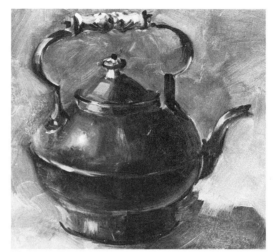

Final details *Now I add lights and midtones, as well as some pattern in the handle.*

ward green. Next, I sketch the pot with white, dropping a plumb line down the center before drawing the three ellipses that will determine the perspective. Then I intensify the major shapes with ultramarine blue.

Block-in

I block-in the shadow area of the tea kettle with one part sap green, two parts alizarin crimson, and one part ultramarine blue (the red-violet adjacent hue). I want the color to be a bit red, so I add more alizarin crimson. Then, using a mixture of two parts cadmium red light (the red-orange adjacent hue) and one part sap green, I begin painting the light areas. Again, I use more red than green, and I gently begin to merge the values and hues.

Background

The background has already been toned with a medium wash of equal parts of alizarin crimson, ultramarine blue, and sap green with some white to vary the value. Now, I use the same combination but add white to soften and gray the color. I vary my brushstrokes until I have a pleasing pattern of tones. The cast shadow is a mixture of two parts ultramarine blue and one part cadmium red light with a touch of white.

Reflected lights

The reflected lights are a mixture of equal parts of cobalt violet, cerulean blue, and touches of white. I add these touches of white to both the back of the pot and also to the curve of the bottom, where the reflection of the tablecloth is seen.

Final details

The handle is brass and is painted with the same shadow tone as the copper pot, but here the mixture leans more toward the green. The lights on the handle are cadmium yellow light and sap green. I block-in the porcelain top of the handle with ultramarine blue and cadmium orange in shadow, and cadmium yellow light, cadmium red light, and white in the light. I suggest the tiny delft-blue line drawing on the porcelain in delicate brushstrokes, using ultramarine blue. I next wipe-down my main areas of highlight. The highlight is white with a touch of cadmium yellow light. The secondary highlights on the pot are a mixture of Matisson pink, cadmium yellow light, and white. I blend the outer edges of the highlights to soften the patina.

Object Study 5: Porcelain

Dominant hue:	violet
Adjacent hues:	blue-violet/red-violet
Complement:	yellow
Oil palette:	titanium white
	ultramarine blue
	cadmium red light
	cadmium yellow light
	sap green
	cobalt violet (Bellini)
	cerulean blue

The smooth, delicate finish of porcelain gives tones that graduate from dark to light with few detectable value changes. It is this creamy surface that is porcelain's main characteristic. I choose a cup and saucer for this study, but you could use a teapot or vase instead. This will be a high-key, cool painting.

Beginning

I paint this study using an approach that differs from my usual procedure. I first mix a middle-value neutral gray using ultramarine blue, cadmium yellow light, and cadmium red light. I add enough white to make a pleasing background tone then apply it so as to opaque the canvas with large brushstrokes in a textured pattern.

Without waiting for the background to dry I mix sap green, ultramarine blue, and turpentine to use for sketching. I drop a plumb line through the center of the cup and saucer then draw the ellipses carefully, always keeping my eye level in mind.

Block-in

The darks, which I block-in first, are equal parts of ultramarine blue, cadmium red light, and white. This results in a soft, violet-gray hue. The light tones are a touch of cadmium red light, and a touch of cadmium yellow light, and two parts white. I blend the dark areas gently with the lights to create smooth halftones. The cast shadow is two parts ultramarine blue, one part cadmium red light, a touch of sap green, and a tiny touch of white.

The dark and light tones on the inside of the cup are the opposite of those on the outside. The lights inside the cup will be on the same side as the darks outside.

The reflected lights, which I paint with one part cerulean blue and two parts white, appear

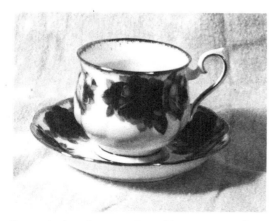

Set-up *Antique items, such as this teacup, are favorites of mine.*

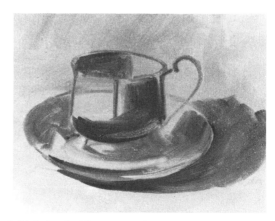

Initial sketch *After toning the canvas, I sketch the outline and secure the darks of the cup.*

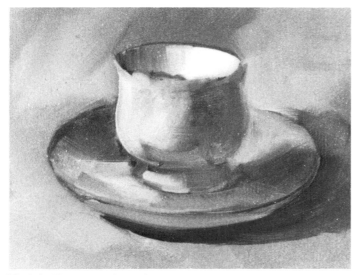

Block-in *Next come the midtones and lights, which begin to build form.*

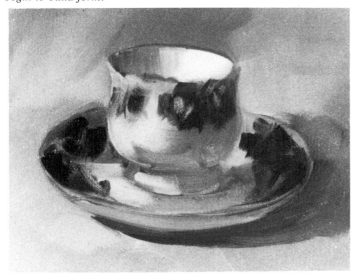

Adding pattern *I block-in the floral pattern with dark color softening to lighten.*

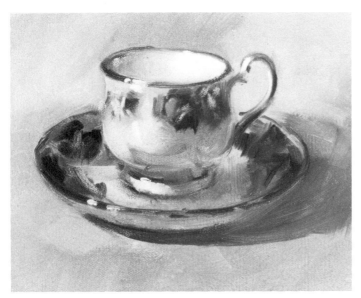

Final details *The last step is adding the handle and the touches of highlights.*

at the outer rim of the shadow side of the cup and also under the cup where the density of the shadow is changed by the reflected light from the saucer.

Background

I have already applied the overall background with opaque paint, but now I will add another layer of slightly darker and slightly lighter tones of the same gray (cadmium red light, ultramarine blue in equal parts, and white in various amounts) to change the value slightly. I want to darken the area behind the light side of the cup and lighten the area behind the dark side of the cup. That gives the illusion of space existing behind the object. At this point, I have covered up my indication of a handle, but I will add it again in the final step.

Final details

I want to indicate the busy floral pattern inside the saucer and outside the cup without getting too involved in painting details. I start on the shadow side using alizarin crimson with a tiny touch of ultramarine blue (the blue-violet adjacent hue). The lighter flowers are Matisson pink with a bit of the dark mixture added for the center (the red-violet adjacent hue). I paint the trim on the rim of the cup with cadmium orange and sap green for the shadow area, and I add a touch of cadmium yellow light for the lighter part. Highlights of pure white show the glistening of the porcelain, and a touch of pure cadmium yellow in just a couple of spots brighten up the gold around the rim. Next I paint the graceful handle using both my porcelain and gold tones. Finally, I add some highlights to the floral pattern on the cup with Matisson pink and white.

Object Study 6: Clear Glass

Dominant hue:	blue
Adjacent hues:	blue-violet/blue-green
Complement:	orange
Oil palette:	ultramarine blue
	cadmium red light
	cadmium yellow light
	titanium white
	cadmium orange
	alizarin crimson

Painting clear glass is much like painting a puff of smoke. Painting just a hint of what you see is usually enough to make it work. For this study, I arrange three glasses of different size and shape, placing one in front of the other to emphasize their transparency. I want a high-key, cool painting and will use a simple three-step approach.

Beginning

Because glass is clear, I need to first finish the background tones (or whatever is visible behind the glass) rather than begin as usual with a thin wash, adding the background color later. I use cadmium red light, ultramarine blue, and white for the background, varying my values by adding cadmium yellow light and more white to the left-hand side and the bottom of the canvas.

Next, I draw the plumb lines and ellipses clearly but lightly, using a middle-value of ultramarine blue and cadmium red light. The sketch must be accurate because the lines, though softened, will be the basis for painting each glass and will be evident in the finished work. Next, I blend my initial sketch lines into the background tone, partially losing some edges and keeping others crisp and clean. To paint the brandy in the snifter I use two parts ultramarine blue, one part cadmium orange, and one part alizarin crimson for the dark body and add a touch of white for the highlight and top surface of the liquid.

Set-up *It's good practice to paint different-sized glasses, both empty and full.*

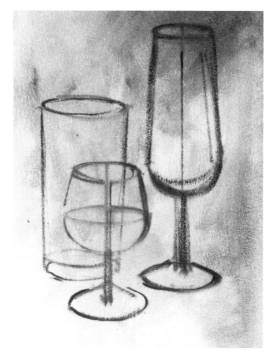

Initial sketch *The first lines form the foundation for the final illusion, so they should be correct.*

Adding lights and darks

The next step is to add those beautiful highlights that make glass sparkle on canvas. Using a small brush I pick up a tiny touch of pure white and paint vertical lines down the side of the glasses as well as some strokes that follow the curves of the stems and the bottoms.

I add cast shadows to the background tone with two parts ultramarine blue and one part cadmium red light plus a touch of white. I also use this mixture to add some subtle darks in the glasses. For the shadow under the brandy snifter, I use a bit of orange.

Final details

It is advisable not to overwork the details when trying to create the illusion of glass. The feeling of transparency is easily lost. Try to keep your lines sharp and crisp with a minimum of blending and refinements. Let the few shimmering highlights and strong edges you use be crisp and sure. As with the painting of a puff of smoke, you don't need a great deal of definition to convincingly tell your story.

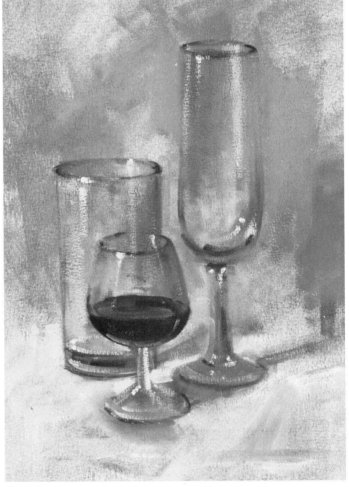

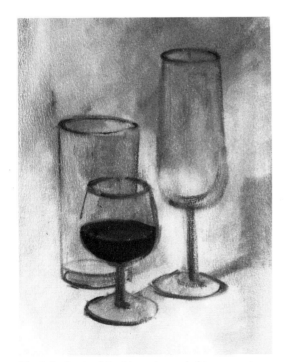

Block-in *Just a bit of tone is needed to separate the glasses from the background.*

Final details *The shimmering white highlights provide the transparent illusion.*

Object Study 7: Wicker

Dominant hue:	red-violet
Adjacent hues:	red and violet
Complement:	yellow-green
Acrylic palette:	violet
	cadmium yellow light
Oil palette:	ultramarine blue
	cadmium orange
	cadmium yellow light
	cadmium red light
	phthalocyanine yellow-green
	viridian green
	titanium white
	cobalt violet (Bellini)

For some students, learning to draw is a dreaded part of learning to paint. It is especially difficult when you want to include a complicated object—such as this wicker chair—in a painting, and you don't even know how to begin. This study should make it easier, and I will demonstrate drawing the chair with the aid of a viewfinder.

Beginning

I tone the canvas with a middle value mixed from cadmium yellow light and violet acrylic paint. My tone leans slightly to the violet, and I want to keep its value slightly dark in order to have contrast while drawing. I let the canvas dry.

Drawing

With a mixture of white and turpentine I lightly indicate the placement of the chair on the canvas. I begin just with the basic shapes, which I will reinforce with a darker tone after I check my accuracy, using a homemade viewfinder.

To make a viewfinder, cut a 2½ x 1½ inch hole in a 5 x 7 inch piece of cardboard. Tape two threads from corner to corner so they form an X in the hole. The crossing thread enables you to establish the center of the composition while the cardboard mask blocks out all surrounding area.

I now place a white dot on the canvas where the two threads cross over the real view. Then I begin to measure from this center, closing one eye and using the brush handle like a ruler, held at arm's length to check

Set-up *This intricate chair can be painted simply.*

Initial sketch *I use a minimum of strokes to suggest the outside contour.*

my drawing accuracy. I check to see if the width of the seat and the back of the chair are the same and to see where the spine comes in relation to the legs. Notice how much longer the nearest leg has become. I adjust any of my lines that do not appear correct.

Block-in

Now that I have successfully determined the structure of the chair, I am ready to give it personality by suggesting trim and structural curves. First, I apply the shadow darks of the chair using ultramarine blue, cadmium orange, and white—keeping the tone toward the blue. Then I begin on the light areas working from the strongest light first. I use small amounts of cadmium red light and cadmium yellow light with white, and I add a bit of the shadow mixture where darker, middle-tones are needed.

Background

Phthalocyanine yellow-green, cadmium red light, and cobalt violet make a background tone that is strong enough to contrast with the white wicker. I've used the complement as well as both adjacent hues in the background.

Final details

You can best achieve the look of wicker by choosing a few areas in light to paint detail, such as showing the direction of the wicker wrap. Then add curls, curves, or fancy trim to the overall pieces. I soften some of my lines and strengthen others by reenforcing some darks. I paint the cast shadow with ultramarine blue, cadmium red light, and a touch of white.

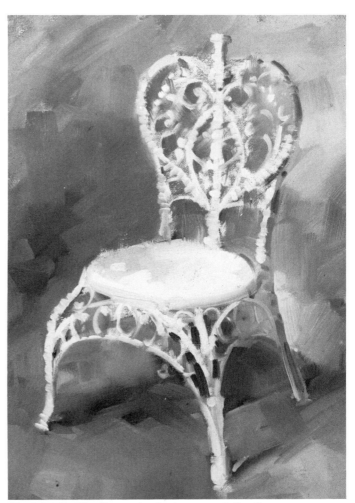

Block-in *As I start to add midtones and lights I also indicate pattern.*

Final details *Blending and softening, especially of cast shadows, help bring the chair into sharp focus.*

Set-up *Adding a doll to a still life can give a feeling of sentimental realism.*

Initial sketch *I go directly to blocking-in the darks and midtones after first sketching the outlines.*

Object Study 8: Cloth Doll

Dominant hue: blue
Adjacent hues: blue-green/blue-violet
Complement: orange
Oil palette: titanium white
cadmium red light
ultramarine blue
ivory black
cadmium orange
Grumbacher red
sap green
cerulean blue

Toys are such fun to paint. I especially like cloth toys because they are plush and limp, and I find it easy to exaggerate the twist of a leg or the droop of a floppy little head. A stuffed toy also serves as a model for learning to paint soft cloth folds, textures (such as hair and trimming), and painted or embroidered features. I like to see how much of an alive look I can give to an inanimate subject such as this. This will be a high-key, cool painting.

Beginning

I tone the canvas with a thin light wash of ultramarine blue, cadmium red light, and turpentine. Next, I sketch with a more intense tone of the same mixture. I use my viewfinder (see Object Study 7 Wicker) to locate the center of the canvas, near the area where the apron meets the dress. Then I draw all parts of the doll in relation to that spot.

Block-in

I added the darks first, beginning with the dark of the dress and the shadow side of the face, using three parts ultramarine blue and one part Grumbacher red (the blue-violet adjacent hue). I add one part black to the same color for the dark of the shoes then gray the tone with a touch of white for the light side. The dark of the apron and hat is one part cadmium orange, two parts ultramarine blue, and two parts white. At this stage, I don't do any blending.

For the doll's dark brown hair, I use one part alizarin crimson, one part sap green, and

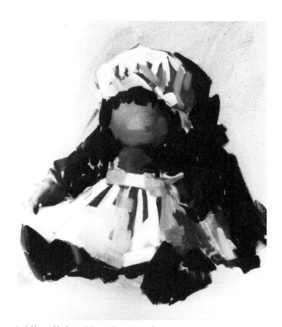

Adding lights *Next I paint the strong pattern of light and shadows on the hat and apron.*

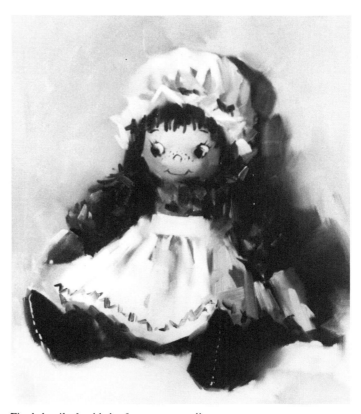

Final details *I add the features as well as pattern details on the dress, hat, and apron.*

one-half part ultramarine blue, keeping the color slightly red. I block-in the face and hands with cadmium orange, adding a touch of black and white for shadow and more orange and white for light. In the face, I blend to merge all the values.

For the white of the apron and hat, I create three values using mixtures of cadmium yellow light, cadmium red light, and white.

Background

The background is three parts ultramarine blue, one part cadmium red light, and enough white to keep the value a bit darker near the white hat. I want to create a blue-violet color (an adjacent hue). For variation, I add a touch of green to the background by mixing in cerulean blue and cadmium yellow light (creating the other adjacent hue). The cast shadows are three parts ultramarine blue, one part cadmium red light, and a tiny touch of cadmium orange, with a half part white. After I add the cast shadows, I soften the edges into the background and the shadow side of the doll.

Final details

I use equal parts cerulean blue and white for the reflected lights, including on the face, the shadow side of the shoes, and the right-hand side of the hat and apron.

I leave the doll's features for last; otherwise, the doll would be looking at me while I painted. I use black with a bit of cadmium red light to suggest the outline of the eyes, nose, mouth, and freckles. The nose sits high on the face close to the eyes, while the mouth is almost lost because the head is turned down. The pupil of the eye is black, and the iris is painted with a bit of cerulean blue. The cheeks get rosy with a small amount of cadmium red light. The rickrack trim on the apron is a mixture of ultramarine blue and cadmium red light in shadow but cerulean blue and ultramarine blue in light.

For realism, I indicate stitching on the shoes, and I gently highlight the hair with cadmium orange. As a final note, I darken a few areas of the patterned dress using ultramarine blue and black, then I lighten other spots using cerulean blue and white.

Object Study 9: Fabric Textures

Dominant hue: red
Adjacent hues: red-violet/red-orange
Complement: green
Spray enamel: quick-drying white
Acrylic palette: cadmium red light
 cadmium yellow light
 ultramarine blue
Oil palette: ultramarine blue
 cadmium orange
 alizarin crimson
 cerulean blue
 Matisson pink
 titanium white

Learning to treat fabric textures is an important part of the still life painting. Fabrics often occur in both subject matter and background and can be a real challenge to paint.

The texture I choose for this study is lace, mostly because I have often painted Victorian subjects and have found painting lace a laborious, time-consuming task. However, one day while experimenting with a can of quick-drying white enamel spray paint, I found a solution to that difficulty. By spraying through cloth lace, you can transfer its pattern to the surface of either an acrylic or a dry turpentine-and-oil underpainting. The lace can be turned in several directions for realism. Then, by scumbling over the dry lace surface with tones of white and gray, you can change values yet still see the lace pattern. I choose a hat for this high-key, warm study, but you can use the same procedure for lace curtains, tablecloths, or even garments.

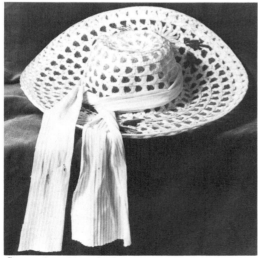

Set-up *I position the hat to make the most of its lacy pattern.*

Beginning

I want to control my grays in this study, so I use all three primaries—cadmium red light (two parts), cadmium yellow light (one part), and ultramarine blue (one part)—for the acrylic underpainting. I mix the color a little stronger toward the red-orange (an adjacent hue) and obtain a middle to dark value. After the canvas has dried, I sketch the basic shape of the hat with a mixture of acrylic ultramarine blue.

Spraying on the lace

I take the canvas outside and lay it flat on the lawn. I place my lace cloth on the canvas and begin to spray it with enamel. I spray lightly at first, then more heavily after I check to see that the coverage is adequate. The enamel will dry almost immediately—by the time I get the canvas back into the studio, I can proceed. I can only see a faint suggestion of my original drawing, so the first step now is to resketch the outline of the hat and scarf with oil paint thinned with turpentine.

Block-in

The cast shadow plays an important part in this composition for two reasons: it provides a dark value, and it echoes the pattern of the lace hat. I block-in the cast shadow first to establish the dark value, using equal parts of ultramarine blue, cadmium orange, with a touch of alizarin crimson, and a bit of white. The color should be red-violet (the other adjacent hue). I paint the lighter areas of the cast

Initial sketch *I loosely indicate the basic outline.*

shadow using the same colors mixed to a lighter tone. I lighten the shadow by adding more white.

Next, I scumble body shadow tone—equal parts ultramarine blue, cadmium orange, and white—over the sprayed lace pattern of the hat. I make sure I can still see the sprayed lace beneath. The ribbon is equal parts Matisson pink with alizarin crimson, a touch of cerulean blue, and white for the shadow areas and a tiny touch of Matisson pink and white for the lights. By adding the shadow tone of the hat to the light ribbon color, I create the illusion of the ribbon falling over the table.

Background

It is necessary to cover the lace pattern where it occurs outside the hat. I use equal parts ultramarine blue, cadmium orange, and a touch of alizarin crimson and a tiny touch of white for the background color. I darken the table edge to further indicate the angle change in the ribbon. I allow a bit of the underpainting to show through, as it contains one of the adjacent hues.

Final details

Finding the pattern on the hat a little stiff, I scumble lightly over the lace with white and just a bit of cadmium orange. Lastly, I add a few areas of gray—around the top of the hat and in the lace pattern—to give the subject more dimension.

Spraying the lace *I use spray enamel to add the pattern of real lace.*

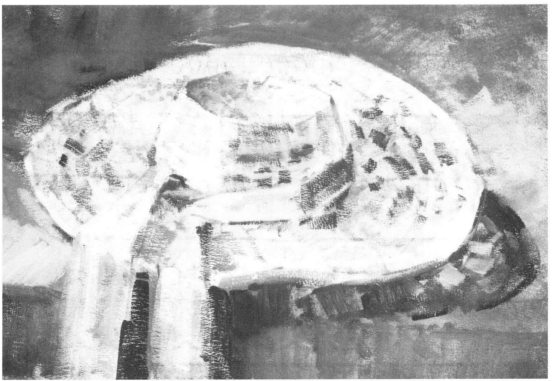

Final details *I scumble both lights and darks over the lace pattern and add background tone.*

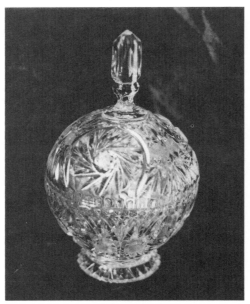

Set-up *A cut-crystal decanter adds both pattern and bits of reflected color to a still life.*

Initial sketch *After toning the canvas I make sure my drawing is accurate.*

Object Study 10: Cut Crystal

Dominant hue:	red
Adjacent hues:	red-violet/red-orange
Complement:	green
Acrylic palette:	violet
	cadmium yellow light
Oil palette:	alizarin crimson
	sap green
	cadmium red light
	ultramarine blue
	cobalt violet (Bellini)
	phthalocyanine yellow-green
	viridian green
	titanium white

Cut crystal can be painted in basically the same way as transparent glass. The difference is that you must show the jewellike appearance which the faceted cuts give to the crystal. Also, the crystal's patterns and designs must be realistically depicted or it will not look authentic. Remember that the light plays tricks on the cut areas of the crystal, and you may see a multitude of colors. It is important to keep those colors subtle yet realistic.

Beginning

I tone my canvas with violet and cadmium yellow light acrylic and then let it dry. Next I indicate the cast-shadow area and the darks on the left side of the canvas by going over the toning with an even darker layer of alizarin crimson and sap green oil paint thinned with turpentine. I use white, thinned to a wash, to sketch the decanter. As in painting clear glass, every stroke should be accurate.

Adding lights *The pattern in the crystal is added in short strokes of white.*

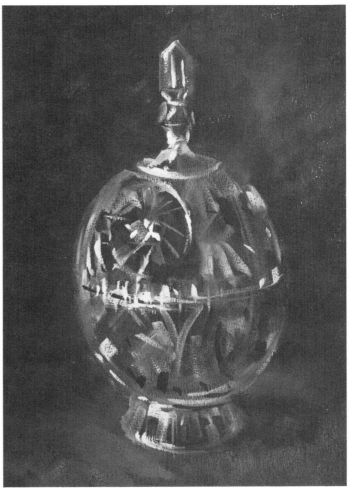

Final details *I add tints of color to the white patterning.*

Block-in

Crystal can be painted with whatever hue you choose using an analogous color harmony. For this study I choose red-violet mixed from equal amounts of alizarin crimson and ultramarine blue. I vary the tone by using its complement, a small amount of phthalocyanine yellow-green. Two parts cadmium red light added to one part sap green produces the red-orange adjacent hue, and I use it for the table surface and upper right-hand corner of the background. The cast shadow is darker.

Background

I finish the background before starting the finishing touches on the crystal. I use a mixture of equal parts of alizarin crimson, ultramarine blue, and sap green and keep the color dark.

Final details

If all the needed preliminary steps have been taken, the finishing steps to painting crystal will be quick and exciting. As when painting transparent glass, I first soften the edges of the crystal by blending, but I don't lose the lines completely. The pattern made by the cut grooves must now be indicated realistically, and tints of color added. Because the design and pattern are so important, I plan each brushstroke before painting. I use one part cerulean blue, one part viridian green grayed with one-half part cadmium red light with different amounts of white, to vary the values as needed. Reflected lights are equal parts cobalt violet and white.

I add highlights with a mixture of white, a tiny touch of cadmium red light, and a mere touch of cadmium yellow light. I vary the hue for secondary highlights. The highest highlight is pure white.

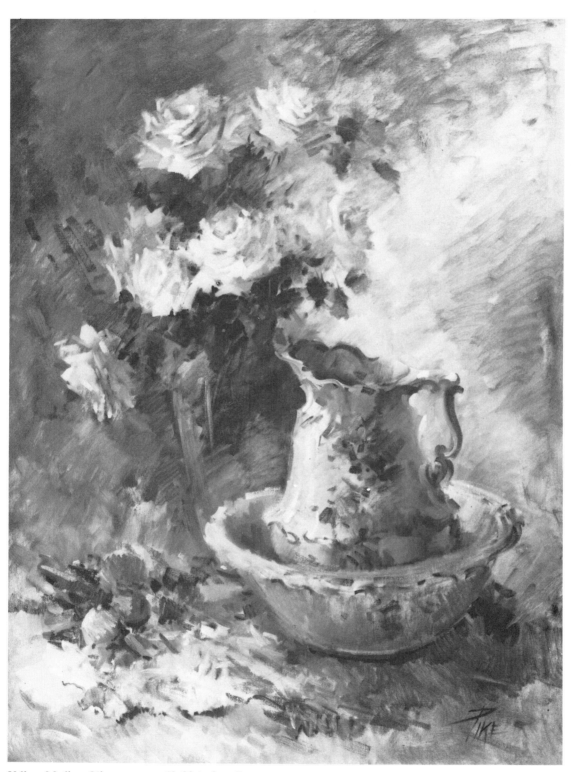

Yellow Medley *Oil on canvas, 40x30 inches. Roses, a porcelain pitcher and wash bowl, and some lemons and limes all combine to give an impressionistic feeling of a sun-drenched dressing room. The mood of the painting is enhanced by the loose, free brushstrokes.*

Painting Floral Still Lifes

*N*ow the fun of actually painting flowers begins! I will demonstrate how to paint various types of flowers—from the sumptuous rose to the majestic gladiola. Once you start to really look at flowers, you will discover that not only does each variety have a specific structure, but each flower within a species has its own particular characteristics. The basic knowledge of how each flower is formed is important. I suggest that as you set up for each study, you sacrifice a flower or two by taking it apart and examining the structure. Look and see if the petals grow side by side or overlap. Note how the petals are attached to the stem and how the centers are formed. Make sketches or notes if necessary.

Leaves are really outgrowths of the stem. They are usually either formed of a single blade (for example, on the iris) or of many leaflets (as on the rose). Make sure before you start painting any flower that you understand how both the flower and the leaves are constructed.

Once you have acquired that basic knowledge, you can begin to paint. If you are unsure about painting an arrangement of flowers, practice first with one blossom. Turn the flower in several directions to see the effect of light on its petals and leaves. Do some quick studies of the light and dark patterns that you observe. Then tackle a group of flowers. Follow the way I approach each type of flower, but don't hesitate to add your own personal style. The studies that follow are not meant to be finished works of art, so repeat them several times to try out different effects.

Each floral study lists the oil and acrylic palettes I use, as well as the color harmony.

I use #3 and #6 bristle brushes for sketching and for painting small details and petals. I also use #6—#36 Royal sable brights for general use and backgrounds.

Now follow along with my simple approach to painting flowers and discover how much fun the process can be.

Arranging the still life

When I arrange my objects I want not only a pleasing, flowing pattern but also a balance of color and size. I find achieving balance to be the most difficult and frustrating part of setting up a painting. The partially visible ornate frame, just behind the white luster in the foreground, balances the large platter of fruit. The crystal nestled behind the white scalloped platter provides a glistening pattern. The white of the roses and daisies clearly establishes a focal point against the cast shadows.

The strongest concentration of color will actually occur in the background and will need to be dark enough to contrast with the flowers. The fruit provides both color and value contrasts, since the white platter by itself doesn't provide enough of a pattern change.

Demonstration 1: White Lusters

The two beautiful lusters in this set-up have special meaning for me. Years ago, when we were newly married and money was extremely scarce, my husband wanted to take up golf. Buying the golf clubs was a big expense, but my husband agreed that I could spend the equivalent for something I wanted, so I bought my lusters. I may have bought them just to look at, but they gave me as much pleasure as my husband's golf clubs gave him. (Unhappily, the lusters were shattered during the 1979 Sylmar earthquake; however, we glued them together and they are still prized still life objects.)

Materials

My canvas is 40x30 inches. I use violet and yellow-green acrylic, and a full oil palette.

Step 1 *I arrange the objects for a pleasing flowing pattern.*

Step 2 *I loosely tone the canvas and indicate shapes.*

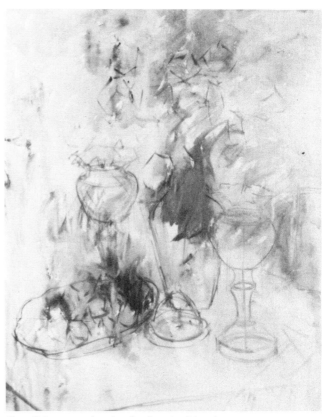

Step 3 *I secure the sketch of each object in proper perspective.*

Toning and underpainting

Because the dominant hue is yellow, I tone the canvas with violet, grayed slightly with yellow-green acrylic. I use an irregular pattern, keeping in mind the position of the bronze vase, dark fruit, and dish, and going darker in the shadow areas of those three items. At this point, I am simply thinking dark, light, and color rather than object. I decide the focal point should be in the cluster of white roses and daisies located near the center of the canvas because nothing else in the painting comes close to having the same degree of dark and light contrast. The next step is to sketch-in individual objects by drawing with ultramarine blue thinned with turpentine.

The flowers

With my underpainting completely dry, I study the outside shape of all my flowers, deciding which to paint in strong light and which to allow to recede into shadow or halftones. I then mix a shadow tone for the white roses and daisies from ultramarine blue, cadmium orange, and a touch of sap green. I add cobalt violet to the shadow mixture to paint a few daisies in the background, adjusting the value with white. I add the light on the dominating flowers with just a whisper of color, mixed from a touch of cadmium red light and cadmium yellow light plus white. After the white flowers are completed, I begin on the leaves. I establish the focal point by placing a dark mixture of sap green, ultramarine blue, and a touch of cadmium red light in the center area. I carefully carve-in around the outside edge of the rose petal to play up the contrast. The rest of the leaves are suggested—not overstated—in slightly lighter tones, which I mix by adding phthalocyanine yellow-green.

The fruit

I want to gray the apples and grapes slightly so they don't take away from the importance of the flowers. I use one part sap green with a half part cadmium orange (the yellow-orange adjacent hue) for the shadow area of the apples. The light tones are basically a mixture of equal parts of cadmium orange and phthalocyanine yellow-green (the other adjacent hue) grayed with a tiny touch of cobalt violet. I add a touch of cadmium yellow light to vary the light tones so all the apples are not exactly the same. The highlights are cadmium yellow and white.

I paint the grapes as a mass using equal parts ultramarine blue and alizarin crimson, graying the mixture with a touch of sap green. I gray the grapes to the extreme left with a combination of cadmium red light, ultramarine blue, and a bit of sap green. I wipe-down for the light areas, leaving the base color for the darks. Then I suggest a few finished grapes by adding two parts cobalt violet and one part white for the dark blue grapes and two parts cadmium red light and one part white for the reddish grapes. For the highlights, I add only a suggestion of Matisson pink to one part white. A few grapes have reflected lights on the shadow side, and I paint those with equal parts phthalocyanine yellow-green and white.

The lusters

I will paint the lusters in much the same way as I paint porcelain. The slight tint of violet on the shadow side is mixed from equal parts of ultramarine blue and cadmium orange. I then add a tiny touch of cobalt violet to a few areas to vary that shadow tone. I also use this color for the crystal butter dish and all the cast shadows. Where the lusters become lighter, I brush on a mixture of equal parts of cadmium orange, cerulean blue, and white. I don't want the mixture to become too white, because I need to allow for enough contrast when I add highlights. I paint the gold trim on the lusters using equal parts sap green and cadmium orange in shadow, with more cadmium orange in the light area. Touches of cadmium yellow light mark the spots where the highlights will later be placed. The values on the fluted edge at the top subtly merge from dark to light. Here I use the same mixture that I used for the light side of the luster, with a bit more white added.

I handle the prisms like crystal, using touches of more intense color to give a stellar look. The important thing to remember when painting prisms is to not blend. I paint the highlights on the lusters and prisms with one part cadmium yellow light and two parts white.

The vase

The vase is part of the dark pattern, and I paint it using the same hue as the background. I give the vase very little detail so that it doesn't take away importance from the lusters. I scrub phthalocyanine yellow-green on the left side and allow it to disappear into the darks. I add a touch of highlight using cadmium yellow light and white blended to just a whisper.

Background

I will use a color harmony containing both the dominant hue and an adjacent hue. To balance the composition the background needs to be dark, and I want to create an animated pattern to prevent it from becoming a dark void. I mix equal amounts of cadmium red light and phthalocyanine yellow-green for the darker areas, gradually changing the color to yellow-gray by adding two parts cadmium yellow light and one part cobalt violet. I add a few touches of cerulean blue and Grumbacher red—providing discords—in equal amounts. I carve-in around the perimeter of the flowers with the background tones, losing and softening edges where necessary.

The tablecloth

The tablecloth is light. I use equal parts of ultramarine blue, cadmium red light, and sufficient white to create a soft violet-gray. For the light-struck area, I add more white, as well as tiny touches of Grumbacher red. With touches of cerulean blue and white, I add a bit more discord and give the cloth some sheen.

Final details

I bring each element to its finished form by placing suggestive touches of white highlights. I paint the centers of the daisies using equal parts cadmium orange and sap green in shadow but cadmium orange and cadmium yellow in the light-struck areas.

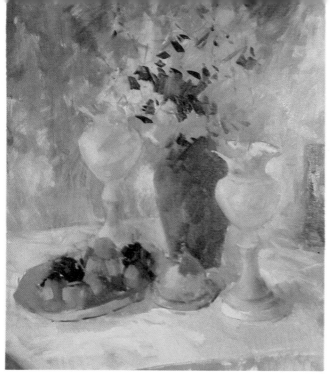

Step 4 *Now I begin to add color and value, block-ing in each object in turn.*

Step 5 *The details and highlights make this white and gold study shimmer with light.*

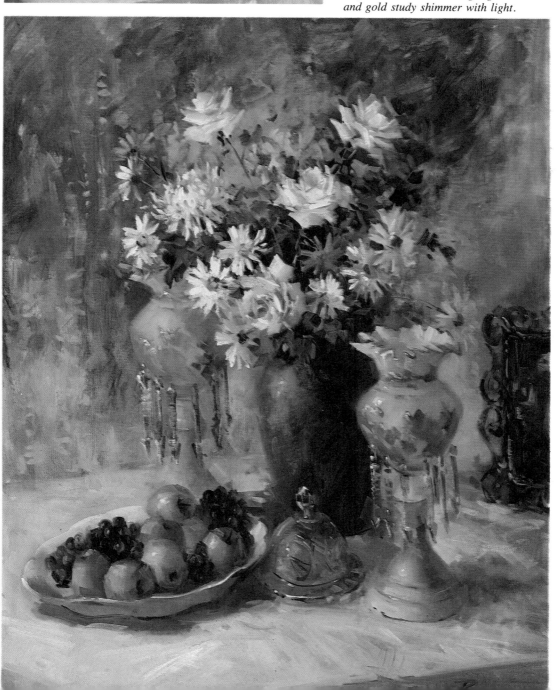

105

Demonstration 2: Mixed Floral with Fruit

The flush of working with a busy and full still life is to see how little you can paint and still maintain the illusion of masses of flowers and fruit. When you work with this type of composition, you must again be especially aware of color and balance. I have chosen a dominant hue of blue, with adjacent hues of blue-green and blue-violet, for my painting. The complement is orange.

You should also be aware of your light source—whether it is warm or cool—so you can determine the intensity of the shadows. This painting is cool, and my light source is a warm spotlight with a 100-watt bulb placed just to the left of my set-up.

Materials

My canvas is 40x30 inches. I use a full oil palette and ultramarine blue and cadmium orange acrylic.

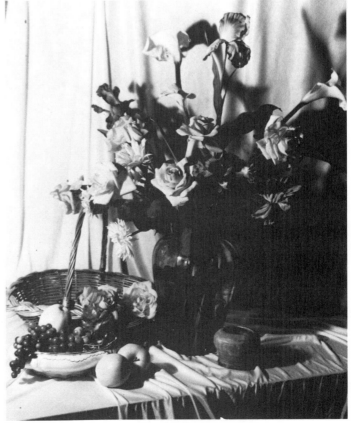

Step 1 *This simple composition is full of warm, romantic color.*

Toning and underpainting

Because this painting has a blue dominant hue, I use a cadmium orange acrylic wash for toning the whole canvas. Then I scumble blue in various values over the orange for an iridescent effect. I control the values of both the orange and blue by thinning with water rather than using white. I then lay-in an acrylic underpainting to establish the pattern of darks and lights created by the flowers and objects.

Focal point

Before I begin on the flowers or fruit, I must first determine the all-important focal point, where the darkest dark meets the lightest light. I chose the area around the warm pink roses and daisies as that strongest point. In a good composition your eye travels through the details of a painting and comes to rest at the focal point without leaving the canvas.

The flowers

The first thing I do is to study the outside shapes of all the flowers. At this point I am not worried about losing edges but simply want to keep the shapes accurate and my colors pure. Each flower is blocked-in using four steps. First I establish the outside shape of the flower using middle-tones of pure pigment (no white added). Second, I establish the lights by wiping-down the lightest areas with a tissue or cloth. Next I paint all the flowers according to the values I see and perhaps indicate the centers of a few flowers. Lastly I complete the outside shape of the flower by using the background tone to carve-in from the outside edge.

I start with the pink and orange roses, blocking-in their shapes with equal parts alizarin crimson and Indian yellow. The shadows of the roses are cool, so I use a touch of cerulean blue to gray them. I wipe-down the lights on all the flowers.

I combine alizarin crimson and ultramarine blue in equal amounts for the iris colors. I make sure to keep the irises relaxed, with a slight curve to the middle of the stem—they have petals that turn both up and downward.

The calla lilly is a joy to paint, but it can easily dominate the composition, so I make sure to lose edges wherever I can. I use equal amounts of cadmium red light, ultramarine blue, cadmium yellow light, and white for these flowers. Notice that I use all three primary colors in the white—this enables me to control my grays.

The fruits

I block-in the grapes as a mass—not as individual objects—using equal parts of ultramarine blue and alizarin crimson grayed with a tiny touch of sap green. If you want to make the fruit appear good enough to eat, paint a few scattered grapes on the table as if they had fallen from the bunch. Then bring a few grapes into realistic detail.

I block-in the apples with equal amounts of sap green and cadmium orange mixture. I add a bit of ultramarine blue for the shadow areas.

The leaves

Finished leaves are so often overpainted that I always leave them for last. They should be considered the stage set for the flowers, and only a few should be brought to completion. I use two parts ultramarine blue, two parts sap green, and a half part cadmium red light to block-in the leaves. For this particular painting I use a touch of yellow in the finish.

The pots and basket

The basket simply fills space, so I don't paint many details—only a few strokes on the handle and several on the body to show the basketweave.

I block-in the blue vase with equal parts cerulean blue and sap green and paint the little blue pot with a mixture of equal parts of ultramarine blue, alizarin crimson, and a touch of cadmium yellow light to gray the violet tones. The small pot should be kept in shadow.

Background

In this painting I feel the background should be the dominant hue, so I keep the same palette but gray all the tones. I paint the background dark on the light side of the set-up and light against the dark side, which helps enforce the illusion of having three dimensions.

Step 2 *I do not use a sketch—only masses of color and value—to show the placement of objects.*

I paint the tablecloth with mixtures of equal parts of cadmium orange, ultramarine blue, and white—adding more cadmium orange and white for the light area. For the cast shadows I use one part cadmium orange, two parts ultramarine blue with a little white added.

Final details

Now I go back and fill in the details of the individual flowers, adding the lightest spots on the petals and leaves. I also reinforce the dark petals with shadow grays, where needed, and add the reflected lights. I then bring the other objects to various degrees of finish. Notice how few colors and details I actually use to create this full composition.

Step 3 *I start to develop subtle detail around the focal area and add the dark masses of the leaves.*

Step 4 *Now I define the flowers and other objects. I bring some fruit into realistic detail to add life to the composition.*

Mixed Floral with Fruit

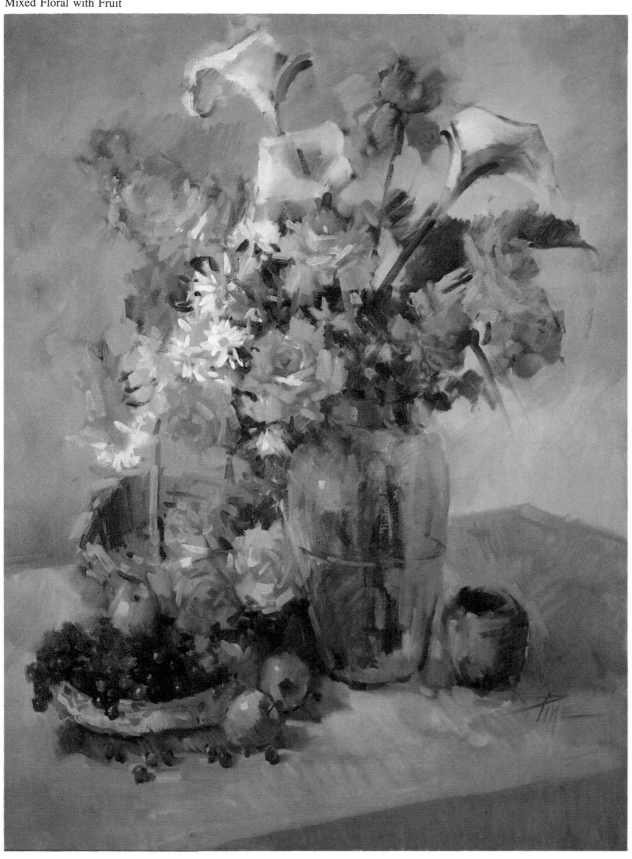

Demonstration 3: White Chrysanthemums with Silver

This entire demonstration is designed to reveal how much pure color can actually be used in painting objects and flowers that are generally considered to be without color—such as in the whites, grays, and neutrals of the chrysanthemums, roses, silver, porcelain, glass, and two dramatic calla lilies.

Painting white-on-white is traditionally considered difficult and frustrating, but I have developed a simplified approach to use. I plan to do a loose, brushy painting without great detail yet with plenty of glistening highlights and reflected lights.

Materials

My canvas is 40x30 inches. I use an acrylic palette of phthalocyanine blue, Grumbacher red, and cadmium yellow light, and a full oil palette. My light is north light coming from the left of the set-up.

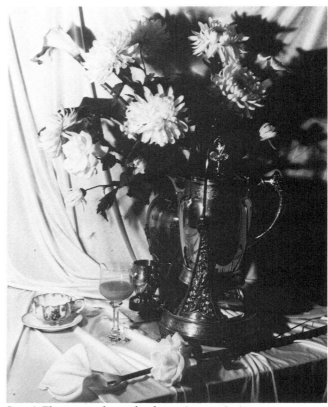

Step 1 *The set-up shows the dramatic use of white and silver tones.*

110

Arranging the still life

I sometimes preplan my composition by doing a small (4x5 inches) sketch of the still life's abstract pattern of lights and darks. I can then adjust any of the objects before starting the actual painting. In this case, I find a sketch especially helpful because of the deceptive lack of color in the set-up. The sketch lets me clearly see where my strong lights and darks are and also helps determine the focal point—located near the large mum close to the center of the canvas.

Next to the blooms the most dominate form in this composition is the large antique coffeepot. Even though it provides many beautiful reflected lights on its silver surface, I know I must paint it in a sketchy manner; otherwise, it will appear overpowering in the picture.

Another important element in this set-up, an element that is often overlooked in still life paintings, is the table edge. Here it helps balance the composition by enabling the eye to travel down from the focal point, in a circular path through the objects in the still life, and then upward again toward the right.

Toning and underpainting

When painting white-on-white, it is best to stay close to the dominant hue, which in this case is blue. I begin with a grayed acrylic wash of the dominant hue, mixed from two parts phthalocyanine blue, a half part of Grumbacher red, and a half part cadmium yellow light. I use my dark colors to begin indicating my dark and light patterns. Then I let the canvas dry completely.

Sketching

I use simple, linear strokes of phthalocyanine blue and turpentine to sketch-in the major forms. I don't go into too much detail in my drawing, but I do want to accurately place the flowers and objects. I also want the ellipses of the objects to be correct, since they indicate that the eye level is somewhat above the table.

The flowers

I first block-in the chrysanthemums and calla lilies using a mixture of one part phthalocyanine blue, one part cadmium red light, and three parts white. This makes a soft violet-gray. Next, I add white warmed with a bit of cadmium orange to paint the light-struck side of each flower. At the same time, I paint the white tones of the porcelain cup and saucer using the same shadow and light mixtures that I used for the flowers.

The silver

I begin by painting the darks with a mixture of equal parts of sap green, phthalocyanine blue, and alizarin crimson. For the small areas, where I feel I need a stronger gray, I add a bit of cadmium yellow light to the mixture. I paint the light areas on the silver items in one part cadmium orange and one part cadmium yellow light cooled with a half part cerulean blue and three parts white.

Background

I have already established my background gray tones. Now, with loose animated brushstrokes, I scumble-in a mixture of two parts cerulean blue and one part white over portions of the background. To add interest I use two parts cobalt violet mixed with one part white and apply them in the same way. I want to suggest the feeling of space behind the objects, and create a contrast between this area and the light, white tablecloth.

The leaves

I want to show the leaves as a dark mass contrasting with the light of the flowers. My mixture is mainly two parts sap green, with one part phthalocyanine blue and one part alizarin crimson. I make a few select leaves lighter by adding one part cadmium orange, one part cerulean blue, and one part white to the mixture.

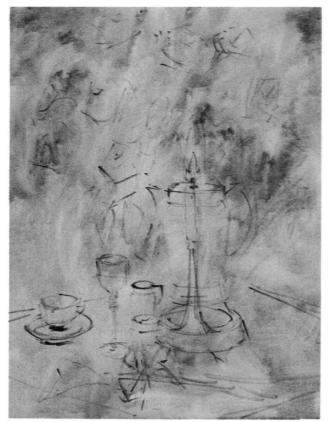

Step 2 *I tone the canvas and suggest shapes with a subtle drawing.*

Final details

Next I paint the vase, barely showing behind the coffeepot, using equal amounts of cerulean blue and white slightly grayed with a touch of cadmium red. I don't want to add too much detail to any of the objects. I use a few controlled angular strokes to indicate the rims on the cup and saucer and also on the wine glass. For the final highlights I use one part cobalt violet and three parts white. I also use a violet-toned white to highlight the coffeepot.

The last thing I work on are the petals of the chrysanthemums. I soften the round look of most of the flowers by both losing edges into the background and selectively bringing some petals into pale definition. With my fingertips I touch-on and soften slightly some glistening white highlights on the white petals.

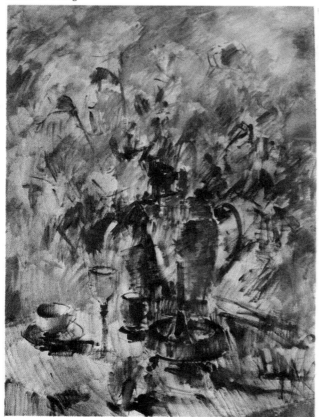

Step 3 *I start to build darks and lights, showing the shapes of flowers, objects, and the table edge.*

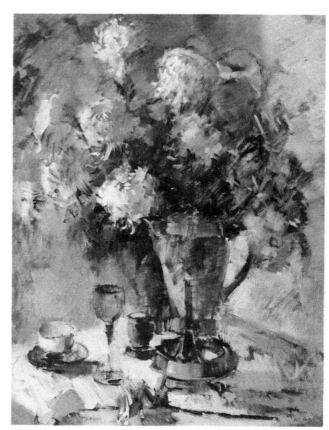

Step 4 *Now I begin to model the petals in the flowers and define the dark mass of leaves.*

White Chrysanthemums with Silver

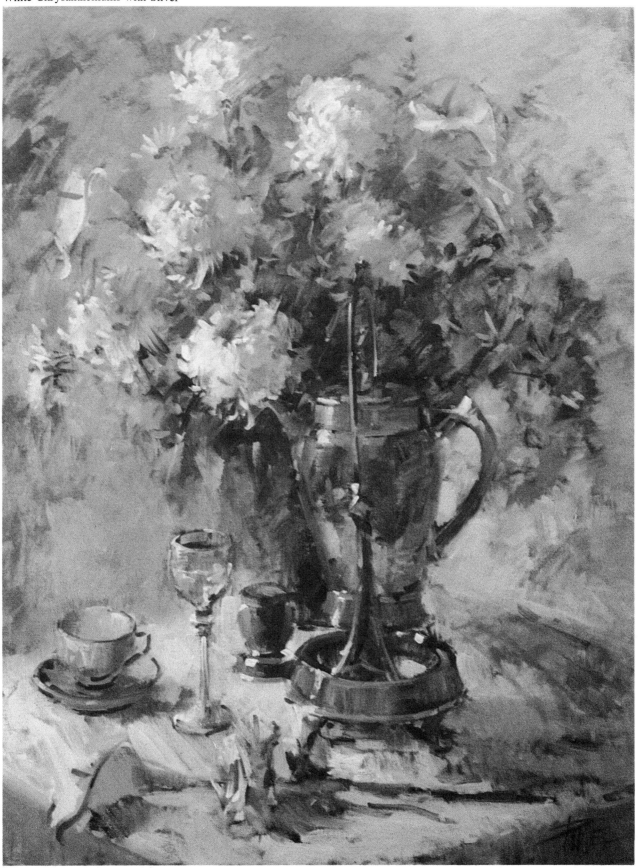

Step 5 *I finish by understating details and securing*
highlights.

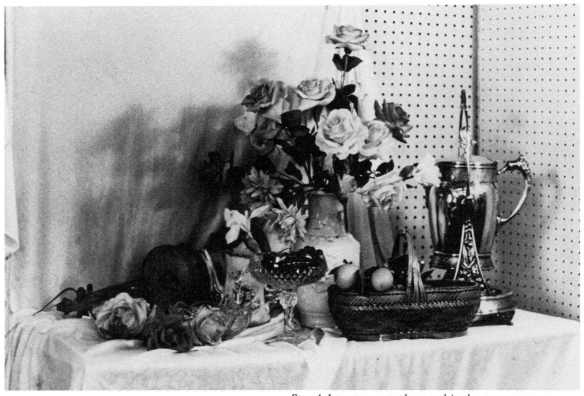

Step 1 *I try to create the mood in the arrangement.*

Demonstration 4: Pink Mood

This demonstration has a set-up similar to *White Chrysanthemums with Silver,* and I even use the same ornate silver coffeepot, but instead of painting white-on-white I use peach and cream-pinks. I love the color pink, when used in a delicate way, but it can be difficult to control the color so the final result is not chalky. You need to concentrate on keeping your colors clean, despite the fact that pink is mixed from red and plenty of white.

In additon to the obvious pinks in the roses, there are reds throughout the composition: the violin is a warm red, the cherries in the crystal bowl are a deep red, the basket picks up the warm tones of the violin, and the coffeepot reflects rosy lights from all over the still life.

Materials

My canvas is 30x40 inches. I use violet, ultramarine blue, Grumbacher red, and cadmium yellow light acrylics, and my usual full oil palette plus Shiva (oil) red crimson.

Arranging the composition

I set up a fairly balanced, simple composition which contains a whole range of textures and surfaces, from the smoothness of porcelain to the stronger patterns of the woven basket.

Toning and underpainting

It can be difficult to plan the temperature of a pink painting so that it does not become overwhelmingly warm. I therefore use reds that lean towards the cool side of the spectrum as well as cooler colors and in the background of this high-key painting.

To tone, I mix equal parts ultramarine blue and violet acrylic thinned with water. I cover the entire canvas using animated brushstrokes, creating a pleasing overall pattern. Then I mix equal parts Grumbacher red and cadmium yellow light to the above mixture for a good gray tone, which I use to broadly block-in the areas where the larger objects will appear.

I let the canvas dry, then mix ultramarine blue oil paint with turpentine to loosely sketch the shapes of the flowers and objects.

The flowers

I first block-in the roses with pure Shiva red crimson. This color isn't normally on my palette, but it is a beautiful red-violet that is perfect for this painting.

Next I add pure Indian yellow over the block-in mixture to obtain the color of the salmon-pink roses. I define the petals through my usual rose treatment of building grays and lights.

There are several other flowers in this still life, including several light pink mums and some white irises. One iris broke off while I was setting up, so in the photo you will see it stuck among the cherries, but in the final painting it appears in its proper position in the center of the flowers. That is artistic license!

The objects

I paint the silver coffeepot with equal parts of ultramarine blue, sap green, and a touch of alizarin crimson. I then add touches of pure cadmium red light and pure cerulean blue for reflected lights of objects surrounding the silver.

The violin is painted with equal parts Grumbacher red and sap green, and I add an equal amount of white for the light areas. For the crystal dish I use all the primary colors in equal parts to paint the cut-glass pattern, and for the cherries I use blue-violet tones consisting of equal amounts of ultramarine blue and Grumbacher red.

I paint the lemons with two parts Indian yellow grayed with one part Grumbacher red with a touch of sap green for the shadows and

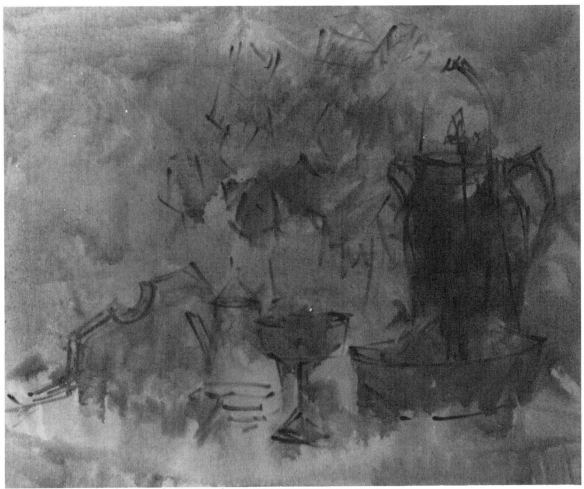

Step 2 *I block-in the shapes and start to indicate color and value over the toned canvas.*

Step 3 *I add detail to the flowers and block-in the rest of the objects.*

one part cadmium yellow and two parts white for the lights.

I paint the basket with one part cadmium orange and one part ultramarine blue in the shadows, adding one part cadmium yellow light and one-half part white for the light.

For the porcelain chocolate pot I use equal amounts of the three primaries, ultramarine blue, Grumbacher red and cadmium yellow light. White was added to adjust the value from dark to light; a tiny touch of cadmium yellow light was added to the light side.

Background

To compensate for the overall rosiness of this painting, I want to add more cool blue and blue-violet tones to the background. I mix four parts white with two parts ultramarine blue and a half part Grumbacher red. Occasionally, I add a half part cadmium yellow light to further vary the tones. I keep my brushstrokes free and loose, attempting to avoid a labored appearance.

The dark table edge is a strong compositional element. I paint this area with two parts ultramarine blue, a half part Grumbacher red, and a half part cadmium yellow light. For the folds of the cloth that hang over the edge I use two parts white and a quarter part cadmium red light.

The leaves

I only want to add a bit of dark around the lighter flowers with my leaves. The leaves are not important in this painting, so I indicate them in a very sketchy manner using two parts ultramarine blue and one part cadmium orange. I add touches of cadmium yellow light to this mixture to indicate a few highlights. To paint this type of leaf, I load my #18 bright brush with paint, use one stroke to make an almond-shaped leaf, then drag the tip of the brush straight back through the shape to suggest a center vein.

Final details

I add touches of sparkling highlights to the crystal with cerulean blue and white, and to the silver coffeepot with cadmium yellow light and white. I use my fingertips to put touches of white on the petals of the most strongly lit flowers, and I blend these highlights softly into the pink tones.

Pink Mood

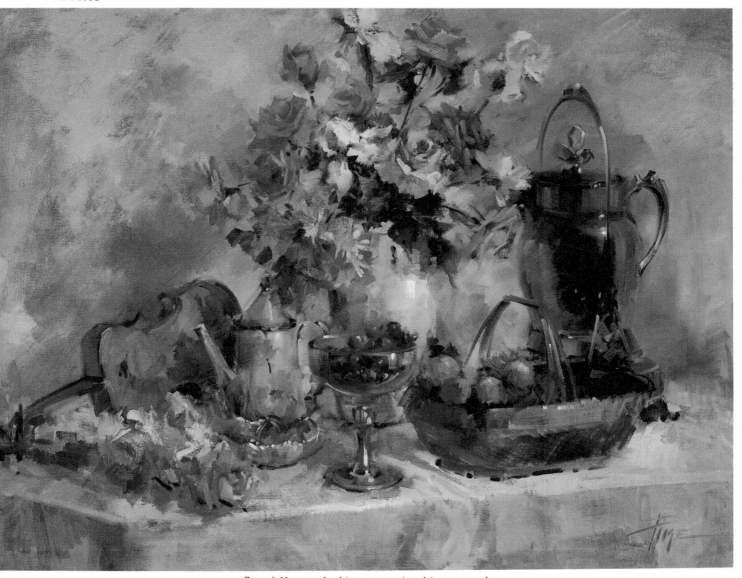

Step 4 *Now each object gets painted in greater detail. I lose and soften edges, indicating more detail around the focal point, and add highlights.*

Demonstration 5: Southern Comfort—Magnolias

When my neighbor's magnolia tree came into full bloom she graciously offered me these magnificent flowers to paint. As I placed the milky blossoms in a vase I naturally began to think about the southern region of our great country, where the fragile magnolia is a traditional flower. They are also plentiful in the West, but their image seems more romantic when surrounded by mint juleps and large plantations.

The magnolia is a regal beauty. However, once cut, the flowers darken and fall apart in a very short time. Therefore, I have to arrange my set-up and complete my painting quickly, or the opportunity will be lost.

Materials

My canvas is 36x24 inches. I use my full oil palette plus phthalocyanine blue.

Arranging the still life

I want to use still life objects that might be traditionally found in a lovely Southern lady's possession. I quickly gather some delicate props, including a lace handkerchief, a jewel box, and some rings. A clock is always a favorite item of mine to include, and I have a beautiful porcelain one that seems perfect for the mood I am trying to create. I add a bowl of lemons (which used to serve as an astringent and might well be found on a dressing table) for both visual balance and a touch of color.

Toning and underpainting

Quickly, as I don't want to lose time, I tone my canvas with a turpentine wash of phthalocyanine blue, viridian green, and cadmium red light. This color is a gray version of my blue dominant hue. I vary the value of the wash from midtone to dark. Using a large broad brush, I apply the paint thinly, allowing it to drip and flow. Then I blot some areas of the canvas with tissues to soak up the wash. In this way, I easily and quickly achieve a textured, animated surface. Then I strongly wipe-down the areas of highlight on the magnolia blossoms, revealing the white of the canvas. This ensures that my petals will be crisp in later stages of the painting.

The magnolia blossoms require careful drawing. Each flower has a unique shape and personality. The clock, jewel box, and fruit bowl must also be drawn with care, paying close attention to the perspective of each item. I use ultramarine blue to quickly establish the outside contours of the flowers and objects. Drawing on a slightly wet surface gives me better control of my brush as it flows much easier over a wet area. It also makes it possible to remove or correct a line by wiping it out.

The flowers and leaves

Now the all-important focal point must be secured. I choose to show the strongest contrast where the light petals and dark leaves come together near the center of the canvas. Because of that choice, I decide to emphasize the blossom in the center right of the canvas and play down the others. I mix a very dark color for the leaves using equal parts of ph-

thalocyanine blue, viridian green, and alizarin crimson. On a few leaves I add equal parts cadmium orange and cadmium yellow light. Other leaves get just a touch more alizarin crimson for a slightly reddish tone.

I mix one part phthalocyanine blue, a half part cadmium orange, and one half part white for the shadows of the magnolias. Cadmium yellow light, cadmium red light, and white mixed in equal amounts are used for the lights. I blend these carefully to show the petallike softness of each flower.

The objects

The fruit bowl is also in the dominant hue, but I change the blue to a blue-violet with two parts ultramarine blue, one part Grumbacher red, and white. I add white to this mixture to slightly vary the value, adding a bit of texture to the bowl. The lemons in the bowl are a mixture of equal parts cadmium yellow light, cadmium orange, and a touch of viridian green for the shadow areas. I keep the color slightly warm in the shadow areas. In the light areas I use cadmium yellow light with a touch of cerulean blue.

The clock is in shadow, so I use a violet-gray for its main color. I mix equal parts ultramarine blue, cadmium red light, and white to block-in the entire clock except for the face, on which I use white and grays. I only allow a few spots of light to catch the edge of the clock and the face. Here I use two parts white, one part cadmium red light, and a touch of sap green. The hands and numbers on the face are barely visible, so I simply indicate their presence with a few strokes of black. I use more contrast on the shadow side of the clock that is silhouetted against the light blue background.

The jewel box is equal parts sap green and cadmium red light in the shadow areas, with a touch of cadmium yellow light and white for the highlights. The rings and handkerchief are painted with previously mixed grays like puffs of smoke—swift brushstrokes of white and cadmium yellow light that simply glaze over the surface of the canvas.

Step 1 *I block-in the darks and background tones, sketch-in the flowers and objects, and then wipe-down for the lights.*

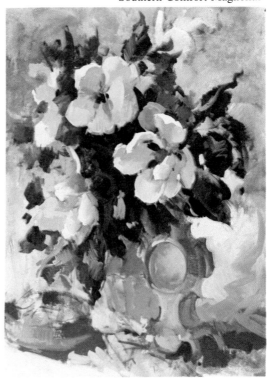

Step 2 *The dark mass of leaves against the pale petals is the focal point. I also begin to model the clock.*

Background

Phthalocyanine blue is a very strong pigment and should be handled carefully. I know I need to add white to cut its intensity, but I don't want the background color to become too light or the blossoms would lose importance. I therefore mix two parts phthalocyanine blue and one part viridian green with a half part cadmium red light and a small amount of white. I keep my background brushstrokes soft and indistinct.

Final details

The leaves seen against the light background need a few touches of highlights, and for this I use a half part white and one part cerulean blue. The highlights on the clock and jewel box are two parts cadmium yellow light, a half part cerulean blue, and one part white. The tone highlight visible on the vase is cadmium yellow light.

The last detail is to reestablish the lights on the blossoms with touches of white, especially around the focal point.

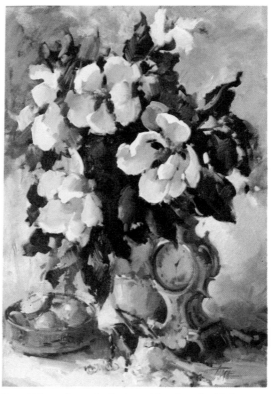

Step 3 *I work on the fruit and bowl and add the delicate objects. I finish the painting with shadows in the magnolia petals and highlights.*

Demonstration 6: Early Americana

The key to this painting is color. I want to use all the warm reds and oranges that are typical of an American Indian theme, yet I don't want to take a standard approach. I therefore pick violet as my dominant hue, to give the painting an extra sense of drama and depth of color.

Materials

My canvas is 24x36 inches. I need Grumbacher red, cadmium yellow light, ultramarine blue, violet acrylics, and also a full oil palette.

Arranging the still life

I often spend longer planning and arranging a still life than actually painting it. I want to be sure that I have set up a pleasing pattern of lights and darks and a good visual balance of color before I begin; otherwise I will not be happy with the results.

In this still life, it is exciting to bring together the many diverse items. The Navajo rug belongs to one of my students, the jewelry is mine, and the caribou hide is a recent purchase from Norway. Those three elements are my starting point, and I gather dried corn, baskets, onions, and other items to support my Indian theme. The brilliant red poppies bring out the spirit as well as the warm colors of this floral still life.

Toning and underpainting

I tone the canvas in acrylic with an initial wash of thin ultramarine blue, Grumbacher red, and cadmium yellow light. Then I use those same colors plus violet to do a more concentrated underpainting. I add bright red washes to the areas where the poppies and the onions will appear. I also indicate the begin-

nings of pattern on the rug. I flood the left side of the canvas with two parts cadmium yellow light grayed slightly with a touch of red and a touch of blue. Then I mix a strong dark from the same three colors for the background in the center of the canvas using one part cadmium yellow light, two parts cadmium red light, and three parts ultramarine blue.

Once the canvas is dry, I can begin my sketch in oil. Because I have indicated so much in the underpainting I only need to draw the outside shapes of a few items, using ultramarine blue thinned with turpentine.

The flowers and leaves

I begin by blocking-in separate poppies with pure Grumbacher red, cadmium red light, and cadmium orange. Gray tones will be added later. I also incorporate cadmium yellow in several blossoms for a more orange tone. The centers of the poppies are ivory black. Highlights are either one part Matisson pink and two parts white or one part cadmium yellow and two parts white, depending on the undercolor. The big poppies are easy to complete in broad, direct brushstrokes.

The objects

I want the onions to be bright but not quite as brilliant as the poppies. I block-in the purple onions with pure cobalt violet (Bellini), adding a half part cadmium red light to warm the tone where the onions turn toward the light. I paint the brown onion using one part cadmium red light and a quarter part phthalocyanine yellow-green. I add one part cadmium orange and a quarter part white to the side struck by light. The highlight on the white onion is a quarter part cadmium yellow light and one part white. With white highlights, I indicate the crackly texture of the onionskins.

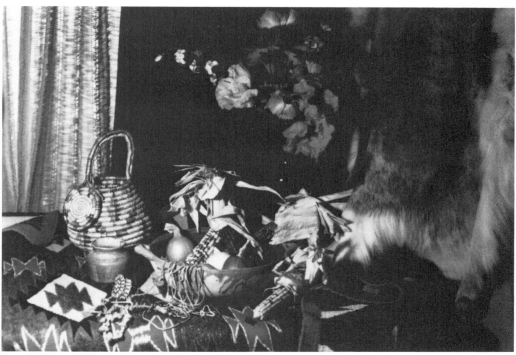

Step 1 *This still life has warmth in both color and subject matter.*

The clay pot is painted with cadmium red light grayed with a touch of sap green. I darken the inside by adding cobalt violet (Bellini). The lights around the rim are created by blending white into the clay color.

The pot holding the poppies is ivory black grayed with white for the light side. Next, using equal parts cadmium red light, phthalocyanine yellow-green, and cadmium yellow light, I block-in the corn that can barely be seen in the clay bowl. I block-in the ear outside the pot using a yellower tone. The kernels are indicated with short, choppy brushstrokes in the clay color. I add a few black kernels for texture and reality. The corn husks are one part cadmium yellow light, two parts white, and a tiny touch of cobalt violet. When painting the husks, I really let my brushstrokes be bold and direct, skimming bursts of light over the area above the onions.

The turquoise jewelry is painted with a mixture of equal parts of cerulean blue and viridian green. I add a touch of ultramarine blue for the shadow areas and a small amount of white for the small spots of light. The small blue pot balances the strength of the turquoise bracelet. I mix equal parts of ultramarine blue and cadmium red light for its shadow side, and two parts cerulean blue and one part white for its light side.

My treatment of the basket here is quite pointillistic: I use dabs of all three primaries to build up a woven surface. I only blend where the right side of the basket is softened into the background.

The pattern in the Navajo rug is very strong, so I want to suggest only its colors and motifs. I begin with a soft blue-gray color mixed from two parts ultramarine blue, one part cadmium red light, and a half part cadmium yellow light. Then I indicate pattern with a combination of separate pure colors—Grumbacher red, ivory black, and cadmium red light.

Background

Because of the strength of my initial toning and underpainting, I don't feel I need to add more to the background.

Final details

I put strong white highlights on the vase, the small blue pot, and the rim of the clay pot. I highlight some of the beads with Matisson pink and make the turquoise sparkle with white dots.

Step 2 *I block-in the shapes in masses of color and value, avoiding detail.*

Step 3 *I paint the fruit, basket, and rug pattern.*

Step 4 *I both intensify color and gray shadow areas where necessary.*

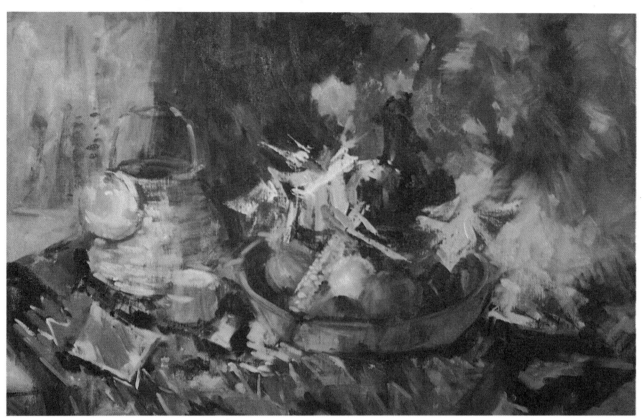

Step 5 *Finally, I add sparkling highlights.*

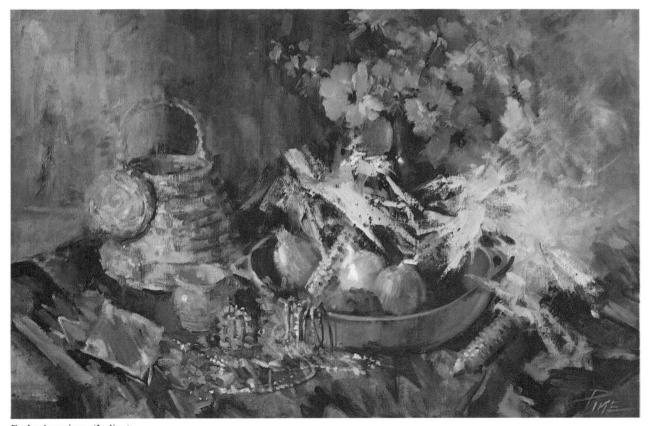

Early American (Indian)

Demonstration 7: Family Heirloom

Painting a commission can be either a pleasure or a difficult chore depending on the flexibility of your client. *Family Heirloom* turned out to be even more enjoyable than I had anticipated. I was asked to paint the antique clock, a treasured object that had been in the client's family for some time. A bit more exploration uncovered that the father had a hobby of growing chrysanthemums, and so it would have been far less meaningful to compose this painting with any other flower.

Materials

I use fine-textured linen for this 30 x 40 inch canvas. My acrylic palette is composed of cadmium yellow light, phthalocyanine blue, Grumbacher red, and violet.

Arranging the still life

The clock is, naturally, the most important feature of this still life. I want the rest of the composition to enhance the warmth of the clock and flowers. I add the bowl of fruit mainly for balance.

Toning and underpainting

I begin toning the canvas with an acrylic mixture of all three primaries—Grumbacher red, phthalocyanine blue, and cadmium yellow light. Then I go back and indicate the placement of the objects, using stronger intensities of the colors. I allow the canvas to dry.

Next using oil, I sketch-in the clock, fruit bowl, and vase with ultramarine blue and turpentine. I pay special attention to the perspective of each object, making sure the ellipses are correct.

The Flowers and leaves

I block-in each individual flower using a midtone gray. For the dark purple mums in shadow I use equal parts ultramarine blue, Grumbacher red, and a tiny touch of sap green. The sap green grays the strong violet tones a

little. Next I use the same mixture to block-in the shadow side of the clock. (I often use the same colors on several objects within a painting to increase color harmony.)

The pink mums in shadow are two parts alizarin crimson and a half part cerulean blue grayed with a tiny touch of cadmium yellow light. The white mums are a half part cadmium red light, a half part sap green, and three parts white for those in shadow. I vary these grays to create midtones, keeping the centers of the flowers dark.

The leaves serve mainly to reestablish the focal area around the white mums. I mix equal parts sap green with ultramarine blue and a touch of Grumbacher red for the block-in. Then I add some leaves in the light with equal parts cerulean blue mixed with cadmium orange and a touch of white.

The fruit

I block-in the pieces of fruit in the large bowl using pure alizarin crimson for the red grapes, Grumbacher red for the apples, and cadmium yellow for the pale grapes. Next I add some sap green to each of those colors and I paint the grayer shadow tones. I use a tissue to wipe-down the areas of fruit that need strong highlights. I darken a few of the areas in deep shadow with a mixture of equal parts of ultramarine blue and equal parts of cadmium red light.

The pomegranate begins with the violet underpainting already on the canvas. The shadow side of the fruit is a mixture of equal parts of cadmium red light, sap green, and cobalt violet with a touch of white. I use that same color to block-in the front of the clock. Next, I indicate the pomegranate membrane with white and a tiny touch of cadmium yellow light. Alizarin crimson provides the juicy color of the seeds.

The objects

I begin the brass bowl with equal parts of cadmium orange, phthalocyanine yellow-green, and cobalt violet for the slightly gray shadow side. I want the bowl to be more of a yellow-orange (an adjacent hue) than a brass color, so I use a mixture of equal amounts of cadmium orange and cadmium yellow light

for the light-struck side.

I have already blocked-in the clock with both shadow and light tones; the details will be understated. I block-in the dark vase, barely seen behind the clock, using two parts ultramarine blue and one part cadmium red light. Then I wipe-down the highlight area with a tissue and add a subtle touch of cadmium yellow light and white.

Background

I want the background tones to be in the dominant hue of orange, toned with both adjacent hues of cadmium yellow and cadmium red and grayed with the complement, cerulean blue. On the left side I use a bit more cerulean blue and white, and throughout I let areas of the initial underpainting show through. For the tablecloth, I add more yellow and white, varying my brushstrokes to suggest the folds in the fabric.

Final details

I now paint the petals on the pink mums using equal parts of Matisson pink and white. The white mums are white with a touch of cadmium yellow light. The previously applied block-in tones are enough to slightly gray the petal strokes.

Lastly, I add some reflected lights and highlights. I use cerulean blue, cobalt violet, and white throughout. On the clock, the violet highlight is mixed from alizarin crimson, cobalt violet, and white. All the fruit except the apples get highlights of cadmium yellow light and white. For the apples I use Matisson pink and white.

Step 1 *I tone the canvas, at the same time suggesting shapes and dark patterns.*

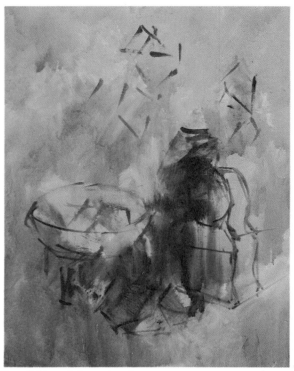

Step 2 *Next, I draw the objects in perspective.*

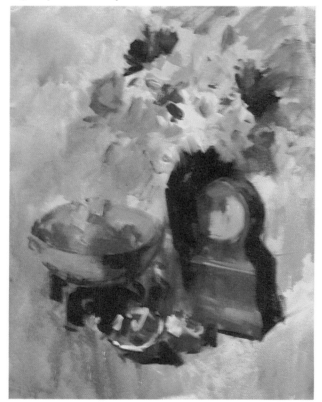

Step 3 *I add the dark and light pattern, building form and securing color harmony.*

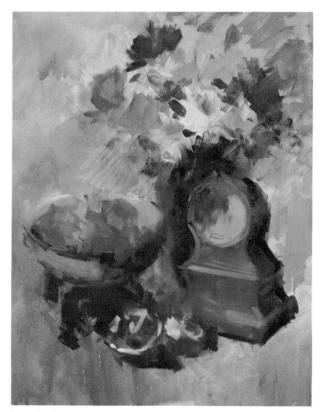

Step 4 *I begin to add detail, losing and finding edges as I progress.*

Family Heirloom

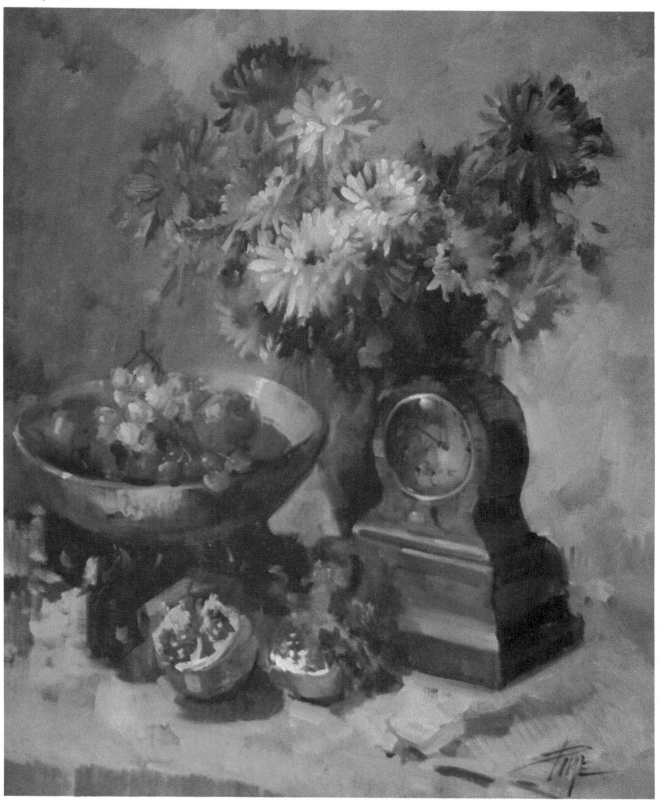

Step 5 *In the final steps I paint both shadows and highlights.*

Demonstration 8: Old Lace

I want this painting to evoke the feeling that someone has just left the table for a moment, where she has been sitting in the warm light, sipping elderberry wine, eating a nectarine, and reading.

This sense of reality adds another dimension to a traditional still life. The painting tells a story and therefore involves the viewer in more than just a visual way.

Materials

My canvas is 40 x 30 inches. I use Grumbacher red, cadmium red light, phthalocyanine blue, cerulean blue, cadmium yellow light, violet acrylic, and also a full oil palette. I will also use some off-white spray enamel.

Arranging the still life

To set the mood of the painting I decide to use a variety of items that have a woven or lacy look. The tablecloth is obviously the "old lace" of the title, but the wicker chair, the woven curtains, and even the ornate picture frame all have the same delicate airy feeling and texture.

The light, coming from a north window, seeps through all the textured fabrics and gives the overall composition a shimmering, pale radiance. The light is cool, which makes all the shadows, especially in the flowers, seem warm.

The rest of the still life creates a dark and light pattern on which to focus amid all the lace. The colors of the wine and fruit balance the tones in the flowers, which are quite strong in contrast to the white lace.

Toning and underpainting

The dominant hue for this painting is orange, so although I begin by using all three acrylic primaries for my beginning washes, I am careful not to stray too much toward the complement (blue). I keep the underpainting colors pure, with few areas of gray except the on-shadow side of the tablecloth, and I loosely indicate the placement of shapes and objects. I keep my brushstrokes large and free, allowing the washes to drip and blend into each other.

When the canvas is completely dry, I sketch-in the outlines and objects in oil with ultramarine blue and turpentine.

The flowers

Because the flowers are lit from behind, they appear in shadow from the front, so I gray all my tones rather than use pure color. The dark pink roses are one part alizarin crimson and a half part phthalocyanine yellow green. The white roses and daisies are a mixture of one part ultramarine blue, about three-quarters part cadmium orange and a touch of violet. This establishes the dark values, most of which is

wiped out with tissue before the lights are added. The irises are ultramarine blue, alizarin crimson, and a bit of phthalocyanine yellow-green. I add a touch of white to all of the above mixtures to give each flower subtle lights, but I use discretion and keep the strong lights mainly toward the edges, where the flowers are struck by the backlight.

The leaves

I want the leaves to be quite dark, especially around the daisies, so I mix two parts ultramarine blue, two parts sap green, and one part alizarin crimson for an almost black color. For contrast within the dark leaves I add touches of cadmium orange. To paint the leaves actually in light I use equal parts cerulean blue, cadmium orange, and white.

The fruit

I block-in the fruit, except for the cut nectarine, using the same tones I used for the flowers. For the nectarine I mix equal parts of Grumbacher red and cadmium yellow light for a brighter tone, varying the color either toward the yellow or the red for the inside and the skin.

The objects

To block-in the decanter where it is filled with deep burgundy wine, I use equal parts of ultramarine blue and alizarin crimson. I lightly indicate the rest of the shape with a gray highlighted with cerulean blue. The wine glass is painted in the same way.

I block-in the fruit compote and the plate with equal parts ultramarine blue and cadmium red light. For the picture frame I use an equal parts mixture of sap green and cadmium orange. I merely indicate the portraits in the frame with a few strokes of gray, and I highlight the shadows of the frame with ultramarine blue.

The lace

The area of the tablecloth still only has the dry acrylic background toning. To achieve the pattern on the tablecloth, I use my special transfer method. I take the painting outside and lay it on the ground. I block off all areas except the tablecloth with newspaper; then I cover the painting with an actual lace cloth. I spray the area with quick-drying off-white enamel. This dries in about ten minutes and gives me a fine lace pattern. I later soften the pattern by scumbling-in areas of whites and grays.

For the shadow side of the cloth I mix equal parts ultramarine blue, cadmium red light, and white. I vary the tone by adding equal parts of cerulean blue and white or equal parts cadmium orange and white. I block-in the chair and Bible at the same time. The cool lights of both the chair and the cloth are tiny touches of alizarin crimson and white.

Background

The dramatic light from the window—two parts cerulean blue, one part cobalt violet, and four parts white—is an important part of my composition, and I reinforce the soft green and violet underpainting tones with similar layers of oil, adding more white to increase the feeling of light. For the drapes, I mix equal parts viridian green, cerulean blue, and cobalt violet. I let the underpainting show through to give the feeling of woven pattern. I also use the drapery color to define the gilt-edged book pages. Shadows are treated with areas of cadmium red light and sap green.

Final details

I add touches of bright color to highlight the edges of the flowers. I mix equal parts cerulean blue and white for the highlights on the fruit, and equal parts viridian green and violet for the reflected lights around the crystal plate. With touches of almost pure white applied in short, small brushstrokes, I highlight the wicker pattern in the chair.

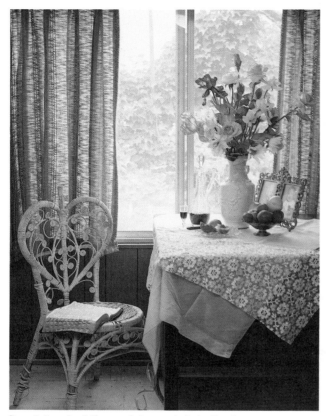

Step 1 *I make full use of the north light flooding through all the open-weave textures.*

Step 2 *I tone the canvas with thin washes of brilliant pure color.*

Step 3 *Next I sketch-in all the objects in perspective.*

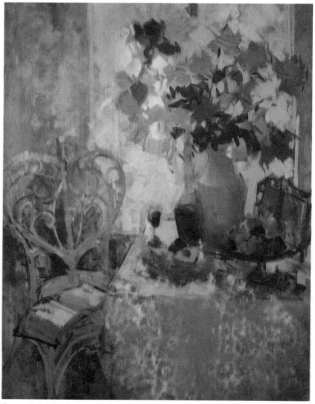

Step 4 *I block-in all the darks, lights, and midtones. Then I spray the lace pattern.*

Old Lace

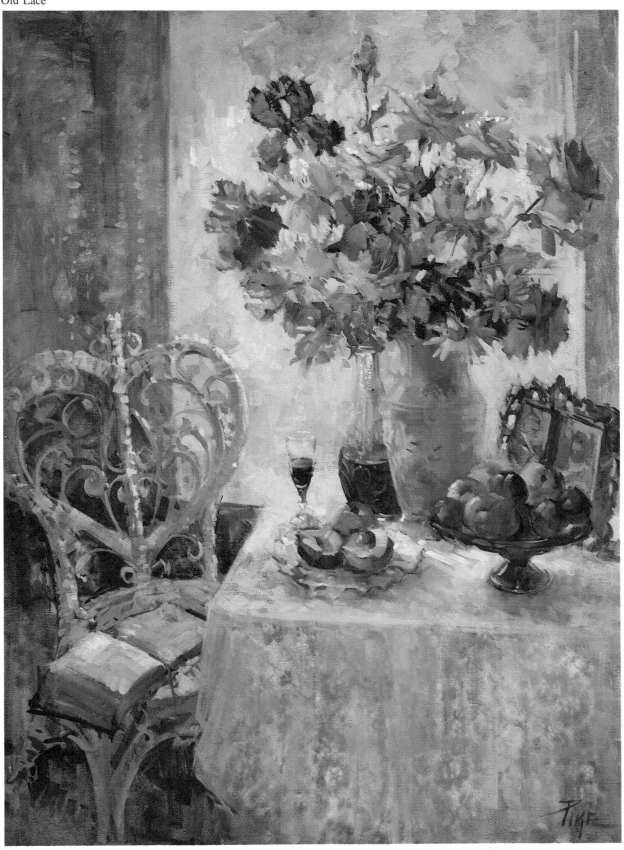

Step 5 *Now I add details and highlights as needed throughout the picture.*

Step 1 *The basket and vase simply support the fresh, blooming roses.*

Demonstration 9: Yellow Roses

Inspiration sometimes occurs in a completely spontaneous way, and it is often then that I do my best work. This painting of yellow roses was inspired in just such a way. I had finished teaching one of my classes when a student went to her car and returned with a big bucket overflowing with damp, fresh, yellow roses from her garden.

I set to work quickly and felt as if someone had given me a time limit. The flowers were so lovely that other objects weren't needed in the still life, so I simply selected a few containers for the flowers and began to paint.

Materials

My canvas is 30 x 24 inches, and I use a full oil palette.

Toning and underpainting

I want the painting to reflect the spontaneity of the arrangement, so I proceed with an underpainting of oil on white canvas. Using Indian yellow and turpentine I begin to block-in the area of the yellow roses. Then I mix ultramarine blue, sap green, and a bit of cadmium red light to block-in the areas of the vase and basket.

For my background wash, I mix cerulean blue and white with the dark block-in color of the vase and basket. I use this blue-gray tone to cover the entire canvas, keeping my brushstrokes free and animated. I complete the underpainting by placing a slight tint of alizarin crimson in both the background and the flower area. Also, I place a bit of the flower tone in the background to ensure that the finished painting has color harmony.

Now I begin to establish the pattern of

Step 2 *I tone the canvas and begin to indicate darker form.*

Step 3 *The block-in quickly establishes the placement of the roses.*

Yellow Roses

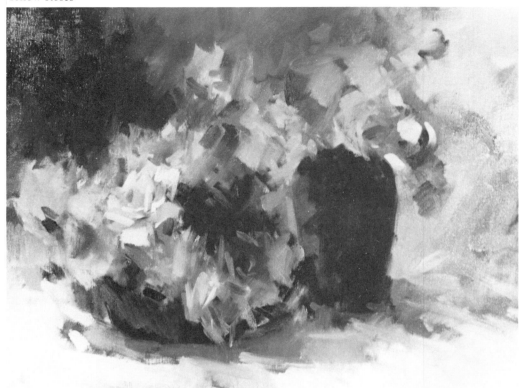

Step 4 *I strenghten the darks and begin adding shadows and lights to the flowers.*

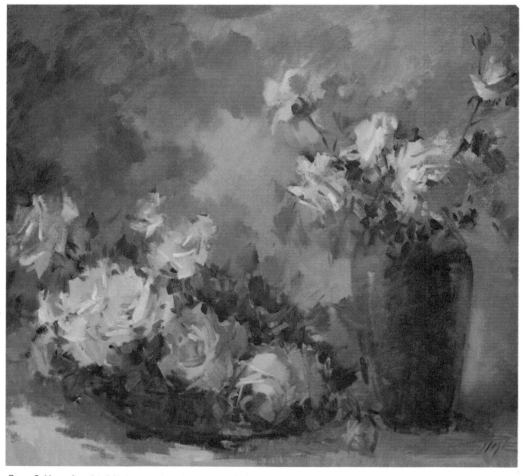

Step 5 *Very few highlights or details are needed for the results to look realistic.*

lights and darks in the composition. I use a more concentrated form of my dark block-in color to darken the vase and basket, adding touches of cerulean blue and cobalt violet to vary the tones.

The flowers

I still want to let the entire painting keep an overall feeling of an abstract pattern. I start to indicate the individual roses, using tones of one part cadmium yellow light and one part Indian yellow. I suggest darks with a mixture of a half part alizarin crimson and two parts Indian yellow. I wipe-down the areas of light with a tissue, thereby indicating the actual petal formation. Then I add white to the wiped-down petal edges and carefully blend the white into the yellow tones with my fingertip.

The leaves

I only want a vague leaf pattern. I begin with a dark mixture of equal parts of ultramarine blue, sap green, and a touch of alizarin crimson, and I bring just a few leaves into the light with equal parts cadmium orange and sap green.

Final details

Because here I am taking an impressionistic approach, very little detail is required to bring this floral still life to its finished state. I give the vase a touch of highlight, using a mixture of equal parts of phthalocyanine yellow-green and white. Then I place a few extra strokes of white on selected rose petal tips, and the painting is complete.

The feeling of accomplishment you can get by doing this type of spontaneous painting is tremendous, and the results are gratifying.

Demonstration 10: Pomegranates with Brass Teapot

I have always been fascinated by the art of losing and finding edges and shapes. The procedure is subtle and requires as much structural knowledge as a clear statement. Painting just a bare suggestion of form allows the viewer's imagination to complete the picture. You may find this a difficult act to do, particularly if you have just worked hard to define an object, but losing a few edges can be well worth the effort. The fruit in this painting is a good subject for practice.

Pomegranates are a favorite of mine. I even have the patience to eat them. As you know, pomegranates have many seeds that are coated with a delicious, juice-filled, burgundy outer skin. The seeds are compressed tightly into a ball and are separated by a white membrane. Be careful to cut through only the outer skin of the fruit, splitting the center open carefully. This will bring the pomegranate seeds into complete view without rupturing the skin and spilling the juice.

An orange, partially peeled, is a good compositional addition. The twisted rind helps to break up the roundness of all the objects. I also add a few grapes just to fill space and scatter a few pomegranate seeds on the table for interest. The brass teapot and cup is part of an antique set. The wooden bowl is simply a vehicle for holding the fruit. The apples will merely be suggested in the painting, giving the still life an almost vignetted appearance.

Materials

My canvas is 20x24 inches, and I use a full oil palette. The light source is warm and placed on the left-hand side.

Toning and underpainting

My dominant hue is red, so first I tone the canvas with an oil and turpentine wash of Grumbacher red and viridian green. This creates a soft gray tone. I keep my brushstrokes fairly even for an all-over pattern.

Sketching

I mix ultramarine blue and turpentine then carefully sketch the shape of each object. I add a plumb line and ellipses to the teapot and cup to help establish reasonably correct perspective. I also concentrate on the partially twisted peel as it winds away from the orange. I draw the pomegranates turning toward and away from the light source. Their fluted ends help indicate their direction. The grapes I draw only in contour.

The fruit

Each piece of fruit will be painted in a different degree of pure color or gray. I begin with the strongest red tones in the pomegranates, using pure Grumbacher red and gradually graying the fruit by adding ultramarine blue and alizarin crimson to the shadow side.

I paint the orange with cadmium orange and a touch of sap green for shadow of the rind and use a stronger concentration of cadmium orange where the fruit turns toward the light. The orange peel membrane in shadow is a half part ultramarine blue, a half part cadmium orange, and four parts white—and where the light gradually increases, I add more cadmium orange and lots of white. To give a subtle suggestion of the orange barely seen behind the fruit bowl, I use the same mixture but lose the edges into the shadows. I add cast-shadow grays where necessary but soften the intensity of colors and values.

The pomegranates are the most important fruit in the arrangement and also provide the focal point. I paint more detail in the cut pomegranate near the center of the canvas. The persimmons are a bright red-orange, which I achieve by using cadmium red light and a touch of alizarin crimson for the shadow areas and cadmium red light and cadmium orange for the lights. The apples are warm—I use phthalocyanine yellow-green and a touch of cadmium red light for the shadows and add cadmium yellow light for the lights. I paint the grapes with Grumbacher red and a touch of sap green, and to go darker between the grapes, I add a bit of ultramarine blue. Then I wipe-down spots where the lights will go on a few grapes.

The objects

The teapot and brass cup are greenish in tone. I mix one part sap green, a quarter part alizarin crimson, and a quarter part ultramarine blue to block-in the shadow areas. Then to the same mix I use one part cadmium yellow light and a touch of white for the light-struck

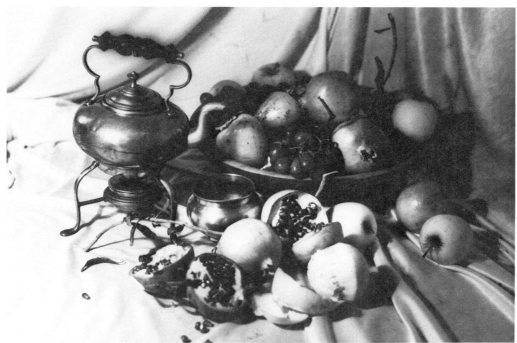

Step 1 *Pomegranates, apples, oranges, grapes, and persimmons give an abundant feeling to the still life.*

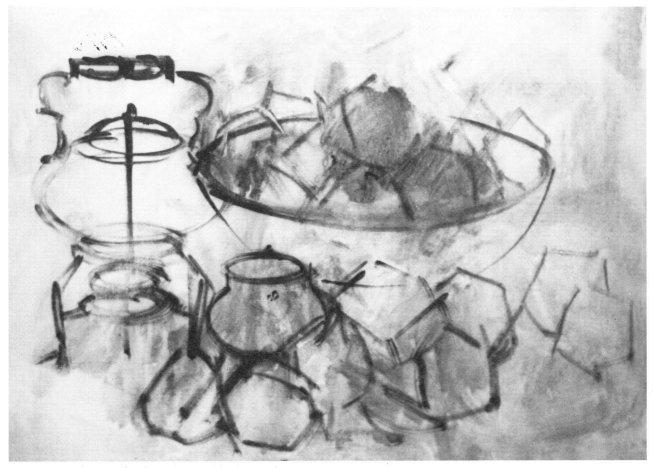

Step 2 *I complete my sketch on the toned background.*

side to gradually darken the value as the pot turns into the background. I vary the hues of the pot and the cup by going a bit more toward the warm tones on the brass, using cadmium red light.

The wooden fruit bowl is a warm red tone. I use equal parts cadmium red light and sap green for the shadow areas, adding white for the light rim. I want to allow the bowl to merge into the background.

Background

I previously toned the canvas with an oil wash, and now I use the same combination of two parts Grumbacher red and one part viridian green, with three parts white added, to cover the background. I carve-in around the outside edges of the objects and fruit, defining and losing edges. Then I bring the tablecloth up to a lighter value by adding white.

Casting shadows

Now I add the reflected lights and cast shadows. I paint the shadows with equal parts cadmium red light and ultramarine blue and intensify the gray tone in some areas with a touch of cadmium yellow light.

The reflected lights are one part cerulean blue, a touch of alizarin crimson, and one part white. I warm the areas where the tablecloth reflects into the fruit by adding a touch of cadmium orange.

Final details

The process of losing and finding edges is best accomplished with a #30 Langnickel Royal bright brush. I hold the brush so the tip can softly blend and merge the edge values of the object into the background tones. Sometimes I find it necessary to go back and re-state an edge for definition. That is why this procedure is referred to as losing and finding.

Highlights are subtle, so I won't want to make them too bright. A touch of Matisson pink and white is perfect for the highlights on all the fruit; I use my fingertip to gently soften each one. Cadmium yellow light and white is the highlight color for the teapot and cup.

With a middle-value dark of equal parts of cadmium red light and sap green, I just suggest a handle on the teapot. I also add a stem to the pomegranates that protrude from the fruit bowl. A bit of stem and a few leaves connect the pomegranates near the bottom of the canvas. These I paint using equal parts sap green, cerulean blue, and a touch of white.

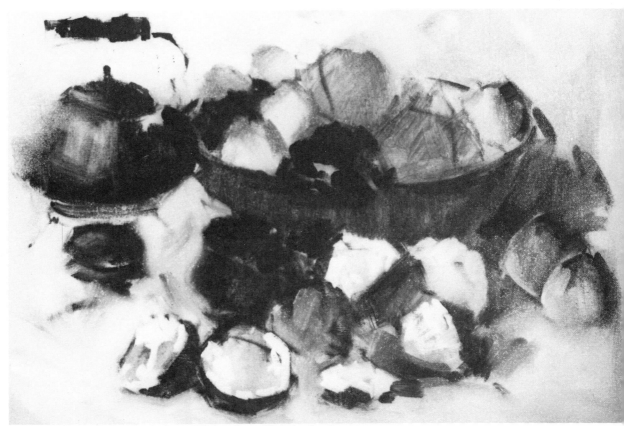

Step 3 *By placing the darks and lights, I establish the focal point.*

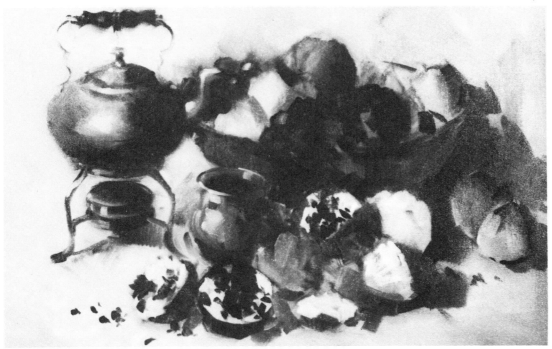

Step 4 *Details, such as the pomegranate seeds and the brass teapot, are next.*

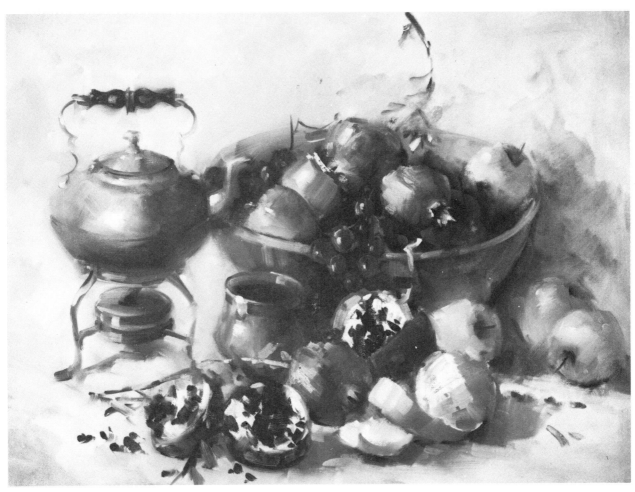

Step 5 *Brushy highlights combine with shadows softened into the background.*

Demonstration 11: Camaraderie

The subject matter for a still life painting does not have to stay within the traditional boundaries of flowers and china, as these two pals aptly demonstrate. The dolls are made by my friend and fellow artist Dorothy Judd, and I often include them in my paintings.

Materials

My canvas is 40x30 inches. I use Grumbacher red, phthalocyanine blue, cadmium yellow light acrylics, and a full oil palette.

Arranging the still life

I want to create a cozy feeling of conversation between the two dolls, but also my primary concern is compositional balance. I plan a low-key, warm painting with the focal point on the left-hand doll, where her apron meets her dress. Once these factors have been established, it is easy to proceed with adding color. One doll's hair is red, the other's is warm brown, and the chair is reddish, so I make the dominant hue a red-orange.

Toning and underpainting

I tone the canvas with a thin mixture of equal parts of Grumbacher red and phthalocyanine blue acrylic, and I add a few spots of cadmium yellow light, as well, for a definite gray. Because the background will need to show through small areas of the chair, I decide to finish my background tone at this initial stage. I use a blue-green oil mixture (the complement) mixed from one part ultramarine blue and a half part cadmium yellow light. I keep my brushstrokes loose and aim for a modelled effect.

Next I block-in the basic light and dark shapes. This is a simple composition so I don't feel the need for an actual line drawing. I begin with the aprons, using a mixture of white, adding only a tiny touch of cadmium red light, and a tiny touch of cadmium yellow light. For the shadow tones I add a touch of ultramarine blue to the above mixture. I indicate the stockings and pantaloons at the same time.

I paint the dress on the left-hand doll in a dark blue-green. I block-in the chair with cadmium red light, ultramarine blue, and white, keeping the overall effect sketchy and unblended.

Step 1 *Painting dolls or any stuffed toy is a great way to learn to create form—your model doesn't move.*

Step 2 *I establish the shapes with color and value rather than with line.*

The dolls

The hands and faces of the dolls are pale but orange in tone. I use equal amounts of white with cadmium orange for the light areas, adding a touch of ultramarine blue and touches of cadmium red light where the faces turn into shadow. I slightly vary the flesh tones in the light with equal parts cadmium orange and phthalocyanine yellow-green. The noses are painted in the same tones. I want to have the feeling of roundness and dimension.

The doll on the right has brown hair and blue eyes; the one on the left has red hair and brown eyes. I use equal parts Grumbacher red and sap green for the hair on both dolls, adding a touch of cadmium orange and white where the braid on the left comes into the light. A bit of pink enhances the cheeks. I use cerulean blue to paint the blue eyes and dark brown to mark the pupils, freckles, and mouths.

The doll on the right has a pale, red-orange, flower-sprigged dress—I use two parts cadmium red light and one part white, adding a touch of sap green for the shadow

tones. I indicate the pattern on the other dress with bits of cadmium red light and phthalocyanine yellow-green.

Final details

I paint the hair bows and shoes in ivory black. I model the chair using cadmium red light, ultramarine blue, and white, softening the edges into the background where the chair recedes in space. I also soften the edges of the dolls' apron and hair.

Step 3 *I secure the midtones and begin to indicate features such as the chair.*

Dolls Camaraderie

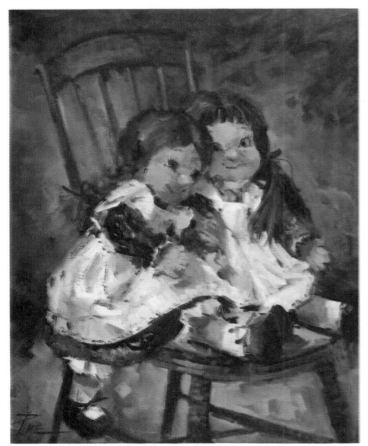

Step 4 *I add details and color with direct unblended brushstrokes.*

Demonstration 12: Sunday Morning

My collection of antique clocks shows up again and again in my still life paintings. The beautiful hand-painted porcelain clock on the left was the inspiration for this entire painting, although the title came from my decision to begin the painting while having coffee and enjoying the ocean view early one Sunday morning.

Materials

My canvas is 30x24 inches. I use cerulean blue, cadmium yellow light, Grumbacher red, cadmium red light acrylics, and also a full oil palette.

Arranging the still life

Although the clock is the focus of my painting I decide to place it toward the rear of the composition. Otherwise, it would be too dominant. I choose all the other elements—flowers and objects—to add color. I want a warm, high-key painting, with an orange dominant hue. So, the entire composition will be in tones of yellow, pink, salmon, and orange, with touches of cerulean blue and violet.

Toning and underpainting

My initial acrylic wash is in tones of Grumbacher red, cerulean blue, and cadmium yellow light. I keep the colors pure and brilliant rather than mix them to an all-over gray. I allow the canvas to dry, then block-in the flowers and vase with ultramarine blue oil paint. Next I sketch-in the outlines of the clock and other objects, making sure my perspective is convincing.

The flowers and leaves

For the flowers I use pure cadmium red light, cadmium orange, cadmium yellow light, and, of course, white. A tiny touch of each color and white is added to each flower in the light. To gray a flower I use a quarter part cerulean blue for the red, a quarter part cobalt violet for the yellow and a quarter part ultramarine blue for the orange. I use short, brushy strokes to directly indicate the petals without too much modelling. Then I add the dark of the leaves (securing the focal point) with equal parts of sap green, ultramarine blue, and a touch of alizarin crimson.

The objects

I block-in the vase and the dish at the left of the canvas with equal parts of alizarin crimson and sap green, softened with cadmium orange and white. For the inside of the dish I use equal parts cadmium orange, ultramarine blue, and white in varied amounts as necessary.

The clock is a soft gray-pink: I mix one part Grumbacher red, a quarter part sap green, and one part white for the shadow side and Grumbacher red with cadmium yellow light and white for the lighter tones. I use even more white on the curve of the left side.

I begin to paint the oranges using one part Grumbacher red, one part cadmium orange,

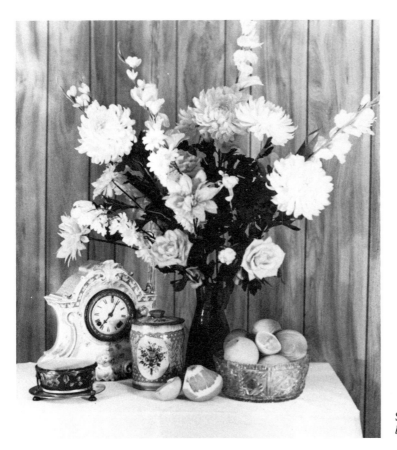

Step 1 *The objects are arranged harmoniously— both for size and shape—around a favorite clock.*

Step 2 *I tone the canvas, establishing an abstract pattern of light and dark.*

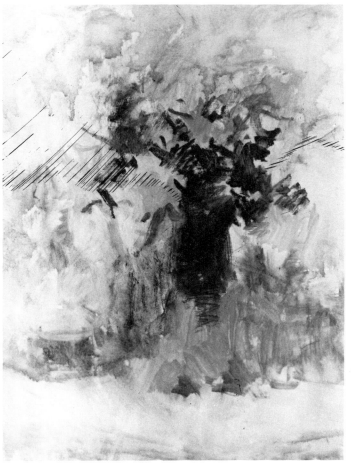

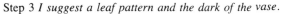

Step 3 *I suggest a leaf pattern and the dark of the vase.*

Step 4 *The sketch of the objects shows correct perspective.*

and a touch of cobalt violet. I add a half part phthalocyanine yellow-green to that color for the shadows. I paint the cut lemons with one part phthalocyanine yellow-green, adding a quarter part cadmium red light in the shadow areas and one part cadmium yellow light on the lighter sides. For the cut orange I use one part cadmium red light mixed with a half part sap green for the shadows; the membrane is cadmium orange, ultramarine blue, and white in shadow, and almost pure white in the light. I merely suggest the cut crystal dish using short strokes of shadow gray and white over the orange fruit.

The tin candy dish is painted with one part ultramarine blue and a half part cobalt violet, and I add touches of cerulean blue and white to the light side. I paint the center design in one part cadmium orange, a half part ultramarine blue, and two parts white.

Background

For the background I mix a pale gray from ultramarine blue and orange with plenty of white. I add Grumbacher red to this mixture for a pinker tone on the tablecloth. Then I strengthen and gray that tone for the shadow side of the cloth with the addition of a touch of ultramarine blue.

Final details

I create varied tones in the flowers with Grumbacher red, cadmium red light, cadmium orange, and cadmium yellow light—all applied as bits of pure color. I feel that using gray is not necessary. The highlights on the flowers and objects are pure color with the addition of white. The features on the clock are an understated soft gray (see pages 148 and 149).

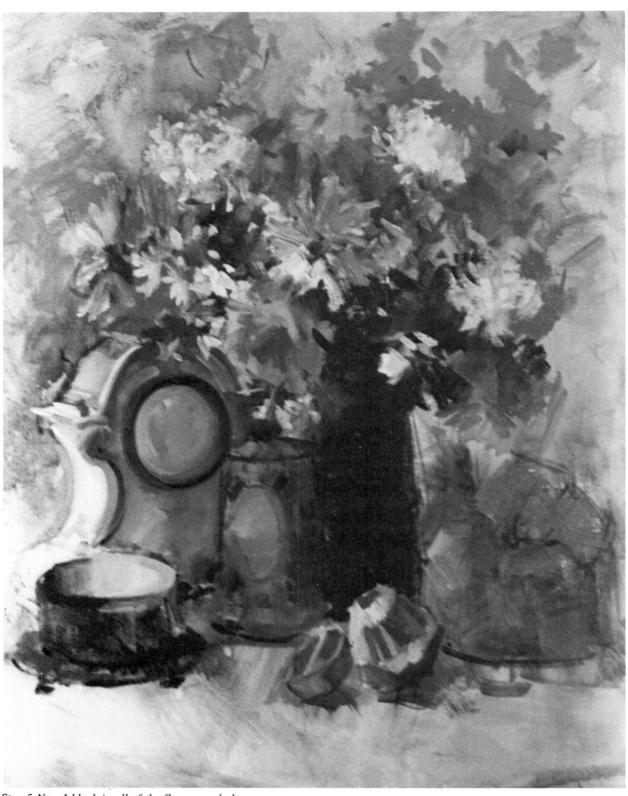

Step 5 *Now I block-in all of the flowers and objects, establishing both color and value.*

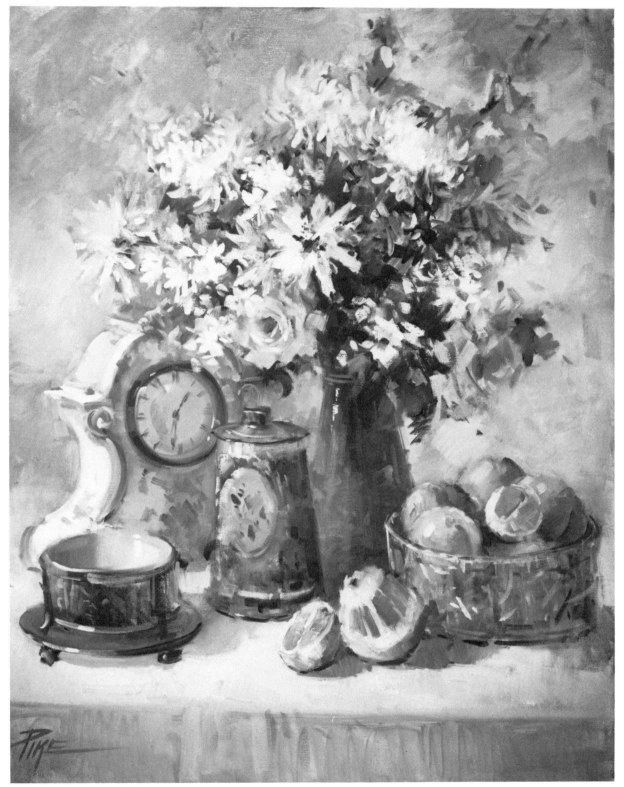

Step 6 *The final step is to lose and find the edges, and secure the focal point.*

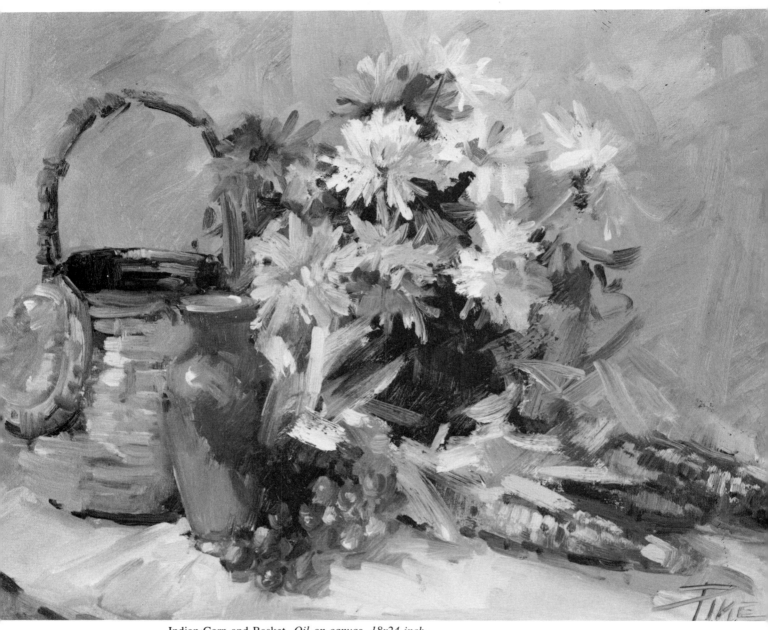

Indian Corn and Basket *Oil on canvas. 18x24 inches. Indian corn is a great addition to a still-life painting. The husks are graceful and add a beautiful pattern of light. This painting was set up one afternoon after class. I often finish a hard day of teaching by doing a painting of my own. I am already at an emotional high, and I often do my best work under these conditions. In addition to the corn, the articles used in this painting are all objects I enjoy painting and which appear in many of my arrangements. The blue vase, for example, is one of my garage sale treasures. It adds a touch of complementary color to the pure warm oranges and reds in the corn basket and the flowers, which set the tone in this painting.*

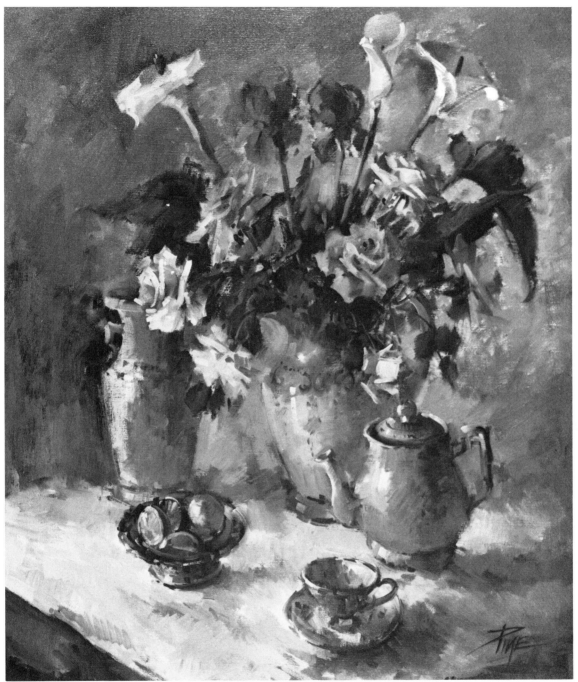

Tea Time *Oil on canvas, 36x30 inches. A beautiful Saturday morning without teaching or lecturing assignments means I can paint. Tea Time was painted on just such a morning. I had finished a commission the night before and still had fresh flowers that I felt just couldn't go to waste. I selected familiar objects to surround the blue pitcher holding the flowers. The pitcher is my strongest area of color; all the other porcelain objects are played down both in color and detail. The background tones and cast shadows are direct brushstrokes with very little blending. The dark and light pattern keeps the eye moving through the mainly blue-violet and blue-gray canvas.*

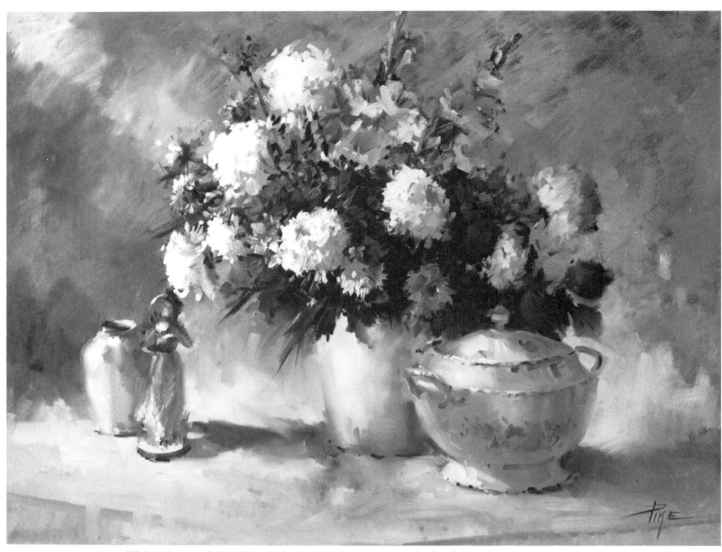

White Mums and Porcelain *Oil on canvas, 24x36 inches. Props can easily be moved from one still life to another. I used the large porcelain soup tureen on the right as a container for a painting entitled* Blue Boy and Pinkie, *but I also felt it would be a beautiful object to place in this composition. The flowers, a mixture of white mums and gladioli, were a gift from one of my students. She is the organist for the local mortuary, and when the family of the departed declines to take the flowers after the funeral, she is often the recipient. It is nice to get double use out of something so beautiful and fragile. This painting is a soft blue-gray leaning a bit to the violet. I only used soft grays rather than pure color. The violet-blue tones keep the finished work soft and subtle.*

Pink Roses in Jet-Black Vase *Oil on canvas, 24x18 inches. I was once asked, "How should you paint a jet-black vase when it seems to dominate everything you put with it?" There are, of course, many ways to compose a painting, but my answer was, "To make your vase important, let it take the limelight, then paint down all areas around it, using carefully placed midtones and lights." Then I demonstrate what I meant with this painting. I always find it easier to talk with a brush in my hand.*

The roses are floppy (Bells of Portugal) and have little detail, so they do not take importance away from the black vase. Showing a bit of the table allowed me to add a mid-tone, which helped balance the massive area of dark. The final effect is one of soft brushiness. The vase certainly dominates, but the variety of tones in the flowers and the table give the painting balance.

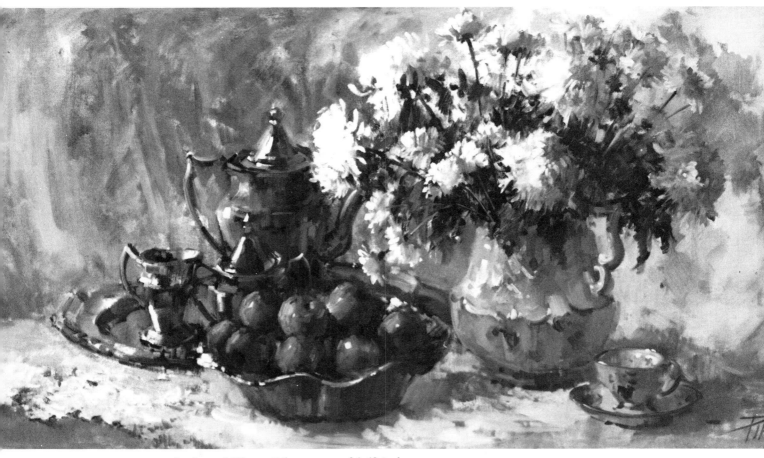

Apples and Silver *Oil on canvas, 24x48 inches.
My first thought when arranging this set-up was
that I wanted the entire painting to have a feeling
of silver, both in color and subject matter. Select-
ing the silver tea set and fluted bowl gave me a
good start, and the white mums and creamy porce-
lain just added to the silver look. The white hand-
embroidered linen tablecloth, which shows a slight
bit of the table on the left side, gives an additional
bit of texture, although it is underplayed.*

*Understating was necessary throughout to en-
sure a unified composition. The only warm tones
in the painting are on the hand-painted trim on the
large pitcher and the soft background washes
which became a subtle gray when covered with
cool overtones. I painted the apples in the fluted
dish realistically yet kept them sufficiently subdued
so they remained a compositional unit. Everything
in the finished painting glistens with tiny touches
of almost pure white. This gives a shiny feeling,
yet the silver appears as it was—not polished.*

China Doll in Blue *Oil on canvas, 40x30 inches. I love to paint antique objects because of the memories they evoke. This beautiful china doll and porcelain bowl and pitcher certainly are nostalgic for many people. I added garden-grown blue delphiniums. I decided to keep all the areas around the doll loosely painted but paint the doll's face with complete realism. A north window light infused the set-up with cool lights and warm shadows.*

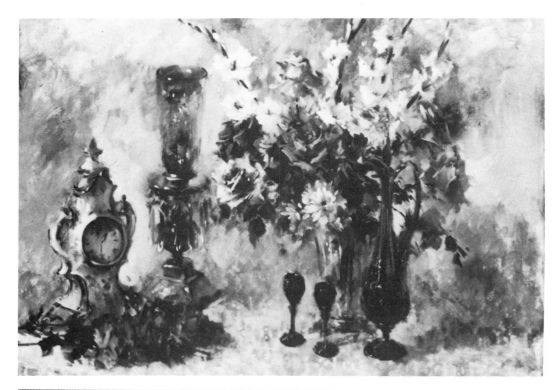

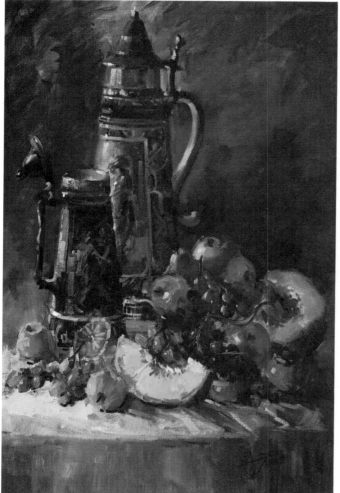

After-Dinner Liqueur *Oil on canvas, 30x40 inches. This painting of pink roses with a cranberry lamp, venetian decanter, and liqueur glasses was done as a demonstration for a group of students. The studio was filled with nostalgic antiques tastefully arranged to accommodate two simultaneous classes. The lamp was brought by one of the students, and I brought my favorite china clock, which was broken in the 1971 Sylmar earthquake. The clock face is now a piece of cardboard with the numbers painted on it, but no one will ever know except you and me. The overall tone of the painting is cool pink and red, leaning toward violet. Touches of yellow highlight the clock and Venetian glass.*

Beer Steins and Fruit *Oil on canvas, 36x24 inches. These giant steins are owned by a collector who has over a hundred such beautifully decorated mugs. I planned a life-sized painting of the steins, which necessitated a thirty-six-inch high canvas. I added masses of fresh fruit to enhance the "eat, drink, and be merry" mood. The figures on the steins are faithfully portrayed and each have a definite meaning.*

The painting is primarily dark, with the focal area in the light. Notice how the melon in the foreground curves upward to bring the eye back and into the painting. I painted most of the fruit softly, especially the grapes. I added a little more detail on the grapes and grapefruit nearest the source of light. Most of the colors are earth tones achieved by mixing colors grayed with their complements. A warm gray background enhances the brilliant cobalt blue of the steins.

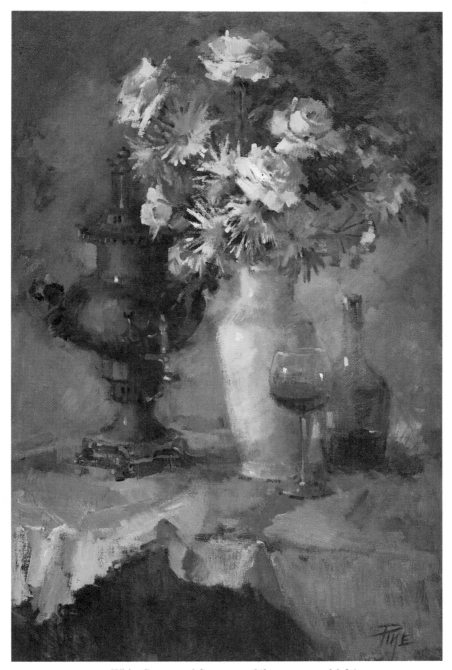

White Roses and Samovar *Oil on canvas, 36x24
inches. I do enjoy painting in earthy tones, but I
prefer mixing my own earth colors and grays. This
painting of white roses in a white vase appears, at
first glance, to be painted with yellow ochre or
burnt umber, but I mixed those tones from the usu-
al colors on my palette. The overall values are
slightly dark, allowing the white of the roses to
dominate. The dark table, at the bottom, adds a
bit of interest by contrasting with the folds of the
tablecloth. Because the tones of the tablecloth are
a yellowed gray, the strongest concentration of
light remains on the flowers.*

Index